Sony NEX-6:
From
Snapshots to
Great Shots

Jerod Foster

**Peachpit
Press**

Sony NEX-6: From Snapshots to Great Shots
Jerod Foster

Peachpit Press
Find us on the Web at www.peachpit.com
To report errors, please send a note to errata@peachpit.com
Peachpit Press is a division of Pearson Education

Copyright © 2013 Peachpit Press
All photography © Jerod Foster

Senior Editor: Susan Rimerman
Production Editor: Lisa Brazieal
Copy Editor/Proofreader: Scout Festa
Composition: WolfsonDesign
Indexer: James Minkin
Cover Design: Aren Straiger
Cover Image: Jerod Foster
Interior Design: Riezebos Holzbaur Design Group

ISBN-13: 978-0-321-90621-2
ISBN–10: 0-321-90621-7

9 8 7 6 5 4 3 2 1

Printed and bound in the United States of America

DEDICATION

To everyone at Peachpit who has made the past couple of years
very special for me, my family, and my work. I'm honored to call you
all friends!

ACKNOWLEDGMENTS

A project like this does not come together with just one person at the helm, and I'm glad to have worked with many fine folks throughout its duration. To Jeff Revell, thanks for creating the foundation for what has resulted in a fantastic series of books and learning resources for many camera owners. Your contribution to this text is invaluable.

I would also like to thank everyone at Peachpit who was instrumental in this project. Specifically, thanks goes to Susan Rimerman, Ted Waitt, Lisa Brazieal, Scout Festa, Aren Straiger, WolfsonDesign, Sara Jane Todd, Scott Cowlin, and Nancy Aldrich-Ruenzel. All of you made this another enjoyable experience that produced another great-looking book. Thank you.

Appreciation also goes to Armadillo Camera in Lubbock, Texas. Steve, Larry, Wayne, and Raymond came through on a large scale in securing the fresh-off-the-line NEX-6 I used to write this book.

I must also thank the College of Media and Communication at Texas Tech University for providing me a venue in which to teach what I love doing every chance I can get. Specifically, Dean Jerry Hudson, Ph.D., and Todd Chambers, Ph.D., deserve a great deal of gratitude for their encouragement and support for me and my work as a professor and photographer.

Last, but certainly not least, I would like to thank my wonderful wife, Amanda, for the support she provides at all times, and my beautiful daughter, Eva, for playing a role in making a few of the images in the book come to life. Thanks also goes to all the family and friends that either assisted with or were photographed for the book—Trace, Seth, Chase, Travis, Mike, Becca, Elic, Mia, Tia, Patrick, Addison, Jude, Peyton, Gavin, and Kyle. Many thanks, all.

Contents

Introduction

There has been much said about the current trend in photography technology to make gear smaller and lighter without sacrificing image quality. A variety of new mirrorless cameras have been at the forefront of this buzz, including the one on which this book focuses. But when I looked around, I did not come across any good resources that married this new camera platform with practical photography instruction. In essence, resources for and about these cameras were nonexistent beyond the World Wide Web, and those were mostly reviews composed of technical jargon. When Peachpit approached me about writing a book about the Sony NEX-6 for this great series, I was excited. This book is not a rehash of the owner's manual, but rather a resource to teach photography with the specific technology present in the camera that you now own. I have put together a short Q&A to help you get a better understanding of just what it is that you can expect from this book.

Q: IS EVERY CAMERA FEATURE GOING TO BE COVERED?

A: Nope, just the ones I felt you need to know about in order to start taking great photos. Believe it or not, you already own a great resource that covers every feature of your camera: the owner's manual. Writing a book that just repeats this information would have been a waste of my time and your money. What I did want to write about was how to harness certain camera features to the benefit of your photography. As you read through the book, you will also see callouts that point you to specific pages in your owner's manual that are related to the topic being discussed. These are meant to expand upon the feature or function that I cover as it applies to our specific needs.

Q: SO IF I ALREADY OWN THE MANUAL, WHY DO I NEED THIS BOOK?

A: The manual does a pretty good job of telling you how to use a feature or turn it on in the menus, but it doesn't necessarily tell you why and when you should use it. If you really want to improve your photography, you need to know the whys and whens to put all of those great camera features to use at the right time. To that extent, the manual just isn't going to cut it. It is, however, a great resource on the camera's features, and it is for that reason that I treat it like a companion to this book. You already own it, so why not get something of value from it?

Q: WHAT CAN I EXPECT TO LEARN FROM THIS BOOK?

A: Hopefully, you will learn how to make great photographs. My goal, and the reason the book is laid out the way it is, is to guide you through the basics of photography as they relate to different situations and scenarios. By using the features of your NEX-6 and this book, you will learn about aperture, shutter speed, ISO, lens selection, depth of field, and many other photographic concepts. You will also find plenty of full-page photos that include captions, shooting data, and callouts so you can see how all the photography fundamentals come together to make great images. All the while, you will be learning how your camera works and how to apply its functions and features to your photography.

Q: WHAT ARE THE ASSIGNMENTS ALL ABOUT?

A: At the end of most of the chapters, you will find shooting assignments, where I give you some suggestions as to how you can apply the lessons of the chapter to help reinforce everything you just learned. Let's face it—using the camera is much more fun than reading about it, so the assignments are a way of taking a little break after each chapter and having some fun.

Q: SHOULD I READ THE BOOK STRAIGHT THROUGH OR CAN I SKIP AROUND FROM CHAPTER TO CHAPTER?

A: Here's the easy answer: yes and no. No, because the first four chapters give you the basic information that you need to know about your camera. These are the building blocks for using the camera. After that, yes, you can move around the book as you see fit, because the later chapters are written to stand on their own as guides to specific types of photography or shooting situations. You can bounce from portraits to shooting landscapes and then maybe to a little action photography. It's all about your needs and how you want to address them. Or, you can read it straight through. The choice is up to you.

Q: IS THERE ANYTHING ELSE I SHOULD KNOW BEFORE GETTING STARTED?

A: In order to keep the book short and focused, I had to be selective about what I included in each chapter. This, however, leaves out a little more information that might come in handy after you've gone through all the chapters. So as an added value for you, I have written a bonus chapter: "Pimp My Ride." It is full of information on photo accessories that will assist you in making better photographs, and you will find my recommendations for things like filters, tripods, and much more. To access the bonus chapter go to Peachpit.com/sonynex6. This link will take you to the product page. Look for the "register your product" link. If you don't have Peachpit account, create one (it's free). After you register the book, a link to the bonus chapter will be listed on your Account page under Registered Products tab.

Q: IS THAT IT?

A: One last thought before you dive into the first chapter. My goal in writing this book has been to give you a resource that you can turn to for creating great photographs with your Sony NEX-6. Take some time to learn the basics and then put them to use. Photography, like most things, takes time to master and requires practice. One of the most important things I tell my students and others about my own photography work is that I'm still learning. Always remember that it's not the camera that makes beautiful photographs—it's the person using it. Photography is one of those activities that let you explore, no matter if you are traveling or shooting your child's birthday party. So enjoy the experience, learn from your mistakes (which I encourage you to make), and take your snapshots to another level—to great shots.

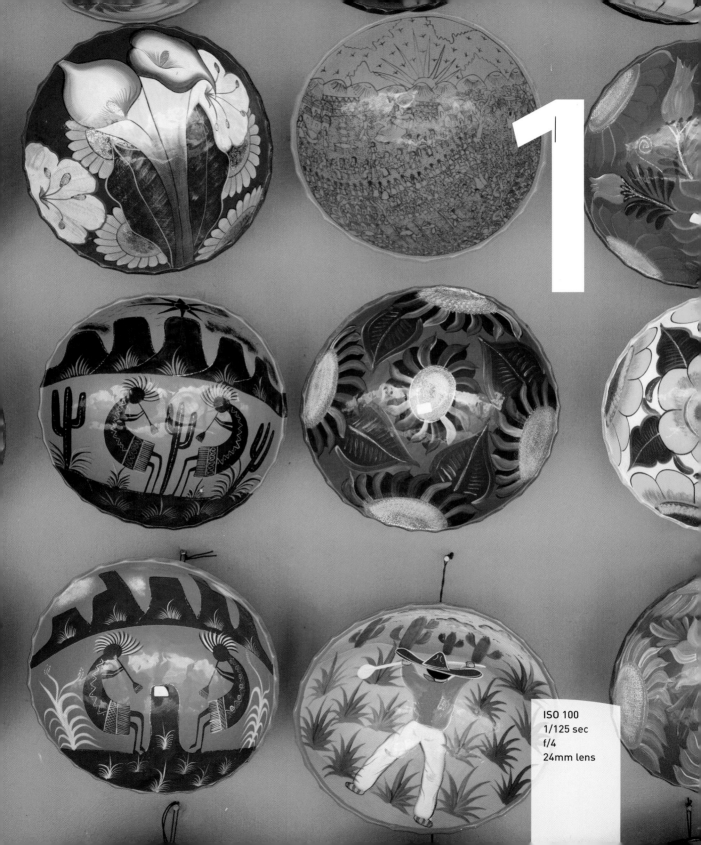

1

ISO 100
1/125 sec
f/4
24mm lens

The NEX-6 Top Ten List

TEN TIPS TO MAKE YOUR SHOOTING MORE PRODUCTIVE RIGHT OUT OF THE BOX

Ah, you have to love that new camera smell, right? I'm always excited to unbox a new piece of equipment, especially a camera. I just want to unwrap the packaging, put the lens on, insert a new memory card, and start rediscovering the world photographically. Sound familiar? Instead of being patient and at least glancing at the owner's manual, I'm always eager to break in the shutter on my new camera!

Of course, this behavior always leads to frustration in the end—there are always issues that would have been easily addressed had I known about them before I started shooting. Maybe if I had a Top Ten list of things to know, I could be more productive without having to spend countless hours with the manual. So this is where we begin.

The following list will get you up and running without suffering many of the "gotchas" that come from not being at least somewhat familiar with your new camera. So let's take a look at the top ten things you should know before you start taking pictures with your Sony NEX-6.

PORING OVER THE CAMERA

CAMERA FRONT

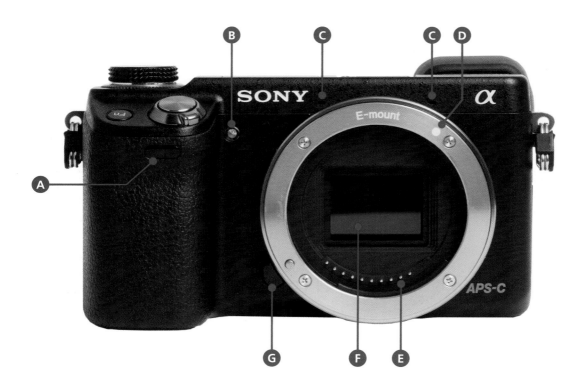

A Remote Sensor
B AF Illuminator/Self-timer Lamp/
 Smile Shutter Lamp
C Microphone

D Lens Mounting Mark
E Lens Contacts
F Sensor
G Lens Release Button

CAMERA BACK

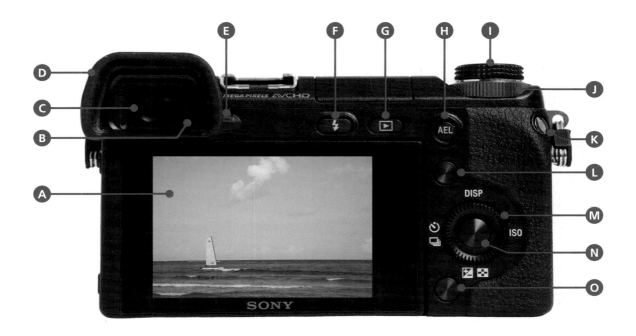

A	LCD Screen	F	Flash Pop-up Button	K	Movie Button
B	Eye Sensor	G	Playback Button	L	Soft Key A — *MENU BUTTON*
C	Viewfinder	H	Auto Exposure Lock Button	M	Control Wheel
D	Eyepiece Cup	I	Mode Dial	N	Soft Key C
E	Diopter-adjustment Dial	J	Control Dial	O	Soft Key B

PORING OVER THE CAMERA

CAMERA TOP

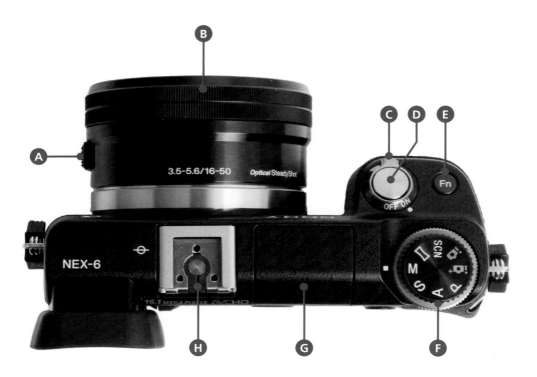

A Zooming Lever
B Zooming/Focusing Ring
C Power Switch
D Shutter Button

E Function (Fn) Button
F Mode Dial
G Pop-up Flash
H Multi Interface Shoe

1. CHARGE YOUR BATTERY

I know that this will be one of the hardest things for you to do because you really want to start shooting, but a little patience will pay off later.

When you first open your camera and slide the battery into the battery slot, you will be pleased to find that there is probably juice in the battery and you can start shooting right away. Resist the temptation, and instead get out the battery charger and give that power cell a full charge. Not only will this give you more time to shoot later on, but it will also start the battery off on the right foot. No matter what claims the manufacturers make about battery life and battery memory, I always find I get better life and performance when I charge my batteries fully and then use them right down to the point where they have nothing left to give. To check your battery's level, insert it into the camera, turn on the camera, and look for the battery indicator in the upper right of the LCD screen (**Figure 1.1**).

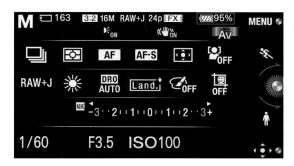

FIGURE 1.1
The LCD screen shows how much charge is left on your battery.

KEEPING A BACKUP BATTERY

If I were to suggest just one accessory that you should buy for your camera, it would probably be a second battery. Nothing stinks more than being out in the field and having your camera die. Keeping a fully charged battery in your bag will give you the confidence that you can keep on shooting without fail. Not only will this extend your shooting time, but alternating between batteries will help lengthen their lives. No matter what the manufacturers say, batteries do have a life, and using them half as much will only lengthen their usefulness.

2. TURN OFF THE AUTO ISO SETTING

The ISO setting in your camera allows you to choose the level of sensitivity of the camera sensor to light. The ability to change this sensitivity is one of the biggest advantages to using a digital camera. In the days of film cameras, you had to choose the ISO by film type. This meant that if you wanted to shoot in lower light, you had to replace the film in the camera with one that had a higher ISO. So not only did you have to carry different types of film, but you also had to remove one roll from the camera to replace it with another, even if you hadn't used up the current roll. Now all we have to do is go to the menu and select the appropriate ISO.

Having this flexibility is a powerful option, but remember that the ISO setting has a direct bearing on the quality of the final image. The higher the ISO, the more digital noise the image will contain. Since our goal is to produce high-quality photographs, it is important that we get control over all of the camera controls and bend them to our will. When you turn your camera on for the first time, the ISO will be set to Auto. This means that the camera is determining how much light is available and will choose what it believes is the correct ISO setting. Since you want to use the lowest ISO possible, you will need to turn this setting off and manually select the appropriate ISO.

Which ISO you choose depends on your level of available or ambient light. For sunny days or very bright scenes, use a low ISO such as 100 or 200. As the level of light is reduced, raise the ISO level. Cloudy days or indoor scenes might require you to use ISO 400. Low-light scenes, such as when you are shooting at night, will mean you need to bump up that ISO to 1600 or higher. The thing to remember is to shoot with the lowest setting possible for maximum quality. Later we will cover some other specifics of exposure so that you know how and why to raise your ISO.

NOISE

Noise is the enemy of digital photography, but it has nothing to do with the loudness of your camera operation. It is a term that refers to the electronic artifacts that appear as speckles in your image. They generally appear in darker shadow areas and are a result of the camera trying to amplify the signal to produce visible information. The more the image needs to be amplified—e.g., raising the sensitivity through higher ISOs—the greater the amount of noise there will be.

1. Activate the camera by pressing the shutter release button halfway.

2. Press the right side of the Control wheel on the back of the camera.

3. Rotate the Control wheel to highlight the desired ISO (from ISO 100 to ISO 25600) (**A**).

4. Press soft key C (the middle of the Control wheel) to lock in your selection and return to shooting.

SET YOUR ISO ON THE FLY

By following the steps above, you can change the ISO without taking your eye from the viewfinder. When you press the right side of the Control wheel, all of the camera settings in the viewfinder will disappear, leaving just the ISO information. Once you press soft key C, your new ISO setting will be displayed along with the regular shooting data. This will get easier to do as you become more familiar with the camera buttons. In fact, anything that can be displayed on the LCD can be displayed in the viewfinder, so you can make many more changes while keeping your eye to the viewfinder. Try it out!

3. SET YOUR JPEG IMAGE QUALITY

Your new NEX-6 has a number of image quality settings to choose from, and you can adjust them according to your needs. Most people shoot with the JPEG option because it allows them to capture a large number of photos on their memory cards. The problem is that unless you understand how JPEG works, you might be degrading the quality of your images without realizing it.

The JPEG (Joint Photographic Experts Group) format has been around since about 1994 and was developed as a method of reducing large file sizes while retaining the original image information. (Technically, JPEG isn't even a file format—it's a mathematical equation for reducing image file sizes—but to keep things simple, we'll just refer to it as a file format.) The problem with JPEG is that, in order to reduce file size, it has to throw away some of the information. This is referred to as "lossy

compression." This is important to understand, because while you can fit more images on your memory card by choosing a lower-quality JPEG setting, you will also be reducing the quality of your image. This effect becomes more apparent as you enlarge your pictures.

The JPEG file format also has one other characteristic: To apply the compression to the image before final storage on your memory card, the camera has to apply all of the image processing first. Image processing involves such factors as sharpening, color adjustment, contrast adjustment, noise reduction, and so on. Many photographers now prefer to use the RAW file format to get greater control over the image processing. We will take a closer look at this in Chapter 2, but for now let's just make sure that we are using the best-quality JPEG possible.

The NEX-6 has two quality settings and three sizes for the JPEG format. The two quality settings are Fine and Standard; I encourage you to use only the Fine option. Standard is more compressed and does not capture the image with as high a quality as Fine. After setting your JPEG quality, you must select the physical size of the image: Large, Medium, or Small. Large takes advantage of all 16 megapixels of the NEX-6's sensor, Medium provides you roughly half of that, and Small provides you an image that is 4 megapixels. Let's work with the highest-quality setting and the largest size: Fine and Large. After all, our goal is to make big, beautiful photographs, so why start the process with a lower-quality, smaller image?

Manual Callout

For a chart that shows the image quality settings with the number of possible shots for each setting, turn to page 75 in your owner's manual.

SETTING THE IMAGE QUALITY AND SIZE

1. Press the Menu button on the back of the camera to bring up the menu list.

2. Rotate the Control wheel to highlight the Image Size submenu, and press soft key C to select it.

3. Use the Control wheel to navigate to Quality under the Still section. Select it with soft key C to open up a list of image formats to choose from (**A**). Select Fine, and return to the Still section of the Image Size submenu.

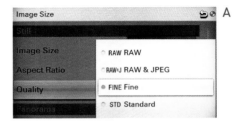

4. Navigate to Image Size, and select it to open the list of JPEG sizes.

5. Select the size L: 16M (**B**) by pressing soft key C.

6. Press the shutter button halfway to return to shooting.

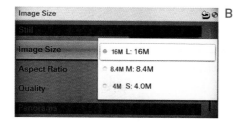

4. CONFIGURE YOUR LCD AND VIEWFINDER

If you are used to looking through the view-finder of an older film camera or a more traditionally styled DSLR, you might find the NEX-6's LCD and electronic viewfinder (EVF) a bit odd. Instead of looking through the lens via a series of mirrors and glass, with both the LCD and EVF you are looking at an electronic display akin to a computer monitor. Shooting with this takes some getting used to, but after a few rounds of shooting with the camera, you might never want to go back to an optical viewfinder again.

Manual Callout

For a complete list of the icons you will see on your NEX-6, see pages 78–81. There are many, but over time you'll probably gravitate to the ones that are most important to your own photographic process.

One feature common to both the LCD and the EVF that makes the camera appealing and very usable is the set of different display modes you can activate. Let's start with the LCD. When you turn the camera on, you'll notice that the LCD on the back of the camera projects the scene that the lens is pointed at. If you press the DISP button at the top of the Control wheel (by now, you have probably discovered that the Control wheel is a primary mechanism of the camera), you can cycle through the seven display modes. All modes display shutter speed, aperture, ISO, exposure compensa-tion, and file format. Each mode displays the information differently, and some modes display additional information. The default mode provides a graphical display of shutter speed and aperture at the bot-tom of the display, as well as movie format information at the top (**A**).

Press the DISP button once, and the display will keep the basic information intact, but even more information will appear in icon form at the left of the display (**B**). Among other things, this grouping of icons inform you of your focus mode, white balance, creative style, metering mode, and drive mode. This mode displays all the information you need about your shot at that time (but it certainly clutters up the display).

A second press of the button reduces the amount of information on the LCD to the bare necessities (**C**). It also increases the size of the font.

Press the DISP button a third time to show only the shutter speed, aperture, exposure compensation, and ISO (**D**). This display is reminiscent of what you might see while looking through the viewfinder of a traditional DSLR.

The fourth press of the DISP button keeps the same basic information as the last display mode, but it adds an electronic level in the middle of the screen (**E**). This comes in handy for landscape photography and reduces the need to purchase a bubble level that attaches to your camera's hot shoe.

Press DISP again and the level disappears, but a live histogram appears above the ISO reading (**F**). Instead of waiting to view exposure levels during playback of your images, you can use the live histogram for instant feedback about over- and under-exposure before you even press the shutter button.

Lastly, a sixth press of the DISP button will completely remove the scene coming through the lens and replace it with a large amount of pertinent information about your shooting (**G**). I prefer this display mode for two reasons. First, pressing the Function (Fn) button next to the shutter button will let you navigate through all the icons on the display and change any of the features by using the Control wheel. Consider this display mode a way to quickly access the functions you will use 90 percent of the time. The second reason I prefer this mode is that I prefer to use the viewfinder when shooting. Since I come from an SLR and DSLR background, I am used to holding the camera close to my eye and looking through the viewfinder to compose and shoot a scene.

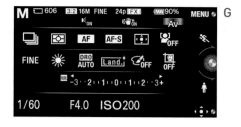

Speaking of the viewfinder, the NEX-6 has a wonderful EVF. At just over 2.5 million dots of resolution, it provides you enough clarity to manually focus your scene. When you press your eye to the viewfinder, a sensor deactivates the LCD and engages the EVF. From here, you can press the DISP button to cycle through three display modes. The first and default mode displays the basic shooting information (shutter speed, aperture, ISO, remaining shots, size, and format, as well as movie format and remaining battery life). Press the DISP button again, and the electronic level also appears in the EVF. Press it one more time and the level is replaced by a live histogram.

My preference is to leave the EVF on the default setting, but it takes nothing more than a press of the thumb to access the level or histogram. You can also press the Fn button to access certain features of the camera, such as white balance, metering mode, and the autofocus controls. Lastly, you can access all the menus using the EVF. Just press the Menu button while your eye is at the viewfinder, and you can get to anything you need by manipulating the Control wheel with your right hand. Nifty, huh?

LIVE VIEW DISPLAY SETTING EFFECT

One thing you might want to do, at least initially, is turn on the Live View display Setting Effect. Turning this function on will let you see the effect on your scene of every feature you manipulate. For example, if you change your white balance with Setting Effect turned on, you will see the change in color that each white balance incurs. Each change you make while operating your camera will come through on the LCD or in the EVF. To turn Setting Effect on, go to Menu › Setup › Live View Display › Setting Effect ON. You can always turn it off if it becomes a distraction.

5. SET YOUR AUTOFOCUS AREA AND MODE

The Sony NEX focusing system is renowned in the mirrorless camera market, especially for its speed. There is, however, one small problem that is inherent in any focusing system. No matter how great it is, the camera is looking at all the subjects in the scene and determining which is closest to the camera. It then uses this information to determine where the focus should be placed. It has no way of knowing what your main emphasis is, so it is using a "best guess" system. To eliminate this factor, you should set the camera's autofocus area to Flexible Spot to ensure that you are focusing on the most important feature in the scene.

The camera has 187 focus spots to choose from. To start, you should choose a focus spot in the middle. Once you have become more familiar with the focus system, you can experiment with other areas, as well as with the automatic autofocus area selections.

You should also change the focus mode to Single-shot so you can focus on your subject and then recompose your shot while holding that point of focus. This method will allow for better composition.

SETTING THE AUTOFOCUS AREA AND AUTOFOCUS MODE

1. To choose a single spot for focusing, wake the camera (if necessary) by lightly pressing the shutter release button.

2. Press Menu and select the Camera submenu. Rotate the Control wheel to highlight and select Autofocus Area.

3. Select Flexible Spot. At this point, you will be given the opportunity to choose the spot on which you want to focus (**A**). Press the top/bottom/left/right of the Control wheel to move the spot to the center (if it is not there already). Press soft key C to lock in your selection.

4. To set the autofocus mode, press Menu again and navigate to the Camera submenu. Find Autofocus Mode and select it using soft key C.

5. Select Single-shot AF (AF-S) (**B**). Once you make your selection, you will be returned to your LCD for shooting.

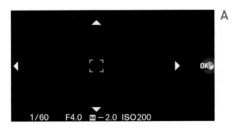

A

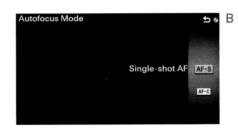

B

The camera is now ready for single focusing. You will hear a chirp when the camera has locked in and focused on the subject. To focus on your subject and then recompose your shot, just place the focus area in the viewfinder on your subject, depress the shutter button halfway until the camera chirps, and without letting up on the shutter button, recompose your shot and then press the shutter button all the way down to make your exposure (**Figure 1.2**).

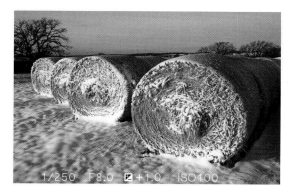

FIGURE 1.2
Using the center focus spot in Single-shot AF mode allows you to focus on your subject and then recompose for better composition.

6. SET THE CORRECT WHITE BALANCE

White balance correction is the process of rendering accurate colors in your final image. Most people don't even notice that light has different color characteristics, because the human eye automatically adjusts to changes in color temperature—so quickly, in fact, that everything looks correct in a matter of milliseconds.

When color film ruled the world, photographers would select which film to use depending on what their light source was going to be. The most common film was balanced for daylight, but you could also buy film that was color balanced for tungsten light sources. Most other lighting situations had to be handled by using color filters over the lens. This process was necessary for the photographer's final image to show the correct color balance of a scene.

Your camera has the ability to perform this same process automatically, but you can also choose to override it and set it manually. Guess which method we are going to use? You are catching on fast! Once again, your photography should be all about maintaining control over everything that influences your final image.

Luckily, you don't need to have a deep understanding of color temperatures to control your camera's white balance. The choices are given to you in terms that are easy to relate to and that will make things pretty simple. Your white balance choices are:

- **Auto:** The default setting for your camera. It is also the setting used by all the automatic modes (see Chapter 3).

- **Daylight:** Most often used for general daylight/sun-lit shooting.

- **Shade:** Used when working in shaded areas that are still using sunlight as the dominant light source.

- **Cloudy:** The choice for overcast or very cloudy days. This and the Shade setting will eliminate the blue color cast from your images.

- **Incandescent:** Used for any occasion where you are using regular household-type bulbs for your light source. Tungsten is a very warm light source and will result in a yellow/orange cast if you don't correct for it.

- **Warm White Fluorescent:** Used to get rid of the color cast that can result from using warmer fluorescent lights as your dominant light source.

- **Cool White Fluorescent:** Used to warm up the green-blue cast that can result from using regular fluorescent lights as your dominant light source.

- **Day White Fluorescent:** A bit warmer than Cool White Fluorescent, this can be used under fluorescents that fit between standard and daylight balanced.

- **Daylight Fluorescent:** Similar to Daylight, this setting allows you to compensate for the color of light from fluorescent lights that are manufactured to replicate the color temperature produced by the sun.

- **Flash:** Used whenever you're using the built-in flash or a flash on the hot shoe. You should select this white balance to adjust for the slightly cooler light that comes from using a flash. (The hot shoe is the small bracket located on the top of your camera; it rests just above and to the right of the viewfinder. This bracket is used for attaching a more powerful flash to the camera; see Chapter 8 and the bonus chapter "Pimp My Ride.")

- **C. Temp/Filter:** Used to manually select both your camera's color temperature in Kelvin and the color shift. If you know what the color temperature of your light source is, you can manually create a white balance setting that is specifically for that light source. In order to take advantage of this setting, you must press soft key B (Options) after you highlight it. From there, you can use the Control wheel to manipulate the white balance. To be honest, I rarely use this setting. The presets are quite good, and if I have a white balance issue that necessitates manual tweaking, I perform it in post-processing software.

- **Custom:** Uses a white balance determined by the Custom Setup function (explained below).

- **Custom Setup:** Allows you to obtain a white balance by pointing the camera at a white reference in the scene and pressing the shutter button. The camera guides you where to place the white reference in the frame. Once you press the shutter button, a color temperature is determined, and you may use that white balance by selecting Custom.

Your camera has two "zones" of shooting modes to choose from: auto and professional. They are located on the Mode dial. The auto modes, which are identifiable by small icons, do not allow for much, if any, customization. The professional modes, identified by letter symbols, allow for much more control by the photographer (**Figure 1.3**).

FIGURE 1.3
The camera's shooting modes are divided into the auto modes and the professional modes.

SETTING THE WHITE BALANCE

1. After turning on or waking the camera, select one of the professional exposure modes, such as P (you can't set the white balance when using the auto modes).

2. Press Menu, and use the Control wheel to highlight and select the Brightness/Color submenu (**A**).

3. Find White Balance, and select it by pressing soft key C. You can now rotate the Control wheel to navigate to your desired white balance setting (**B**).

4. Press soft key C to lock in your selection.

5. Check the LCD or electronic viewfinder to ensure that the proper white balance is selected.

WHITE BALANCE AND THE TEMPERATURE OF COLOR

When you select white balances, you are selecting changes in the color temperature of your frame, which is measured along the Kelvin (K) temperature scale. Kelvin temperatures refer to colors in the visible spectrum. The visible spectrum is the range of light that the human eye can see (think of a rainbow or the color bands that come out of a spectrum). The Kelvin temperature scale identifies the thermodynamic temperature of a given color of light. Put simply, reds and yellows are "warm" and greens and blues are "cool." Even more confusing can be the actual temperature ratings. Warm temperatures are typically lower on the Kelvin scale, ranging from 3000 degrees to 5000 degrees, while cool temperatures run from 5500 degrees to around 10000 degrees. Take a look at this list for an example of Kelvin temperature properties.

KELVIN TEMPERATURE PROPERTIES

Flames	1700K–1900K	Daylight	5000K
Incandescent bulb	2800K–3300K	Camera flash	5500K
White fluorescent	4000K	Overcast sky	6000K
Moonlight	4000K	Open shade	7000K

The most important thing to remember here is how the color temperature of light will affect the look of your images. If something is "warm," it will look reddish-yellow, and if something is "cool," it will have a bluish cast.

7. SET YOUR COLOR SPACE

You'll hear photographer after photographer talk about getting the most out of digital images. One of the reasons we say this is because the camera is a very limited machine. Underneath all the technological bells and whistles (and the NEX-6 has plenty of them) is a machine that needs you to operate it, and it can only do so much. This is true of all cameras, but being a photographer means making sure you're squeezing every bit out of those buttons, dials, and 1s and 0s.

To maintain the highest quality in your images, make sure you are capturing as much information as possible, especially when it comes to your image's color space. A color space designates the amount of color that can be captured when you snap a shot. It's all about reproducing accurate color. Your NEX-6 can capture digital images in two color spaces: Adobe RGB and sRGB. Folks have written books on the RGB color space, so I'll keep the descriptions short and useful. Adobe RGB was developed in 1998 to encompass the CMYK color gamut, which is used by printing presses (think magazines, brochures, and even this book); it is the largest color space your camera offers. sRGB is rather small, and its purpose is to produce colors consistent with those that most computer monitors are able to display and that inkjet printers use. sRGB is also the color space synonymous with images on the Internet. The smaller color space means smaller file sizes, making for easier uploads and downloads.

I advise using Adobe RGB. It's large enough to include both CMYK and sRGB, and post-processing software will enable you to convert down. It doesn't make quite as much sense to try to convert up. This ensures that you are making the most of your camera's sensor and, subsequently, your images.

CHANGING YOUR COLOR SPACE TO ADOBE RGB

1. Press Menu, and select the Setup submenu.
2. Using the Control wheel, navigate to Color Space under the Shooting Settings section. Select it by pressing soft key C (**A**).
3. Rotate the Control wheel to highlight and select AdobeRGB (**B**).
4. That's it. Press the shutter button halfway to return to shooting. You will not see any difference in color with the naked eye. This all happens in the background—but it's worth knowing when it's time for post-processing.

 A

 B

8. KNOW HOW TO OVERRIDE AUTOFOCUS

I'll be honest: Autofocus is awesome! It truly rocked the photography world in the late 1970s and early 1980s. I'm in autofocus 80–90 percent of the time, and I'm willing to bet many other photographers are the same. The technology has developed so much in the past few decades that we now talk about focusing in milliseconds and we are frustrated when it doesn't lock on. This latter situation—and when shooting macro images or static subject matter—is when switching to manual focus comes in handy.

Unlike traditional DSLR lenses, the E-Mount lenses available for the NEX line of cameras do not feature a physical switch to change between autofocus and manual focus. You will have to dig into the camera's menus to make this switch. Your NEX-6 has three focus modes to choose from: autofocus, manual focus, and Direct Manual Focus (DMF). Autofocus focuses the lens for you, and manual focus puts you in full control. Direct Manual Focus is a hybrid of both: When you're in this setting, press the shutter button halfway to engage the autofocus; once the camera grabs focus, you can then rotate the focusing ring on the lens to ensure accuracy.

SWITCHING TO MANUAL OR DIRECT MANUAL FOCUS

1. Press the Menu button, then navigate to and select the Camera submenu (**A**).

2. Select AF/MF Select, and rotate the Control wheel to highlight either Manual Focus (MF) or Direct Manual Focus (DMF) (**B**).

3. Press soft key C to lock in your change.

 A

 B

Manually focusing using an LCD or electronic viewfinder can be troublesome due to the pixels through which you are viewing the scene. Your NEX-6 addresses this issue with Manual Focus Assist and focus peaking. Both features are incredibly useful in manual focus mode. Manual Focus Assist magnifies the scene in the LCD or electronic viewfinder while you rotate the focus ring on the lens, allowing you a greater level of precision. Focus peaking highlights edges and contrasting tones with a color of your choice as your subject matter comes into focus.

1. To activate Manual Focus Assist, press the Menu button and navigate to and select the Setup submenu.

2. Rotate the Control wheel to highlight and select MF Assist (**A**). Select On, and press the shutter button halfway to return to shooting.

3. Rotate the focus ring on the lens and watch through the viewfinder as it magnifies the center of the scene. Use the top/bottom/right/left of the Control wheel to redirect the magnification. Keep turning the focusing ring until what you want to focus on is in focus.

4. To turn on focus peaking, first navigate back to the Setup submenu.

5. Find and select Peaking Level (**B**). From here, you can determine the strength of the peaking. I prefer the Low setting so the peaking does not distract from the image framing. Press soft key C to select your desired level. This will also return you to the Setup submenu.

6. Before testing the peaking out, choose a peaking color. Rotate your Control wheel down one click to Peaking Color (**C**). Select white, red, or yellow (I like red).

7. Return to shooting. Now when you focus, you should see colored highlights on the outlines of in-focus areas.

9. REVIEW YOUR SHOTS

One of the greatest features of digital cameras is their ability to give us instant feedback. By reviewing your images on the camera's LCD screen, you can instantly tell if you got your shot. This visual feedback allows you to make adjustments on the fly and make certain that you nailed the shot before moving on.

When you first press the shutter release button, your camera quickly processes your shot and then displays the image on the rear LCD display. The default duration setting for that display is 2 seconds. I don't mind this "quick glance" method because it allows me to get back to shooting more quickly. But if you want more time for visual feedback, you can always set your review time to 5 or 10 seconds. (Note that longer reviewing durations will drain your batteries a little faster than the default setting.)

CHANGING THE IMAGE AUTO REVIEW DURATION

1. Press the Menu button, and then use the Control wheel to select the Setup submenu.

2. Use the Control wheel to scroll down to Auto Review, and press soft key C (**A**).

3. Use the Control wheel to highlight and select the desired duration (**B**).

4. Press the Menu button twice to leave the menus and continue shooting.

Now that you have the image review time set, let's check out some of the other visual information that will help you when shooting.

For image playback, there are three display modes, and each gives you a different amount of information. The default view (**Figure 1.4**) simply displays your image.

To get more visual feedback, press the DISP button (it is the top of the Control wheel). Press it once to see shutter speed, aperture, ISO, file name, the date and time of the shot, size and format, and the shot's order on the card and folder ("7/22" would mean that you're looking at the seventh image of 22 total images) (**Figure 1.5**).

FIGURE 1.4
The default display mode on the NEX-6

FIGURE 1.5
Press the DISP button to see the second display option.

Pressing the DISP button a second time results in a huge amount of information being displayed along with the image. You will now be able to see the following items in your display: shutter speed, aperture, exposure compensation, file name, image thumbnail, four histograms (one for luminance and three for each color used to process digital images: red, green, and blue), exposure mode, ISO, white balance setting, creative style, size and format, metering mode, level of dynamic range optimization, image number, date, and time (**Figure 1.6**).

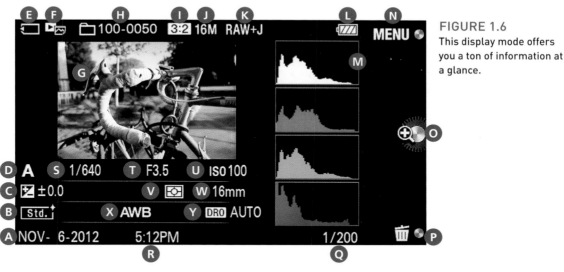

FIGURE 1.6
This display mode offers you a ton of information at a glance.

A Date	H Playback folder	M Exposure and	S Shutter speed
B Creative style	and File number	color histograms	T Aperture
C Exposure compensation	I Aspect ratio	N Menu (Soft Key A)	U ISO
D Exposure mode	J Image size	O Zoom (Soft Key C)	V Metering mode
E Memory card	K Image quality	P Trash (Soft Key B)	W Focal length
F View mode	L Remaining	Q Image number	X White balance
G Image	battery	R Time	Y Dynamic range optimization

That's a huge amount of information on a 3-inch screen! You probably won't want to use this display option as your default review setting, but if you are trying to figure out what settings you used or want to review the histogram (see the sidebar "The Value of the Histogram," later in this chapter), you now have all of this great information available.

The different display modes are activated by pressing the DISP button while an image is displayed on your LCD screen. That display mode will remain for all future images until you press the DISP button again. Also, pressing the shutter release button or the Menu button closes the image display. To get your image back up on the LCD screen, simply press the Playback button on the back of the camera.

DELETING IMAGES

Deleting or erasing images is a fairly simple process that is covered on page 32 of your manual. To quickly get you on your way, simply press the Playback button and find the picture that you want to delete with the Control wheel. Then press the Trash button (soft key B, next to the trash can icon displayed on the LCD), followed by pressing the center of the Control wheel (soft key C) (**Figure 1.7**).

Caution: Once you have deleted an image, it is gone for good. Make sure you don't want it before you drop it in the trash.

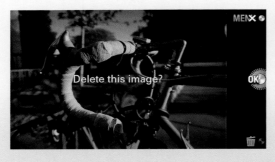

FIGURE 1.7
Deleting images on the NEX-6 is simple.

10. HOLD YOUR CAMERA FOR PROPER SHOOTING

Mirrorless cameras, along with most cameras out there, are made to favor the right-handed individual. The basics of properly holding the camera begin with grasping the camera body with the right hand. You will quickly find that most of the important camera controls are within easy reach of your thumb and forefinger. The next step is to create a stable base for your camera to rest on. This is accomplished by placing the camera body on the up-facing palm of your left hand (**Figure 1.8**). Now you can curl your fingers around the lens barrel to quickly zoom or manually focus the lens.

Now that you know where to put your hands, let's talk about what to do with the rest of your body parts. By using the underhand grip, your elbows will be drawn closer to your body. You should concentrate on pulling them in close to your body to stabilize your shooting position. You should also try to maintain proper upright posture. Leaning forward at the waist will begin to fatigue your back, neck, and arms. Nothing ruins a day of shooting like a sore back, so make sure you stand erect with your elbows in. Finally, place your left foot in front of your right foot, and face your subject in a slightly wide stance. By combining all of these aspects into your photography, you will give yourself the best chance of eliminating self-imposed camera shake (or hand shake) in your images, resulting in much sharper photographs.

FIGURE 1.8
The proper way to hold your camera to ensure sharp, blur-free images. (Photos by Amanda Waters Foster)

THE VALUE OF THE HISTOGRAM

Simply put, histograms are two-dimensional representations of your images in graph form. There are two different histograms that you should be concerned with: luminance and color. A luminance histogram displays pixel brightness and is most valuable when evaluating your exposures. In **Figure 1.9**, you see what looks like a mountain range. The graph represents the entire tonal range that your camera can capture, from the whitest whites to the blackest blacks. The left side represents black, and the right side represents white. The heights of the peaks represent the number of pixels that contain those luminance levels (a tall peak in the middle means your image contains a large number of medium-bright pixels). Looking at an image, it can be hard to determine where all of the ranges of light and dark areas are and how much of each I have. If I look at the histogram, I can see that the largest peak of the graph is near the middle and trails off as it reaches the edges. In most cases, you would look for this type of histogram, indicating that you captured the entire range of tones, from dark to light, in your image. Knowing that is fine—but here is where the information really gets useful.

A histogram that has a spike or peak riding up the far left or right side of the graph means that you are clipping detail from your image. In essence, you are trying to record values that are either too dark or too light for your sensor to accurately record. This is usually an indication of over- or underexposure. It also means that you need to correct your exposure so that the important details will not record as solid black or white pixels (which is what happens when clipping occurs). There are times, however, when some clipping is acceptable.

If you are photographing a scene where the sun will be in the frame, you can expect to get some clipping, because the sun is just too bright to hold any detail. Likewise, if you are shooting something that has true blacks in it—think coal in a mineshaft at midnight—there are most certainly going to be some true blacks with no detail in your shot. The main goal is to ensure that you aren't clipping any "important" visual information, and that is achieved by keeping an eye on your histogram.

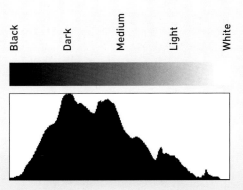

FIGURE 1.9

This is a typical histogram, where the dark to light tones run from left to right. The black-to-white gradient above the graph demonstrates where the tones lie on the graph and does not appear above your camera's histogram display.

Take a look at **Figure 1.10**. The histogram displayed on the image shows a heavy skew toward the left, with no part of the mountain touching the right side. This is a good example of what an underexposed image histogram looks like. Compare that to **Figure 1.11**, the histogram for the same image correctly exposed. Notice that even though there are two distinct peaks on the graph, there is a more uniform distribution of other tones across the entire histogram. You'll also note that since there is a great deal of contrast between the blacks and whites of the image, it is properly documented on the right and left sides of the histogram with a dip in the middle.

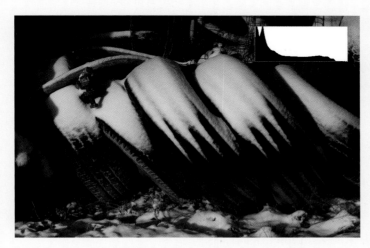

FIGURE 1.10
This image is about a stop and a half underexposed. Notice that the histogram is skewed to the left.

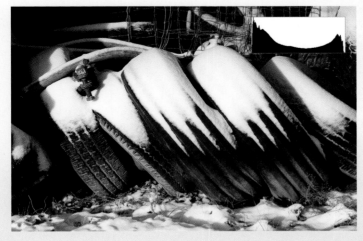

FIGURE 1.11
This histogram reflects a correctly exposed image.

Chapter 1 Assignments

Let's begin our shooting assignments by setting up and using all of the elements of the Top Ten list. Even though I have yet to cover the professional shooting modes, you should set your camera to the P (Program Auto) mode. This will allow you to interact with the various settings and menus that have been covered thus far.

Basic camera setup

Charge your battery to 100% to get it started on a life of dependable service. Next, using your newfound knowledge, set up your camera to address the following: LCD and electronic viewfinder display modes, image quality, and Auto ISO.

Selecting the proper white balance

Take your camera outside into a daylight environment and photograph the same scene using different white balance settings. Pay close attention to how each setting affects the overall color cast of your images. Next, move inside and repeat the exercise while shooting in an incandescent lighting environment. Finally, find a fluorescent light source and repeat once more.

Focusing with Flexible Spot and Single-shot

Change your camera setting so that you are focusing using the Flexible Spot autofocus area. Try moving the focus spot around the frame to see how it works in focusing your scene. Then set your autofocus mode to Single-shot, and practice focusing on a subject and recomposing before actually taking the picture. Try doing this with subjects at varying distances.

Evaluating your pictures with the LCD display

Set up your image display properties, and then review some of your assignment images using the different display modes. Review the shooting information for each image, and take a look at the histograms to see how the content of your photo affects their shapes.

Get a grip: proper camera holding

This final assignment is something that you should practice every time you shoot: proper grip and stance for shooting with your camera. Use the described technique and then shoot a series of images. Try it with improper techniques to compare the stability of the grip and stance.

Share your results with the book's Flickr group!

Join the group here: flickr.com/groups/sonynex6_fromsnapshotstogreatshots

2

ISO 100
1/100 sec.
f/13
24mm lens

First Things First

A FEW THINGS TO KNOW AND DO BEFORE YOU BEGIN TAKING PICTURES

Now that we've covered the top ten tasks to get you up and shooting, we should probably take care of some other important details. You must become familiar with certain features of your camera before you can take full advantage of it. Additionally, we will take some steps to prepare the camera and memory card for use. So to get things moving, let's start off with something that you will definitely need before you can take a single picture: a memory card.

PORING OVER THE PICTURE

It doesn't snow often in north central Texas, but it does get cold enough for what little snow there is to stick. This image was made on the ranch on which I grew up. There is a hill where hay is stowed away all summer long for the livestock, and the large round bales are lined up neatly each year. On top of these bales was the perfect spot to get an encompassing view of part of the ranch.

Combined with a relatively short focal length, an aperture of f/8 keeps the image sharp from the foreground to the hills in the background.

ISO 200
1/160 sec.
f/8
24mm lens

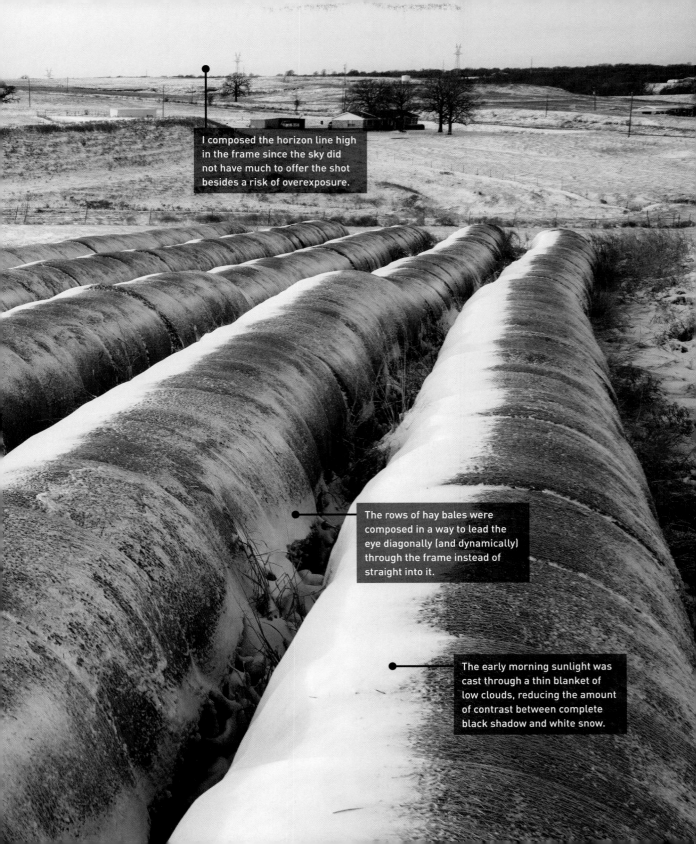

I composed the horizon line high in the frame since the sky did not have much to offer the shot besides a risk of overexposure.

The rows of hay bales were composed in a way to lead the eye diagonally (and dynamically) through the frame instead of straight into it.

The early morning sunlight was cast through a thin blanket of low clouds, reducing the amount of contrast between complete black shadow and white snow.

CHOOSING THE RIGHT MEMORY CARD

FIGURE 2.1
Make sure you select an SD card that has enough capacity and speed to handle your photography needs.

Memory cards are the digital film that stores every shot you take until you move them to a computer. The cards come in all shapes and sizes, and they are critical for capturing all of your photos. It is important not to skimp when it comes to selecting your memory cards. The NEX-6 uses Secure Digital (SD) memory cards (**Figure 2.1**).

If you have been using a point-and-shoot camera, you may already own an SD media card. Which brand of card you use is completely up to you, but here is some advice about choosing your memory card:

- Size matters, at least in memory cards. At 16 megapixels, the NEX-6 will require a lot of storage space, especially if you shoot in the RAW or RAW+JPEG mode (more on this later in the chapter) or shoot HD video. You should definitely consider using a card with a storage capacity of at least 4 GB.

- Consider buying High Capacity (SDHC) cards. These cards are generally much faster, both when writing images to the card and when transferring them to your computer. If you are planning on using the Continuous shooting mode (see Chapter 5) for capturing fast action, you can gain a boost in performance just by using an SDHC card with a Class rating of at least 6. The higher the Class rating, the faster the write speed. Having a fast card will also benefit your video capture by keeping the flow of video frames moving quickly to your card.

- Buy more than one card. If you have already purchased a memory card, consider getting another. It's a bad day when your card is almost full and you have to either erase shots or choose a lower-quality image format so you can keep on shooting. With the cost of memory cards what it is, keeping a spare just makes good sense.

- To get the fastest memory possible, you could consider purchasing an SDXC memory card. Although they appear to be the same as SD and SDHC cards, they are made to new specifications that allow memory capacities above 32 GB. Your camera is SDXC compliant, but if you plan to share SDXC cards between devices such as your NEX-6 and a video camera, make sure the other device is SDXC compatible too. SDXC cards will work only in SDXC devices. Also, you should format your SDXC card only in your camera.

Sony recommends a speed rating of at least Class 4 for shooting video. What you need to know is that all cards are not created equal. In the past, I have had issues with Class 4 cards that could not keep up with the demands of video recording and caused the camera to stop in the middle of a recording session. My recommendation is that, if you know you are going to be shooting video with your camera, you should use a Class 6 or 10 card to keep the pixels flowing.

FORMATTING YOUR MEMORY CARD

Now that you have your card, let's talk about formatting for a minute. When you purchase any new SD card, you can pop it into your camera and start shooting right away—and everything will probably work as it should. However, what you *should* do first is format the card in the camera. This process allows the camera to set up the card to record images from your camera. Just as a computer hard drive must be formatted, formatting your card ensures that it is properly initialized. The card may work in the camera without first being formatted, but chances of failure down the road are much higher.

As a general practice, I always format new cards or cards that have been used in different cameras. I also reformat cards after I have downloaded my images and want to start a new shooting session. Note that you should always format your card in the camera, not in your computer. Using the computer could render the card useless in your camera. You should also pay attention to the manufacturer's recommendations with respect to moisture, humidity, and proper handling procedures. It sounds a little cliché, but when it comes to protecting your images, every little bit helps.

Most people are under the impression that formatting the memory card is equivalent to erasing it. Not so. The truth is that when you format the card, all you are doing is changing the file management information on the card. Think of it as removing the table of contents from a book and replacing it with a blank page. All of the contents are still there, but you wouldn't know it by looking at the empty table of contents. The camera will see the card as completely empty, so you won't be losing any space, even if you have previously filled the card with images. Your camera will simply write the new image data over the previous data.

FORMATTING YOUR MEMORY CARD

1. Press the Menu button, and rotate the Control wheel to highlight and select the Setup submenu.

2. Using the Control wheel, navigate to Format under the Memory Card Tool section (**A**). Select it by pressing the middle of the Control wheel (soft key C).

3. You'll be prompted by another screen, letting you know that all of the data on your card will be deleted. This screen is a safety feature, ensuring that you want to format the card. Press soft key B to complete the formatting process (**B**). If you choose not to format, press soft key A.

4. Once the formatting is complete, you'll be directed back to the Setup submenu. Depress the shutter button halfway to begin shooting.

UPDATING THE NEX-6'S FIRMWARE

I know that you want to get shooting, but having the proper firmware can affect the way the camera operates. It can fix problems as well as improve operation, so you should probably take care of it sooner rather than later. Updating your camera's firmware is something that the manual completely omits, yet it can change the entire behavior of your camera's operating system and functions. The firmware of your camera is the set of computer operating instructions that controls how your camera functions. Updating this firmware is a great way to not only fix little bugs but also gain access to new functionality. You will need to check out the information at Sony Support (www.esupport.sony.com) to review how a firmware update will affect your camera, but it is always a good idea to be working with the most up-to-date firmware version available. Like most things Sony, the website is a bit menu heavy, but once you are on the home page, click the Drivers & Software button and follow the instructions to get to your camera model.

CHECKING THE CAMERA'S CURRENT FIRMWARE VERSION

1. Press Menu and navigate to the Setup submenu.

2. Rotate the Control wheel until you highlight Version under the Main Settings section.

3. Press soft key C to select Version. You will see the current version numbers for the camera and lens (**A**). If these versions are not the latest ones listed on the Sony Support website, follow the steps in the next section to load the latest version.

At the time of this writing, the current version of the firmware for the NEX-6 is 1.00 for the camera and 01 for the lens/mount adapter. Make sure you check the Sony Support webpage often for any updates, and then follow the directions below for updating your camera.

UPDATING THE FIRMWARE

1. Access the Sony Support website (www.esupport.sony.com), click Drivers & Software, and enter your camera model.

2. Once you are on your model's page, click the Drivers & Software tab. Choose your computer's operating system from the pull-down menu, and select Firmware from the resulting list (keep in mind that if there is no firmware update available for your camera, the Firmware item will not appear in the list).

3. After you click Firmware, a summary of the update will appear, as well as a button to download it. Don't go directly to the download. Instead, click the update itself.

4. In the next screen, you will be provided very detailed instructions on how to prepare your camera for the update and how to download and install it. The update that you download will contain the installation software as well, so it is important that you follow these instructions carefully.

CLEANING THE SENSOR

Cleaning camera sensors used to be a nerve-racking process that required leaving the sensor exposed to scratching and even more dust. Now cleaning the sensor is pretty much an automatic function. Every time you turn the camera off, the SteadyShot technology vibrates the sensor to remove any dust particles that might have landed on it.

Every now and then, though, there will just be a dust spot that is impervious to the anti-dust vibration technology. If this happens, you have two more options to clean the sensor. First, you can dig into the camera's menus and activate the Cleaning Mode function. Doing so essentially does what the automatic anti-dust vibration technology does when you turn the camera off.

USING THE CLEANING MODE FEATURE

1. Press the Menu button, navigate to the Setup submenu, and select it by pressing soft key C.

2. Highlight Cleaning Mode under the Main Settings section. Select it (**A**).

3. You will be instructed to turn the camera off after the cleaning (**B**). Press soft key C to start the cleaning process. That's it. After the vibration technology does its thing, turn the camera off.

4. Turn the camera on and continue shooting.

After you perform a cleaning, however, pesky pieces of dust might still persist. This will require manual cleaning of the sensor. If you choose to manually clean your sensor, please use a device that has been made to clean sensors (not a cotton swab from your medicine cabinet). There are dozens of commercially available devices—such as brushes, swabs, and blowers—that will clean the sensor without damaging it. To keep the sensor clean, always store the camera with a body cap or a lens attached.

The camera sensor is an electrically charged device. This means that when the camera is turned on, there is a current running through the sensor. This electric current can create static electricity, which will attract small dust particles to the sensor area. Even though the NEX-6's sensor includes a static-free coating, it is always a good idea to turn off the camera prior to removing a lens. Cleaning the sensor yourself requires that you repeat the steps for activating the Cleaning Mode function. You can then use a blower, brush, or swab that is dedicated to cleaning sensors to remove any dust before shutting the camera off.

You should also consider having the lens mount facing down during lens removal so there is less opportunity for dust to fall into the inner workings of the camera. Since the NEX-6 is a mirrorless camera, the sensor is immediately exposed upon removing a dust cap or lens. Keep this in mind when you are changing lenses the next time. But keeping your camera's sensor clean is part of owning and using the camera, so don't let the idea of a little dust keep you from shooting.

USING THE RIGHT FORMAT: RAW VS. JPEG

When shooting with your NEX-6, you have a choice of image formats that your camera will use to store the pictures on the memory card. JPEG is probably the most familiar format to anyone who has been using a digital camera. I touched on this topic briefly in Chapter 1, so you already have a little background on what JPEG and RAW files are.

There is nothing wrong with JPEG if you are taking casual shots. JPEG files are ready to use, right out of the camera. Why go through the process of adjusting RAW images of the kids opening presents when you are just going to email them to Grandma? Also, for journalists and sports photographers who are shooting ten frames per second and need to transmit their images across the wire—again, JPEG is just fine. So what is wrong with JPEG? Absolutely nothing—unless you care about having complete creative control over all of your image data (as opposed to what a compression algorithm thinks is important).

As I mentioned in Chapter 1, JPEG is not actually an image format. It is a compression standard, and compression is where things can go bad. When you have your camera set to JPEG—whether it is set to Fine or Standard compression—you are telling the camera to process the image however it sees fit and then throw away enough image data to make it shrink into a smaller space. In doing so, you give up subtle image details that you will never get back in post-processing. That is an awfully simplified statement, but it's still fairly accurate.

SO WHAT DOES RAW HAVE TO OFFER?

First and foremost, RAW images are not compressed. (Some cameras offer a compressed RAW format, but it is lossless compression, which means there is no loss of actual image data.) Note that RAW image files will require you to perform post-processing on your photographs. This is not only necessary—it is the reason that most photographers use it.

RAW images have a greater dynamic range than JPEG-processed images. This means that you can recover image detail in the highlights and shadows that just isn't available in JPEG-processed images.

There is more color information in a RAW image because it is a 14-bit image, which means it contains more color information than a JPEG, which is almost always an 8-bit image. More color information means more to work with and smoother changes between tones—kind of like the difference between performing surgery with a scalpel as opposed to a butcher's knife. They'll both get the job done, but one will do less damage.

Regarding sharpening, a RAW image offers more control because you are the one who is applying the sharpening according to the effect you want to achieve. Once again, JPEG processing applies a standard amount of sharpening that you cannot change after the fact. Once it is done, it's done.

Finally, and most importantly, a RAW file is your negative. No matter what you do to it, you won't change it unless you save your file in a different format. This means that you can come back to that RAW file later and try different processing settings to achieve differing results and never harm the original image. By comparison, if you make a change to your JPEG and accidentally save the file, guess what? You have a new original file, and you will never get back to that first image. That alone should make you sit up and take notice.

ADVICE FOR NEW RAW SHOOTERS

Don't give up on shooting RAW just because it means more work. Hey, if it takes up more space on your card, buy bigger cards or more smaller ones. Will it take more time to download your images? Yes, but good things come to those who wait. Don't worry about needing to purchase expensive software to work with your RAW files; you already own a program that will allow you to work with your RAW files. Sony's Image Data Converter software comes bundled in the box with your camera and gives you the ability to work directly on the RAW files and then output the enhanced results.

My recommendation is that you shoot in JPEG mode while you are using this book. This will allow you to quickly review your images and study the effects of future lessons. Once you have become comfortable with all of the camera features, you should switch to shooting in RAW mode so that you can start gaining more creative control over your image processing. After all, you took the photograph—shouldn't you be the one to decide how it looks in the end?

IMAGE RESOLUTION

When discussing digital cameras, image resolution is often used to describe pixel resolution, or the number of pixels used to make an image. This can be displayed as a dimension, such as 4912 x 3264. This is the physical number of pixels in width and height of the image sensor. Resolution can also be referred to in megapixels (MP), such as 16 MP. This number represents the number of total pixels on the sensor and is commonly used to describe the amount of image data that a digital camera can capture.

SELECTING RAW + JPEG

Your camera has the added benefit of being able to write two files for each picture you take: one in RAW and one in JPEG. This can be useful if you need a quick version to email but want a higher-quality version for more advanced processing.

It should be noted that using both formats requires more space on the memory card. I recommend that you use only one format or the other unless you have a specific need to shoot both.

SELECTING YOUR IMAGE QUALITY SETTING

1. Press the Menu button, and select the Image Size submenu.
2. Rotate the Control wheel to select Quality under the Still section (**A**).
3. Use the Control wheel to change the quality setting (**B**). Keep in mind that Fine and Standard are two JPEG compression formats—Fine is higher quality than Standard.
4. Press soft key C to lock in your changes.

LENSES AND FOCAL LENGTHS

If you ask most photographers what they believe to be their most critical piece of photographic equipment, they would undoubtedly tell you that it is their lens. The technology and engineering that goes into your camera is a marvel, but it isn't worth a darn if it can't get the light from the outside world onto the sensor. The NEX-6, as a mirrorless camera that depends upon an interchangeable lens system, uses the lens for a multitude of tasks, from focusing on a subject to metering a scene to delivering and focusing the light onto the camera sensor. The lens is also responsible for the amount of the scene that will be captured (the frame). With all of this riding on the lens, let's take a more in-depth look at the camera's eye on the world.

Lenses are composed of optical glass that is both concave and convex in shape. The alignment of the glass elements is designed to focus the light coming in from the front of the lens onto the camera sensor. The amount of light that enters the camera is also controlled by the lens, the size of the glass elements, and the aperture mechanism within the lens housing. The quality of the glass used in the lens will also have a direct effect on how well the lens can resolve details and the contrast of the scene (the ability to deliver great highlights and shadows). Most lenses now routinely include things like the autofocus motor and, in some cases, an image-stabilization mechanism.

There is one other aspect of the camera lens that is often the first consideration of the photographer: lens focal length, which determines the angle of view delivered through the lens. Lenses are typically divided into three or four groups, depending on the field of view they cover.

Wide-angle lenses cover a field of view from around 110 degrees to about 60 degrees (**Figure 2.2**). There is also a tendency to get some distortion in your image when using extremely wide-angle lenses. This will be apparent toward the outer edges of the frame. As for which lenses would be considered wide angle, anything 30mm or smaller could be considered wide.

FIGURE 2.2
The 16mm lens set-ting provides a wide view of the scene but little detail of distant objects.

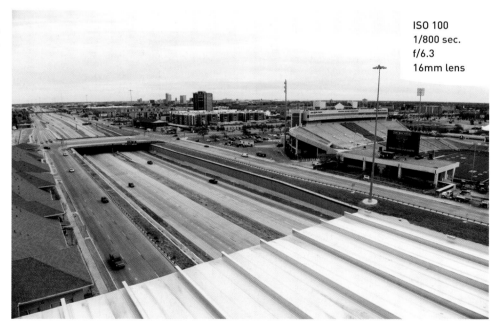

ISO 100
1/800 sec.
f/6.3
16mm lens

Wide-angle lenses can display a large depth of field, which allows you to keep the foreground and background in sharp focus. This makes them very useful for landscape photography. They also work well in tight spaces, such as indoors, where there isn't much elbow room available (**Figure 2.3**). They can also be handy for large group shots but, due to the amount of distortion, not so great for close-up portrait work.

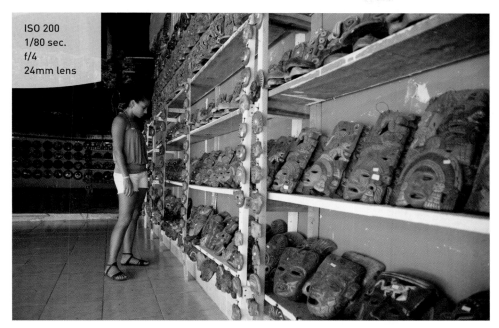

ISO 200
1/80 sec.
f/4
24mm lens

FIGURE 2.3
When you are shooting in tight spaces or want to exaggerate attractive lines, a wide-angle lens helps capture more of the scene.

A *normal* lens has a field of view that is about 45 degrees and delivers approximately the same view as the human eye (not in angle of view but in size and perspective of subjects). The perspective is very natural, and there is little distortion in objects. The normal lens for full-frame and 35mm cameras is the 50mm lens, but for the NEX-6 and its cropped sensor, it is more in the neighborhood of a 35mm lens (**Figure 2.4**).

Normal focal length lenses are useful for photographing people, architecture, and most other general photographic subjects. They have very little distortion and offer a moderate range of depth of field (**Figure 2.5**).

FIGURE 2.4
Long considered the "normal" lens for 35mm photography, the 50mm focal length can be considered somewhat of a telephoto lens on the NEX-6 because it has the same angle of view and magnification as a 75mm lens on a 35mm camera body.

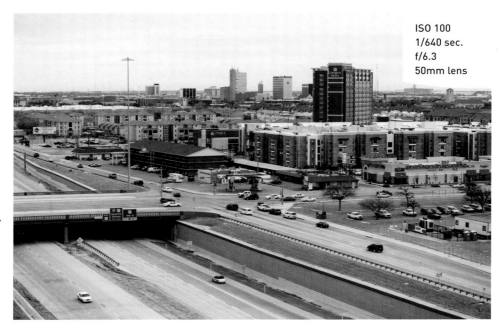

ISO 100
1/640 sec.
f/6.3
50mm lens

FIGURE 2.5
Normal lenses are handy when photographing in the city, offering you the ability to quickly move from street photography to architectural photography.

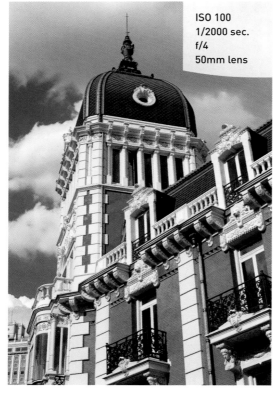

ISO 100
1/2000 sec.
f/4
50mm lens

Most longer focal length lenses are referred to as *telephoto* lenses. They can range in length from 100mm up to 800mm or longer and have a field of view that is about 35 degrees or smaller. These lenses have the ability to greatly magnify the scene, allowing you to capture details of distant objects, but the angle of view is greatly reduced (**Figure 2.6**). You will also find that you can achieve a much narrower depth of field. They also demonstrate something called distance compression, which means they make objects at different distances appear to be much closer together than they really are.

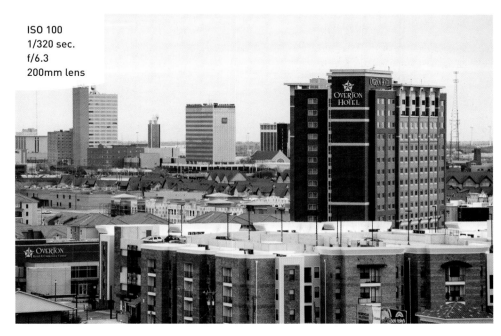

ISO 100
1/320 sec.
f/6.3
200mm lens

FIGURE 2.6
The telephoto lens helped me get a tighter crop on West Texas's downtown.

Telephoto lenses are most useful for sports photography or any application where you just need to get closer to your subject. They can have a compressing effect—making objects look closer together than they actually are (**Figure 2.7**)—and a very narrow depth of field when shot at their widest apertures.

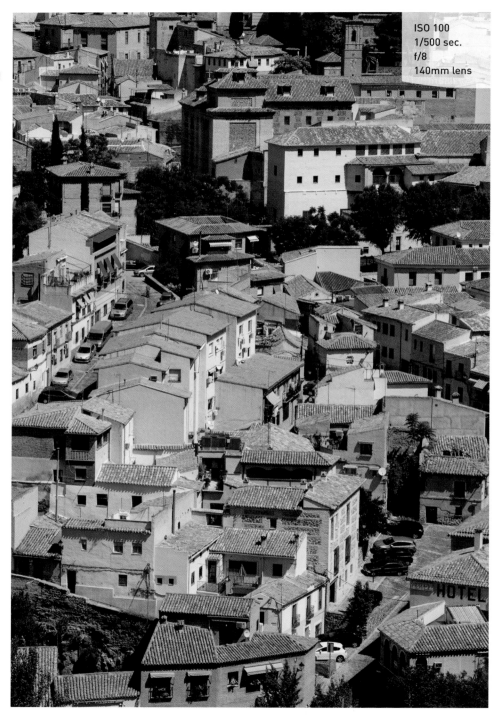

FIGURE 2.7
The longer focal length compresses the distance between foreground and background objects.

ISO 100
1/500 sec.
f/8
140mm lens

A *zoom* lens is a great compromise to carrying a bunch of single focal-length lenses (also referred to as "prime" lenses). They can cover a wide range of focal lengths because of the configuration of their optics. However, because it takes more optical elements to capture a scene at different focal lengths, the light must pass through more glass on its way to the image sensor. The more glass, the lower the quality of the image sharpness. The other sacrifice that is made is in aperture. Zoom lenses typically have smaller maximum apertures than prime lenses, which means they cannot achieve a narrow depth of field or work in lower light levels without the assistance of image stabilization, a tripod, or higher ISO settings. (We'll discuss all this in more detail in later chapters.)

The NEX-6 can be purchased as a body only, but many folks will purchase it with a kit lens, the E-Mount 16–50mm f/3.5–5.6. Another great lens option for the NEX-6 is the E-Mount 18–200mm f/3.5–6.3 lens. Although pricier than the 16–50mm, the 18–200mm is a great all-around lens that provides a range of focal lengths, from the very wide to the medium telephoto. Combine that with great Optical SteadyShot image stabilization technology and you have what I like to call the perfect vacation lens. Unfortunately, it is not available as a kit lens at the moment, but you should definitely consider it if you are thinking of adding a new lens to your camera bag.

A-MOUNT LENS COMPATIBILITY

The Sony NEX line of cameras uses a proprietary lens mount known as the E-Mount. Sony and a number of third-party lens manufacturers make several lenses for this type of mount. Sony also produces a number of lenses for its A-Mount, the mount it includes on its digital SLR camera line. Several of these lenses offer features—such as larger apertures on zooms and heavier construction—that are not found in the E-Mount line. Fortunately, Sony makes it possible to use these lenses via the A-Mount Lens to NEX Camera Mount Adapter (the LA-EA2). It's not a cheap addition to the camera bag, but if you ever find the need to put on one of the "bigger" lenses, this is the surest way to get there. That being said, the E-Mount lens lineup is impressive, and if it's faster apertures you're after, there are several E-Mount lenses that will offer it to you.

WHAT IS EXPOSURE?

In order for you to get the most out of this book, I need to briefly discuss the principles of exposure. Without this basic knowledge, it will be difficult for you to move forward in improving your photography. For our purposes, I will just cover some of the basics of exposure. This will give you the essential tools to make educated decisions in determining how best to photograph a subject.

So what is exposure? It is the process whereby the light reflecting off a subject reflects through an opening in the camera lens for a defined period of time onto the camera sensor. The combination of the lens opening, shutter speed, and sensor sensitivity is used to achieve a proper exposure value (EV) for the scene. The EV is the sum of these components necessary to properly expose a scene. The relationship between these factors is sometimes referred to as the "exposure triangle."

At each point of the triangle lies one of the factors of exposure:

- **ISO:** Determines the sensitivity of the camera sensor. ISO stands for the International Organization for Standardization, but the acronym is used as a term to describe the sensitivity of the camera sensor to light. The higher the sensitivity, the less light is required for a good exposure. These values are a carryover from the days of traditional color and black and white films.

- **Aperture:** Also referred to as f-stop, this determines how much light passes through the lens at once.

- **Shutter Speed:** Controls the length of time that light is allowed to hit the sensor.

So here's how it works. The camera sensor has a level of sensitivity that is determined by the ISO setting. To get a proper exposure—not too much, not too little—the lens needs to adjust the aperture diaphragm (the size of the lens opening) to control the volume of light entering the camera. Then, in the case of a mirrorless camera like the NEX-6, the sensor is activated for a relatively short period of time to allow the light to record on it before the shutter covers it and ends the exposure.

ISO numbers for the NEX-6 start at 100 and then double in sensitivity as you double the number. So 200 is twice as sensitive as 100. If you select your ISO manually, you are able to select in full-stop increments (ISO 100, 200, 400, and so on up to ISO 25600). If you place the camera in Auto ISO, it will determine the proper ISO from 100 to 3200 in 1/3-stop increments. There are also a wide variety of shutter speeds that you can use to achieve a proper exposure. The speeds on the NEX-6 range from as long as 30 seconds to as short as 1/4000 of a second. Typically, you will be working with a shutter speed range from around 1/30 of a second to about 1/2000, but these

numbers will change depending on your circumstances and the effect that you are trying to achieve. The lens apertures will vary slightly depending on which lens you are using. This is because different lenses have different maximum apertures. The typical apertures that are at your disposal are f/4, f/5.6, f/8, f/11, f/16, and f/22.

When it comes to exposure, a change to any one of these factors can require changing one or more of the other two. This is referred to as a reciprocal change. If you let more light in the lens by choosing a larger aperture opening, you will need to shorten the amount of time the shutter is open. If the shutter is allowed to stay open for a longer period of time, the aperture needs to be smaller to restrict the amount of light coming in.

HOW IS EXPOSURE CALCULATED?

We now know about the exposure triangle—ISO, shutter speed, and aperture—so it's time to put all three together to see how they relate to one another and how you can change them as needed.

STOP

You will hear the term *stop* thrown around all the time in photography. It relates back to the f-stop, which is a term used to describe the aperture of your lens. When you need to give some additional exposure, you might say that you are going to "add a stop." This doesn't just equate to the aperture; it could also be used to describe the shutter speed or even the ISO. So when your image is too light or dark or you have too much movement in your subject, you will probably be changing things by a "stop" or two.

When you point your camera at a scene, the light reflecting off your subject enters the lens and is allowed to pass through to the sensor for a period of time dictated by the shutter speed. The amount and duration of the light needed for a proper exposure depends on how much light is being reflected and how sensitive the sensor is. To figure this out, your camera utilizes a built-in light meter that looks through the lens and measures the amount of light. That level is then calculated against the sensitivity of the ISO setting, and an exposure value is rendered. Here is the tricky part: There is more than one way to achieve a perfect exposure, because the f-stop and shutter speed can be combined in different ways to allow the same amount of exposure. See, I told you it was tricky.

Here is a list of reciprocal settings, known as exposure equivalencies, that would all produce the same exposure result. Let's use the "sunny 16" rule, which states that, when using f/16 on a sunny day, you can use a shutter speed that is roughly equal to the ISO setting to achieve a proper exposure. For simplification purposes, we will use an ISO of 100.

RECIPROCAL EXPOSURES: ISO 100

F-STOP	2.8	4	5.6	8	11	16	22
SHUTTER SPEED	1/4000	1/2000	1/1000	1/500	1/250	1/125	1/60

If you were to use any one of these combinations, they would each have the same result in terms of the exposure (i.e., how much light hits the camera's sensor). Also take note that every time we cut the f-stop in half, we reciprocated by doubling our shutter speed. For those of you wondering why f/8 is half of f/5.6, it's because those numbers are actually fractions based on the opening of the lens in relation to its focal length. This means that a lot of math goes into figuring out just what the total area of a lens opening is, so you just have to take it on faith that f/8 is half of f/5.6 but twice as much as f/11. A good way to remember which opening is larger is to think of your camera lens as a pipe that controls the flow of water. If you have a pipe that is 1/2" in diameter (f/2) and one that is 1/8" (f/8), which would allow more water to flow through? It would be the 1/2" pipe. The same idea works here with the camera f-stops; f/2 is a larger opening than f/4 or f/8 or f/16.

Now that we know this, we can start using this information to make intelligent choices in terms of shutter speed and f-stop. Let's bring the third element into this by changing our ISO by one stop, from 100 to 200.

RECIPROCAL EXPOSURES: ISO 200

F-STOP	2.8	4.0	5.6	8	11	16	22
SHUTTER SPEED	—	1/4000	1/2000	1/1000	1/500	1/250	1/125

Notice that, since we doubled the sensitivity of the sensor, we now require half as much exposure as before. We have also reduced our maximum aperture from f/2.8 to f/4 because the camera can't use a shutter speed that is faster than 1/4000 of a second.

So why not just use the exposure setting of f/16 at 1/250 of a second? Why bother with all of these reciprocal values when this one setting will give us a properly exposed image? The answer is that the f-stop and shutter speed also control two other important aspects of our image: motion and depth of field.

MOTION AND DEPTH OF FIELD

There are distinct characteristics that are related to changes in aperture and shutter speed. Shutter speed controls the length of time the light has to strike the sensor; consequently, it also controls the blurriness (or lack of blurriness) of the image. The less time light has to hit the sensor, the less time your subjects have to move around and become blurry. This can let you do things like freezing the motion of a fast-moving subject (**Figure 2.8**) or intentionally blurring subjects to give the feel of energy and motion (**Figure 2.9**).

ISO 200
1/2000 sec.
f/5.6
24mm lens

FIGURE 2.8
A fast shutter speed was used to freeze the action of the mountain biker coming into camp for respite from the desert sun.

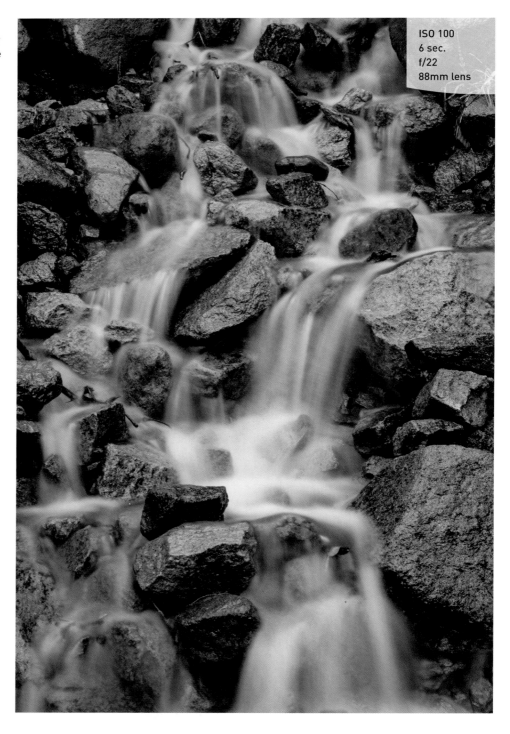

FIGURE 2.9
The slower shutter speed captured the flow of water over the rocks.

ISO 100
6 sec.
f/22
88mm lens

The aperture controls the amount of light that comes through the lens, but it also determines what areas of the image will be in focus. This is referred to as depth of field, and it is an extremely valuable creative tool. The smaller the opening (the larger the number, such as f/22), the greater the sharpness of objects from near to far (**Figure 2.10**).

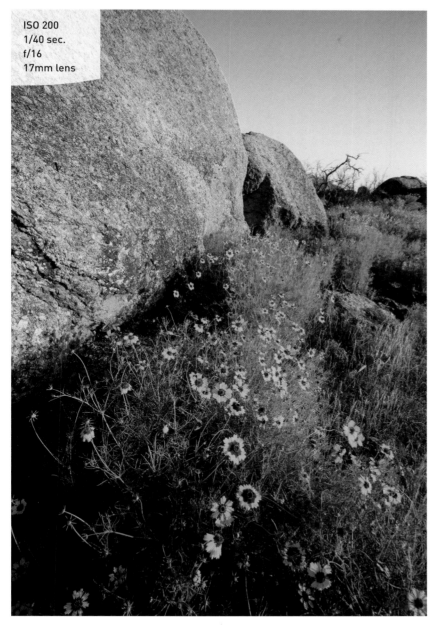

ISO 200
1/40 sec.
f/16
17mm lens

FIGURE 2.10
By using a small aperture, the area of sharp focus extends from a point that is near the camera all the way out to distant objects. In this instance, I wanted the flowers in the foreground as well as the boulders in the background to be in focus.

A large opening (or small number, like f/2.8) means more blurring of objects that are not at the same distance from the camera as the subject you are focusing on (**Figure 2.11**).

As we further explore the features of the camera, we will learn not only how to utilize the elements of exposure to capture properly exposed photographs, but also how we can make adjustments to emphasize our subject. It is the manipulation of these elements—motion and focus—that will take your images to the next level.

FIGURE 2.11
By using a very large aperture, I was able to isolate the abandoned motorcycle from the busy background.

ISO 100
1/2500 sec.
f/2
50mm lens

Chapter 2 Assignments

Formatting your card

Even if you have already begun using your camera, make sure you are familiar with formatting the SD card. If you haven't done so already, follow the directions given earlier in the chapter and format as described (make sure you save any images that you may have already taken). Then perform the Format function every time you have downloaded or saved your images or use a new card.

Checking your firmware version

Using the most up-to-date version of the camera firmware will ensure that your camera is functioning properly. Use the menu to find your current firmware version, and then update as necessary using the steps listed in this chapter.

Cleaning your sensor

Make sure you are familiar with the Cleaning Mode function so you can use it every time you change a lens.

Exploring your image formats

I want you to become familiar with all of the camera features before using the RAW format, but take a little time to explore the Quality and Image Size menus so you can see what options are available to you.

Exploring your lens

If you are using a zoom lens, spend a little time shooting with all of the different focal lengths, from the widest to the longest. See just how much of an angle you can cover with your widest lens setting. How much magnification will you be able to get from the telephoto setting? Try shooting the same subject with a variety of focal lengths to note the differences in how the subject looks, and also the relationship between the subject and the other elements in the photo.

Share your results with the book's Flickr group!

Join the group here: flickr.com/groups/sonynex6_fromsnapshotstogreatshots

3

ISO 2500
1/80 sec.
f/5.6
50mm lens

The Auto Modes

GET SHOOTING WITH THE AUTOMATIC CAMERA MODES

The Sony NEX-6 is an amazing camera that has some incredible features. In fact, with all of the technology built into it, it can be pretty intimidating for the person new to photography. Its features allow it to operate just like a DSLR camera but without the size and, of course, the mirror. Fortunately, Sony has made it a little easier for you to get great-looking photographs without having to do a lot of thinking. Enter the automatic modes. The icon-labeled automatic camera modes on the Mode dial are set up to use specific features of the camera for various shooting situations. Let's take a look at the different modes and how and when to use them.

The statue was placed off center, with the distant tree and the city lights leading the viewer's eye into the scene.

The underlighting on the statue adds a certain ghost-like aesthetic to the shot.

ISO 800
1/50 sec.
f/1.8
50mm lens

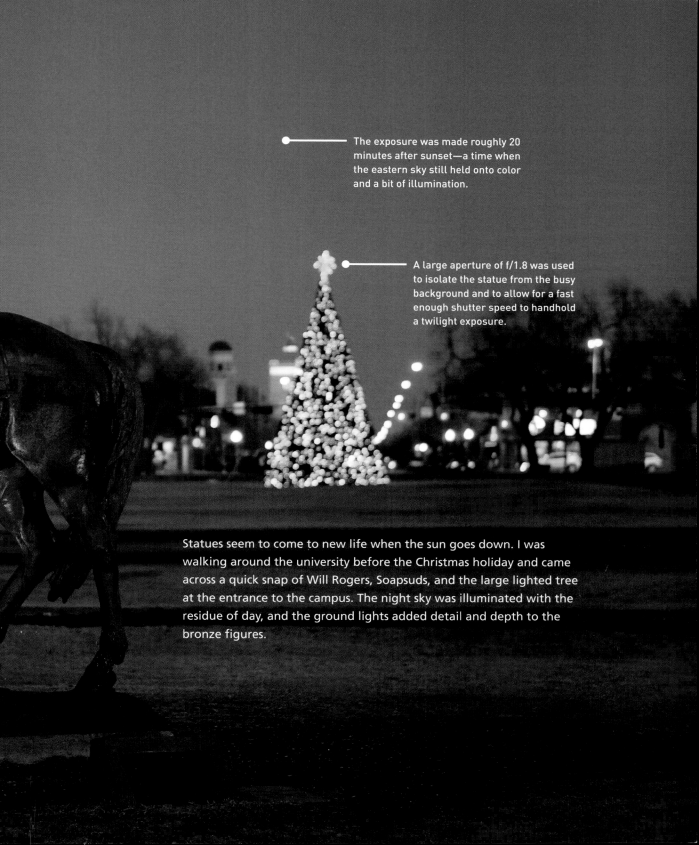

The exposure was made roughly 20 minutes after sunset—a time when the eastern sky still held onto color and a bit of illumination.

A large aperture of f/1.8 was used to isolate the statue from the busy background and to allow for a fast enough shutter speed to handhold a twilight exposure.

Statues seem to come to new life when the sun goes down. I was walking around the university before the Christmas holiday and came across a quick snap of Will Rogers, Soapsuds, and the large lighted tree at the entrance to the campus. The night sky was illuminated with the residue of day, and the ground lights added detail and depth to the bronze figures.

INTELLIGENT AUTO MODE

 Intelligent Auto mode is all about thought-free photography. There is little to nothing for you to do in this mode except point and shoot. It even determines what type of scene you're pointing the camera at, from a macro setting to portraiture. Your biggest concern when using Intelligent Auto mode is focusing. The camera will utilize the automatic focusing modes to achieve the best possible focus for your picture. Naturally, the camera is going to assume that the object that is closest to the camera is the one that you want in sharpest focus. Simply press the shutter button down halfway while looking through the viewfinder, and you should see one or several focus points light up over the subject. Of course, putting your subject in the middle of the picture is not always the best way to compose your shot. So wait for the chirp to confirm that the focus has been set, and then, while still holding down the button, recompose your shot. Now just press down the shutter button the rest of the way to take the photo. It's just that easy (**Figures 3.1** and **3.2**).

FIGURE 3.1
Intelligent Auto mode

FIGURE 3.2
Intelligent Auto mode is great when you just want to snap some shots without thinking too much, like when I was walking around this colorful resort in Mexico.

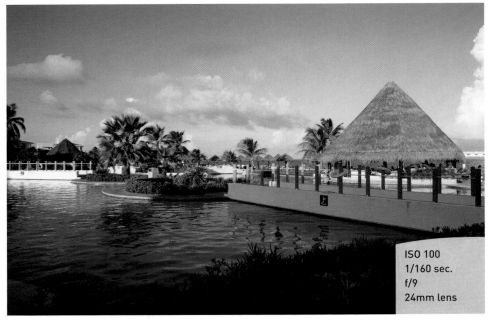

ISO 100
1/160 sec.
f/9
24mm lens

The camera will take care of all your exposure decisions, including ISO. You do have two options while using this mode: the built-in flash and the self-timer. Above the LCD display, there is a button that that has a lightning bolt icon on it—press it to enable the built-in flash. To set the camera to self-timer mode, simply press the left side of the Control wheel and rotate it until you select the Self-Timer drive mode. You'll notice that when you highlight this function, an Option button appears on the bottom right of the display. Select this to choose between a 2-second and 10-second self-timer.

SUPERIOR AUTO MODE

 If Intelligent Auto does most of the work for you, Superior Auto does just a little more. Like Intelligent Auto, this mode detects the type of scene you are shooting and determines all exposure settings. Superior Auto takes this hands-free notion one step further in that it will create a high dynamic range (HDR) image of a troublesome exposure and then select the best image for you.

FLASH DURING AUTO MODES

The built-in flash on your NEX-6 does not pop up automatically when you're using Intelligent Auto or Superior Auto mode. If you feel that your primary subject needs more light (especially if you are photographing people), press the flash pop-up button on the back of the camera (the button has a lightning bolt on it). Once the flash is up, the mode will do the rest for you. It's not until you switch into P, S, A, or M mode that you have to exert a bit of control over the flash. The use of the built-in flash and flash compensation are covered in Chapter 8.

USING PHOTO CREATIVITY WITH INTELLIGENT AUTO AND SUPERIOR AUTO

An additional feature that Intelligent Auto and Superior Auto have in common is your ability to affect the way an image is created based on certain aesthetic options you have within finger's reach. In either mode, the Photo Creativity function can be accessed by pressing the bottom of the Control wheel (**Figure 3.3**) and manipulating one or all of the five effects provided: Background Defocus, Brightness, Color, Vividness, and Picture Effect.

FIGURE 3.3
The Photo Creativity function

BACKGROUND DEFOCUS

This setting forces the camera to use either a larger or smaller aperture setting to change the depth of field in your image: The smaller the aperture (which means a larger number, such as f/16 or f/22), the greater the sharpness in your background. To change this setting, highlight the Background Defocus icon (the leftmost of the Photo Creativity effects) and rotate the Control wheel accordingly (**Figure 3.4**). Each step will change the exposure by about 1/3 of a stop.

BRIGHTNESS

The Brightness effect adjusts just that: brightness. In truth, this effect adjusts the aperture and ISO of the exposure formula to either under- or overexpose the scene to your liking. This is exposure compensation without you actually having to look at any numbers or figure out exposure equivalencies in your head. You manipulate this effect by rotating the Control wheel (**Figure 3.5**). However, you can always revert it back to its Auto default by pressing soft key B.

FIGURE 3.4
Background Defocus

FIGURE 3.5
Brightness

COLOR

The Color effect simply augments the color temperature of the image, allowing you to make the scene warmer or cooler. Adjust this effect using the Control wheel (**Figure 3.6**), and there is a default Auto function to allow the camera control over this setting.

VIVIDNESS

Vividness adjusts the image's color saturation. From black and white tones to full-on technicolor, you can adjust the "mood" of the shot by simply rotating the Control wheel on this effect (**Figure 3.7**).

FIGURE 3.6
Color

FIGURE 3.7
Vividness

PICTURE EFFECT

If you are a fan of the filters on many popular smartphone photography apps, you might find the Picture Effect function in the NEX-6 appealing. Located on the far right of the Photo Creativity menu (**Figure 3.8**), this feature allows you to choose a predetermined "filter" for your image. These filters include Toy Camera, Pop Color, Color Posterization, Black and White Posterization, Retro Photo, Soft High Key, High Contrast Mono, and several partial color filters. Each has its own look and feel, and it's best to simply experiment with each of them in different environments to see if you find them appealing.

FIGURE 3.8
Picture Effect

SCENE SELECTION MODES

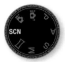 Let's face it: Intelligent Auto and Superior Auto are the lazy person's modes. But sometimes it's just nice to be lazy and click away without giving thought to anything but preserving a memory. There will be times, though, when you want to use your camera's advanced features, which are tailored to specific shooting environments. Turning the Mode dial to the SCN setting is the first step to reaching this level of control. From here, you can rotate the Control dial to select a dedicated automatic mode based on the type of photography you are setting out to do.

PORTRAIT MODE

One problem with Intelligent Auto mode is that it has little idea what type of subject you are photographing and, therefore, is applying the settings based on its "best guess" for each situation. Shooting portraits is a perfect example. When you are taking a photograph of someone, you typically want the emphasis of the picture to be on them, not necessarily on the stuff going on in the background.

This is what Portrait mode is for (**Figure 3.9**). When you set your camera to this mode, you are telling the camera to select a larger aperture so that the depth of field is much narrower and will give more blur to objects in the background. This blurry background places the attention on your subject (**Figure 3.10**). This mode is also optimized for skin tones and will be a little softer to improve the look of skin.

FIGURE 3.9
Portrait mode

USING THE BEST LENS FOR GREAT PORTRAITS

When using Portrait mode, it's usually best to use a lens that is 50mm or longer. The longer lens will give you a natural view of the subject, as well as aid in keeping the depth of field narrow.

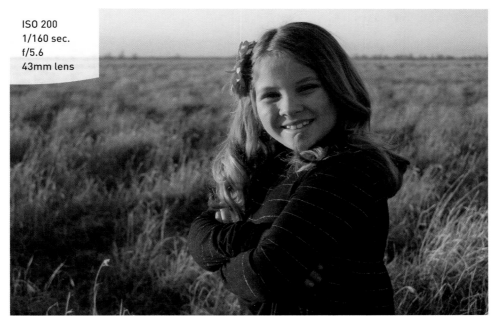

ISO 200
1/160 sec.
f/5.6
43mm lens

FIGURE 3.10
Portrait mode is a great choice for shots like this one, where the background is not significant enough to bring into focus but adds a certain abstract context to the shot.

LANDSCAPE MODE

As you might have guessed, Landscape mode has been optimized for shooting landscape images. Particular emphasis is placed on making colors more vivid and contrasty, particularly those that are common in landscape photography, such as greens and blues (**Figures 3.11** and **3.12**). This makes sense, since the typical landscape would be outdoors, where grass, trees, and skies should look more colorful. This mode also increases

FIGURE 3.11
Landscape mode

the sharpness of the entire image by stopping down the aperture in bright conditions. The camera also utilizes the lowest ISO settings possible in order to keep digital noise to a minimum. The downfall to this setting is that, once again, there is no control over any settings but the file type and the self-timer.

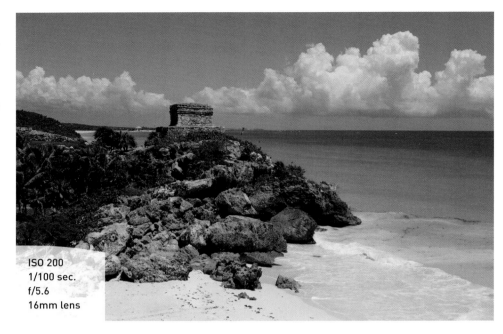

FIGURE 3.12
The edges, the blues and greens, and the Tulum sky scream out for Landscape mode. The small aperture helps achieve a greater depth of field.

ISO 200
1/100 sec.
f/5.6
16mm lens

MACRO MODE

Although most zoom lenses don't support true "macro" settings, that doesn't mean you can't shoot some great close-up photos. The key here is to use your camera-to-subject distance to fill the frame while still achieving sharp focus. This means moving yourself as close to your subject as you can while still being able to get a good sharp focus. Each lens model has a different minimum focusing distance. On the Sony 16–50mm kit zoom, it is .82 feet (you can find this information on page 96 of the owner's manual if you have the NEX-6 bundled with this particular lens). To help get the best focus in the picture, Macro mode will use the smallest aperture it can while keeping the shutter speed fast enough to get a sharp shot (**Figures 3.13** and **3.14**). It does this by simply raising the ISO. Unfortunately, there is no way to turn off this ISO adjustment, so it's possible you'll get more digital noise (from a high ISO) in your image.

FIGURE 3.13
Macro mode

ISO 800
1/30 sec.
f/1.8
24mm lens

FIGURE 3.14
Macro mode made for an interesting look at the symmetrical leaves of this small plant. The large aperture, combined with forgiving light, pulls the pattern of the greenery away from the background.

SPORTS ACTION MODE

Although this is called Sports Action mode, you can use it for any moving subject that you are photographing. The mode is built on the principles of sports photography: continuous shooting, large apertures, and fast shutter speeds (**Figures 3.15** and **3.16**).

To handle these requirements, the camera sets the drive mode to Continuous shooting, the aperture to a very large opening, and the ISO to Auto. Overall, these are sound settings that will capture most moving subjects well. We will take an in-depth look at all of these features, like Continuous drive mode, in Chapter 5.

FIGURE 3.15
Sports Action mode

FIGURE 3.16
With Sports Action mode, action-freezing shutter speeds and continuous focusing capture the moment.

ISO 200
1/800 sec.
f/5.6
50mm lens

You can, however, run the risk of too much digital noise in your picture if the camera decides that you need a very high ISO (such as 1600). Also, when using Sports Action mode, you will need to frame your subject in the middle of the viewfinder so that the autofocus, which is heavily geared toward the center of the frame in this mode, can find it efficiently. You won't hear the familiar chirp or see the focus points illuminate in this mode because, as long as you are holding down the shutter button halfway, the camera will continue to focus on the subject. The only problem with this is that you won't be able to recompose while shooting.

SUNSET MODE

Simply put, Sunset mode (**Figure 3.17**) emphasizes the colors in a vibrant sunset. Reds, the most dominant and advancing color in these types of skies, are given priority (**Figure 3.18**). Otherwise, the Sunset mode acts similarly to Landscape mode.

FIGURE 3.17
Sunset mode

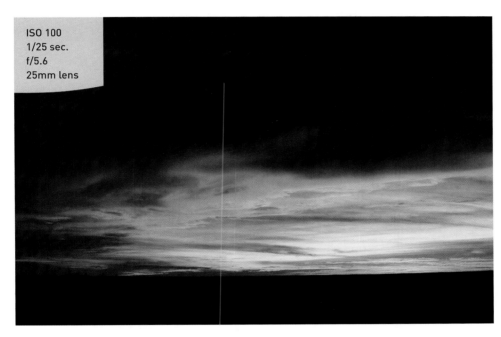

ISO 100
1/25 sec.
f/5.6
25mm lens

FIGURE 3.18
Sunsets where the reds are especially prominent are given even more visual drama in Sunset mode. The low ISO will also reduce the amount of noise acquired during exposure.

NIGHT PORTRAIT MODE

You're out on the town at night and you want to take a nice picture of someone, but you want to show some of the interesting scenery in the background as well. You could use Intelligent Auto mode with the flash activated. The problem is that, while it would give you a decent exposure for your subject, the background might end up being completely dark. The solution is to use Night Portrait mode (**Figure 3.19**). When you choose this mode, you are telling the camera that you want to use a slower-than-normal shutter speed so that the background is getting

FIGURE 3.19
Night Portrait mode

more time (and, thus, more light) to achieve a proper exposure. Pop the flash, and you are ready to shoot.

The maximum shutter speed for using flash in Night Portrait mode is 1/60 of a second. By limiting the shutter speed to 1/60, the camera allows more of the background to be exposed so that you get a much more balanced scene (**Figure 3.20**). This is also a great mode for taking portraits during sunset. Once again, the camera uses an automatic ISO setting, so you will want to keep an eye on it to make sure that the setting isn't so high that the noise levels ruin your photo. Also, since your shutter speed will be longer, it's a good idea to use a tripod or place your camera on a stable surface so the background elements don't end up looking shaky.

FIGURE 3.20
Night Portrait mode is especially useful for those portraits you want to make against a fading western sky at dusk.

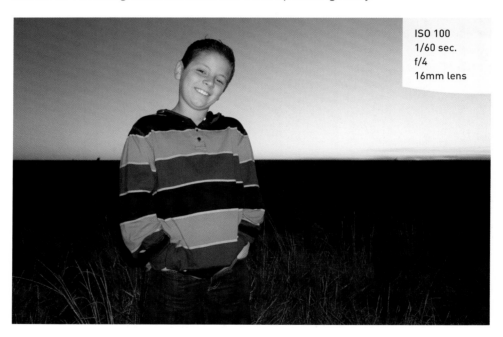

ISO 100
1/60 sec.
f/4
16mm lens

NIGHT SCENE MODE

Consider Night Scene mode (**Figure 3.21**) akin to Night Portrait mode but without the use of flash. Shutter speeds are still slow in order to expose for details, but fast enough to hand-hold the camera in many cases. One of the reasons you're still able to hand-hold the camera during exposure without incurring blur is that the camera will use higher ISOs (**Figure 3.22**). Remember that this will cause unwanted noise levels, so keep an eye on what ISO is chosen.

FIGURE 3.21
Night Scene mode

FIGURE 3.22
Shooting at night or in very dark conditions without a tripod is made possible by Night Scene mode, though the higher ISOs do introduce more noise.

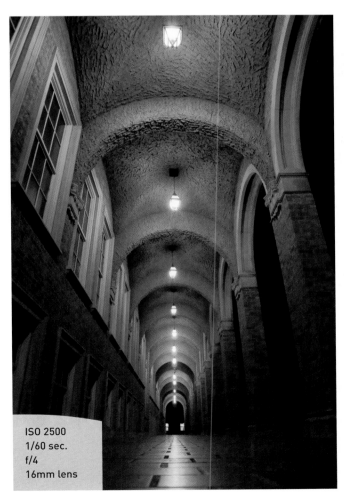

ISO 2500
1/60 sec.
f/4
16mm lens

HAND-HELD TWILIGHT MODE

This is an interesting mode. Hand-held Twilight (**Figure 3.23**) allows you to shoot in low-light conditions without a tripod, and it reduces the noise levels caused by high ISOs. How does it do this? When you press the shutter button, the camera shoots a quick burst of six frames, analyzes them, stacks them, and performs a high level of noise reduction in the process. The result is a fairly clean exposure, and the benefit is that it

FIGURE 3.23
Hand-held Twilight mode

allows you to shoot unencumbered by a tripod (**Figure 3.24**). Tripod or not, though, try to find a way to stabilize yourself or the camera when shooting, such as leaning against a streetlight or setting the camera on a solid surface.

FIGURE 3.24
By using Hand-held Twilight, I was able to shoot these arches without a tripod and still keep the noise level down.

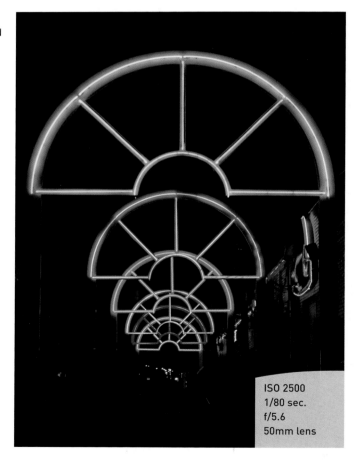

ISO 2500
1/80 sec.
f/5.6
50mm lens

ANTI MOTION BLUR MODE

Anti Motion Blur mode (**Figure 3.25**) operates just like Hand-held Twilight mode: It shoots several images in a quick volley and then stacks them together to reduce subject blur and noise. In fact, the two modes are so similar that from a practical point of view, there is no difference other than that Anti Motion Blur mode is meant for indoor shooting. This mode would come in handy inside a museum that doesn't allow flash photography (**Figure 3.26**) or at an event such as a birthday party where candles light the subject. With this in mind, though, proceed with this mode as you would with the previous one: with steady hands!

FIGURE 3.25
Anti Motion Blur

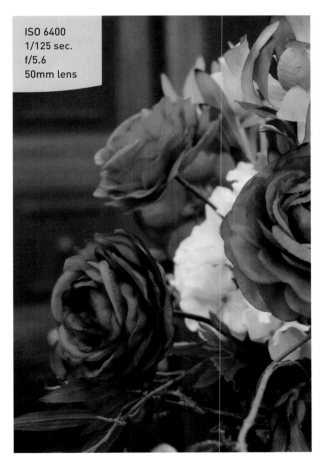

ISO 6400
1/125 sec.
f/5.6
50mm lens

FIGURE 3.26
Anti Motion Blur can come in handy when you want to grab a shot in an environment where flash is frowned upon, such as the foyer of a chapel.

SWEEP PANORAMA

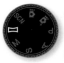 The Sweep Panorama exposure mode provides a quick way to shoot panoramas and stitch them together (**Figures 3.27** and **3.28**). This mode is considered an automatic mode because the camera determines your shutter speed, aperture, and ISO. But unlike the other automatic modes, Sweep Panorama allows you to compensate for your exposure if you feel it is over- or underexposed. Simply press the bottom of the Control wheel and rotate it to select your desired compensation value. We'll discuss exposure compensation further in Chapter 7.

FIGURE 3.27
Sweep Panorama mode

FIGURE 3.28
The Sweep Panorama function makes for easy panos.

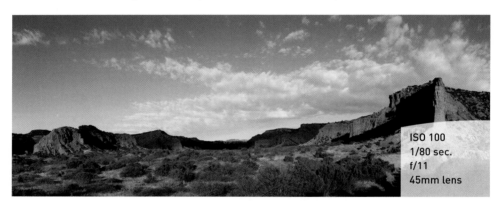

ISO 100
1/80 sec.
f/11
45mm lens

Manual Callout

On pages 63–64 of your owner's manual, two tables highlight the functions available for all shooting modes. The functions include exposure compensation, self-timer, continuous shooting, face detection, Picture Effect, and flash mode. This is a useful set of tables—having this information will let you make wiser decisions about when to employ each mode.

Although panoramas seem daunting to create, the Sweep Panorama function makes it painless. Turn the Mode dial to the icon that looks like a concave rectangle. The LCD will now provide you with instructions on how to proceed. You can change the direction in which the shot is to be created by rotating the Control dial. When you make this choice, press the shutter button halfway down to grab focus, and depress the button the entire way once. When you do this, the camera will shoot successively until you have finished "sweeping" the camera in the direction the display instructs. The camera will then stitch the images together, forming your pano.

WHY YOU MAY NEVER WANT TO USE THE AUTO MODES AGAIN

With so many easy-to-use camera modes, why would anyone ever want to use anything else? Well, the first thing that comes to mind is control. The ability to control every aspect of your photography will open up creative avenues that just can't be navigated using the automatic modes. Let's look at what we are giving up when we work with them.

- **ISO.** None of the automatic modes allow you to change the ISO setting from the default of Auto ISO. This will undoubtedly lead to unwanted digital noise in your images when the ISO begins to reach up into the higher settings.

- **Creative style.** If you are using anything but Sweep Panorama mode, you cannot change the creative style or any of its attributes to fine-tune your images.

- **White balance.** There is no choice available for white balance in any of the modes except Sweep Panorama. You are simply stuck with the Auto setting. This isn't always a bad thing, but your camera doesn't always get it right.

- **Drive mode.** The automatic exposure modes also limit whether or not you can shoot multiple frames at once, or even whether or not you can shoot just one at a time. Sports Action mode does not allow you to do the latter but gives you two different speeds of the former. It can be frustrating to have to switch modes to change something as basic to digital photography as the drive mode.

- **Autofocus.** Each of the modes uses a specific focus type. For example, Portrait mode uses Single-shot AF, while Sports Action uses Continuous AF. Even more frustrating is the fact that they all use the Multi AF Area for autofocusing. This means that you can't manually select a focus point, so you must constantly recompose your image.

- **Exposure compensation.** Apart from Intelligent Auto's and Superior Auto's brightness controls, only Sweep Panorama mode allows you to adjust the exposure to brighten or darken your image.

FOCUS MODES ON THE NEX-6

Two autofocus modes are available on the NEX-6. When you're shooting with any of the professional modes (discussed in the next chapter), you can easily select the mode that will be most beneficial to the type of photography you're doing. The default mode is called Single-shot AF, which allows you to focus on one spot and hold the focus until you take the picture or release the shutter button. The Continuous AF mode will constantly refocus the camera on your subject the entire time you are depressing the shutter release button; this is great for sports and action photography.

Chapter 3 Assignments

These assignments will have you shooting in the automatic modes so you can experience the advantages and disadvantages of using them in your daily photography.

Shooting in Intelligent Auto mode

It's time to give up complete control and just concentrate on what you see in the viewfinder. Set your camera to Intelligent Auto and practice shooting in a variety of conditions, both indoors and outside. Take notice of the camera settings when you are reviewing your pictures. Try picking a focus and then recomposing before taking the picture.

Checking out Portrait mode

Grab your favorite photogenic person and start shooting in Portrait mode. Try switching between Intelligent Auto and Portrait mode while photographing the same person in the same setting. You should see a difference in the sharpness of the background as well as the skin tones. If you are using a zoom lens, set it to about 50mm if available.

Capturing the scenery with Landscape and Macro modes

Take your camera outside for some landscape and macro work. Find a nice scene, and with your widest available lens, take some pictures using Landscape mode. Then switch back to Intelligent Auto so you can compare the settings used for each image as well as the changes to colors and sharpness. Now, while you are still outside, find something in the foreground—a leaf or a flower—and switch the camera to Macro mode. See how close you can get, and take note of the f-stop that the mode uses. Then switch to Intelligent Auto and shoot the same subject.

Stopping the action with Sports Action mode

This assignment will require that you find a subject that is in motion. That could be the traffic in front of your home or a child at play. The only real requirement is that the subject be moving. This will be your opportunity to test out Sports Action mode. There isn't a lot to worry about here—just point and shoot. Try shooting a few frames one at a time, and then hold down the shutter button and shoot a burst of five or six frames. It will help if your subject is in good available light to start with so that the camera won't be forced to use high ISOs.

Capturing the mood with Night Portrait mode

This time, wait for it to get dark outside and have a friend sit in a location that has an incandescent lamp in the background (not too bright, though). Switch the camera to Night Portrait and pop up the built-in flash. Then, using a wide enough angle to see the subject and some of the room in the background, take a photo. The goal is to get a well-lit picture of your subject and balance that with the light from the lamp in the background. For a comparison, switch the camera back to Intelligent Auto and shoot the same subject. Take notice of the difference in the brightness of the background. Now, take another picture with the flash down and your camera in Anti Motion Blur mode. This time, however, have your subject sit near the lamp so that it lights up their face. Ask them to sit as still as possible while you hold the camera as still as possible.

Getting creative with Photo Creativity

Now it's time to have a little fun exploring the options that are available to you using the Photo Creativity feature in the Intelligent Auto and Superior Auto modes. Get a feel for navigating through the options. Then, working your way across the screen, start making adjustments to each option, taking a picture with each to see how it affects the final photo. The key here is to select one scene and then use it for each change in your settings. This will give you a reference for how the image is affected by each option. Try using more than one option to fine-tune your photos.

Share your results with the book's Flickr group!

Join the group here: flickr.com/groups/sonynex6_fromsnapshotstogreatshots

4

ISO 400
1/100 sec.
f/2
50mm lens

The Professional Modes

TAKING YOUR PHOTOGRAPHY TO THE NEXT LEVEL

Creativity comes through in your images when you can control your camera, and the professional exposure modes allow you such control. To anyone who has been involved with photography for any period of time, these modes are known as the backbones of photography. They allow you to influence two of the most important factors for taking great photographs: *aperture* and *shutter speed*. Accessing these modes is as simple as turning the Mode dial to P, A, S, or M. But wouldn't it be nice to know exactly what those letters and corresponding modes control and how to make them do our bidding? Well, if you really want to take that next step in controlling your photography, it is essential that you understand not only how to control these modes, but why and when to adjust them so that you get the results you want. So let's move that Mode dial to the first of our professional modes: Program Auto.

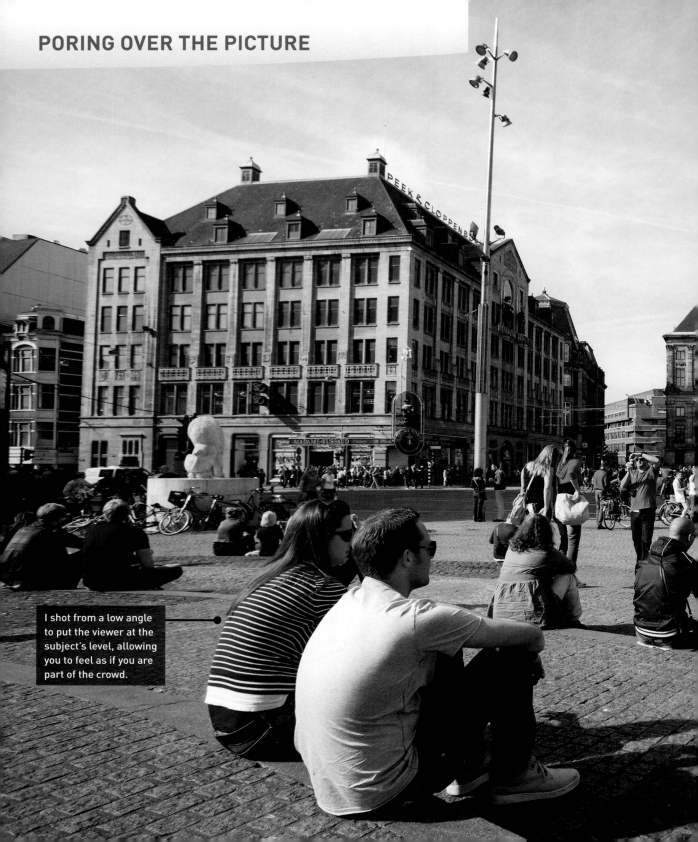

I shot from a low angle to put the viewer at the subject's level, allowing you to feel as if you are part of the crowd.

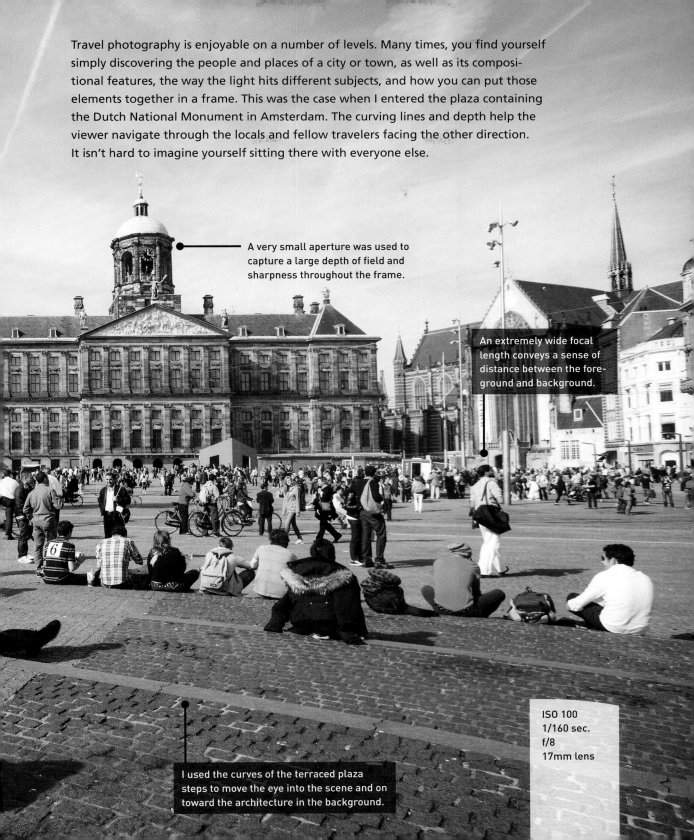

Travel photography is enjoyable on a number of levels. Many times, you find yourself simply discovering the people and places of a city or town, as well as its compositional features, the way the light hits different subjects, and how you can put those elements together in a frame. This was the case when I entered the plaza containing the Dutch National Monument in Amsterdam. The curving lines and depth help the viewer navigate through the locals and fellow travelers facing the other direction. It isn't hard to imagine yourself sitting there with everyone else.

A very small aperture was used to capture a large depth of field and sharpness throughout the frame.

An extremely wide focal length conveys a sense of distance between the foreground and background.

ISO 100
1/160 sec.
f/8
17mm lens

I used the curves of the terraced plaza steps to move the eye into the scene and on toward the architecture in the background.

P: PROGRAM AUTO MODE

 There is a reason that Program Auto (P) mode is only one click away from the Intelligent Auto and Superior Auto modes: With respect to aperture and shutter speed, the camera is doing most of the thinking for you. So, if that is the case, why even bother with Program Auto mode? First, let me say that it is very rare that I will use this mode, because it just doesn't give as much control over the image-making process as the other professional modes. There are occasions, however, when it comes in handy, like when I am shooting in widely changing lighting conditions and don't have the time to think through all of my options, or when I'm not very concerned with having ultimate control of the scene. Think of a picnic outdoors in a partial shade/sun environment—I want great-looking pictures, but I'm not looking for anything to hang in a museum. If that's the scenario, why choose Program Auto over one of the other automatic modes? Because it gives me choices and control that none of the automatic modes, including Superior Auto, can deliver.

> ## Manual Callout
>
> To see a comparison of all of the different shooting modes for the NEX-6, check out the list on page 43 of your owner's manual.

WHEN TO USE PROGRAM AUTO (P) MODE INSTEAD OF THE AUTOMATIC MODES

- When shooting in a casual environment where quick adjustments are needed

- When you want control over the ISO

- If you want or need to shoot in the Adobe RGB color space

- If you want to make corrections to the white balance

Let's go back to our picnic scenario. As I said, the light is moving from deep shadow to bright sunlight, which means that the camera is trying to balance our three photo factors (ISO, aperture, and shutter speed) to make a good exposure. From Chapter 1, we know that Auto ISO is just not a consideration, so we have already turned that feature off (you did change it, didn't you?). Well, in Program Auto mode, you can choose which ISO you would like the camera to base its exposure on. The lower the ISO number, the better the quality of our photographs, but the less light sensitive the camera becomes. It's a balancing act, with the main goal always being to keep the ISO as low as possible—too low an ISO, and we will get camera shake in our images from a long shutter speed; too high an ISO means we will have an unacceptable amount of digital noise. For our purposes, let's go ahead and select ISO 400 so that

we provide enough sensitivity for those shadows while allowing the camera to use shutter speeds that are fast enough to stop motion.

With the ISO selected, we can now make use of the other controls built into Program Auto mode. By rotating the Control dial, we have the ability to shift the program settings. Remember, your camera is using the internal light meter to pick what it believes are suitable exposure values, but sometimes it doesn't know what it's looking at and how you want those values applied (**Figures 4.1** and **4.2**). With the program shift, you can influence what the shot will look like. Do you need faster shutter speeds in order to stop the action? Just turn the Control dial counterclockwise. Do you want a smaller aperture so that you get a narrow depth of field? Then turn the dial clockwise until you get the desired aperture. The camera shifts the shutter speed and aperture accordingly in order to get a proper exposure, and you will get the benefit of your choice as a result.

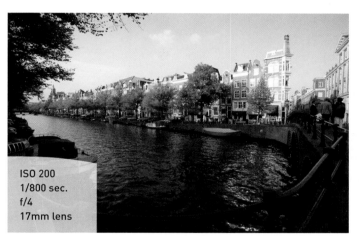

ISO 200
1/800 sec.
f/4
17mm lens

FIGURE 4.1
This is my first shot using Program Auto mode. Since I was pointing the camera in a manner that allowed the meter to read more dark tones than light, the exposure was longer, overexposing the sky and the brighter parts of the buildings along the canal.

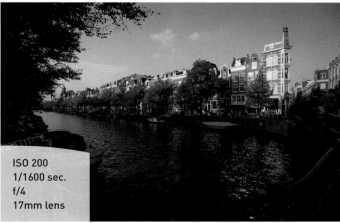

ISO 200
1/1600 sec.
f/4
17mm lens

FIGURE 4.2
To correct for the overexposure, I used the camera's exposure compensation function to reduce the brightness by one stop. The camera automatically changed the shutter speed to make this adjustment.

STARTING POINTS FOR ISO SELECTION

There is a lot of discussion concerning ISO in this and other chapters, but it might be helpful if you know where your starting points should be for your ISO settings. The first thing you should always try to do is use the lowest possible ISO setting. That being said, here are some good starting points for your ISO settings:

- 100: Bright, sunny day
- 200: Hazy, or outdoor shade on a sunny day
- 400: Indoor lighting at night or cloudy conditions outside
- 800: Late night, low-light conditions or sporting arenas at night

These are just suggestions, and your ISO selection will depend on a number of factors that will be discussed later in the book. You might have to push your ISO even higher as needed, but at least now you know where to start.

Let's set up the camera for Program Auto mode and see how we can make all of this come together.

SETTING UP AND SHOOTING IN PROGRAM AUTO MODE

1. Turn your camera on, and then turn the Mode dial to align the P with the indicator line.
2. To select your ISO, press the right side of the Control wheel (next to where it reads ISO), rotate the Control wheel to the desired setting, and press the middle of the wheel to select (the ISO selection will appear in the electronic viewfinder and the rear LCD panel).
3. Point the camera at your subject, and then activate the camera meter by depressing the shutter button halfway.
4. View the exposure information in the electronic viewfinder or on the display panel on the back of the camera.
5. While the meter is activated, use your thumb to roll the Control dial left and right to see the changed exposure values.
6. Select the exposure that is right for you and start shooting. (Don't worry if you aren't sure what the right exposure is. We will start working on making the right choices for those great shots beginning with the next chapter.)

S: SHUTTER PRIORITY MODE

 S mode is what we photographers commonly refer to as Shutter Priority mode. The nomenclature can vary between cameras—some manufacturers use the initials Tv (for Time Value) to indicate you are shooting in Shutter priority mode. Luckily, the NEX-6 makes it easy on us. S stands for *shutter*; hence, Shutter priority. It can't be any more practical than that, right?

Like Program Auto mode, S mode gives us more freedom to control certain aspects of our photography. In this case, we are talking about shutter speed. The selected shutter speed determines just how long you expose your camera's sensor to light. The longer it remains open, the more time your sensor has to gather light. The shutter speed also, to a large degree, determines how sharp your photographs are. This is different from the image being sharply in focus. Two of the major influences on the sharpness of an image are camera shake and the subject's movement. Because a slower shutter speed means that light from your subject is hitting the sensor for a longer period of time, any movement by you or your subject will show up in your photos as blur.

SHUTTER SPEEDS

A *slow* shutter speed refers to leaving the shutter open for a long period of time—like 1/30 of a second or longer. A *fast* shutter speed means that the shutter is open for a very short period of time—like 1/250 of a second or less.

WHEN TO USE SHUTTER PRIORITY (S) MODE

- When working with fast-moving subjects where you want to freeze the action (**Figure 4.3**); much more on this in Chapter 5

- When you want to emphasize movement in your subject with panning or with motion blur (**Figure 4.4**)

- When you want to use a long exposure to gather light over a long period of time (**Figure 4.5**); more on this in Chapter 8

- When you want to create silky-looking water in a waterfall (**Figure 4.6**)

FIGURE 4.3
Fast-moving subjects in proximity to the camera can be frozen with the right shutter speed.

ISO 100
1/400 sec.
f/8
17mm lens

FIGURE 4.4
Slowing down the shutter speed allows your photographs to convey a sense of movement, indicated by the lateral blurring of the background in this pan.

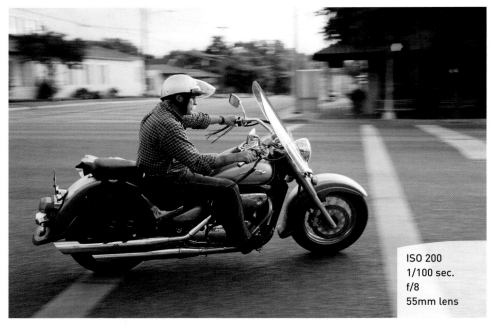

ISO 200
1/100 sec.
f/8
55mm lens

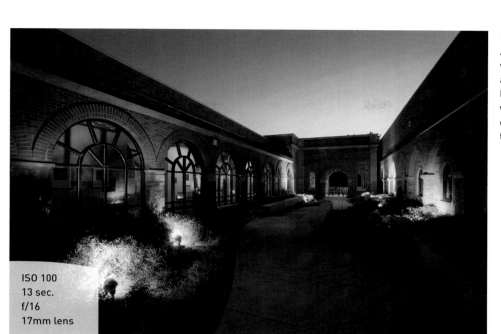

ISO 100
13 sec.
f/16
17mm lens

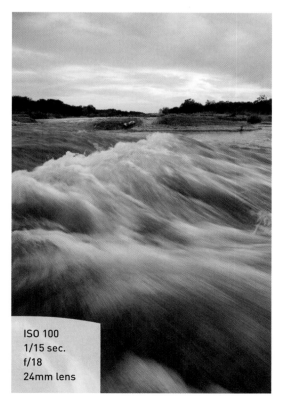

FIGURE 4.6
Increasing the length of the exposure gives flowing water a more fluid, silky look.

ISO 100
1/15 sec.
f/18
24mm lens

As you can see, the subject of your photo usually determines whether or not you will use S mode. It is important that you be able to visualize the result of using a particular shutter speed. The great thing about shooting with digital cameras is that you get instant feedback by checking your shot on the LCD screen. But what if your subject won't give you a do-over? Such is often the case when shooting sporting events. It's not like you can ask the quarterback to throw that touchdown pass again because your last shot was blurry from a slow shutter speed. This is why it's important to know what those speeds represent in terms of their ability to stop the action and deliver a blur-free shot.

First, let's examine just how much control you have over the shutter speeds. The NEX-6 has a shutter speed range from 1/4000 of a second all the way down to 30 seconds. With that much latitude, you should have enough control to capture almost any subject. The other thing to think about is that S mode is considered a "semiautomatic" mode. This means that you are taking control over one aspect of the total exposure while the camera handles the other. In this instance, you are controlling the shutter speed and the camera is controlling the aperture. This is important to know because there will be times that you want to use a particular shutter speed but your lens won't be able to accommodate your request.

For example, you might encounter this problem when shooting in low-light situations: If you are shooting a fast-moving subject that will blur at a shutter speed slower than 1/125 of a second but your lens's largest aperture is f/3.5, you might see your aperture display in the electronic viewfinder and the rear LCD panel begin to blink. This is your warning that there won't be enough light available for the shot—due to the limitations of the lens—so your picture will be underexposed (too dark).

Another case where you might run into this situation is when you are shooting moving water. To get that look of silky, flowing water, it's usually necessary to use a shutter speed of at least 1/15 of a second, if not longer. If your waterfall is in full sunlight, you may get that blinking aperture display once again because the lens you are using only closes down to f/22 at its smallest opening. In this instance, your camera is warning you that you will be overexposing your image (too light). There are workarounds for these problems, which we will discuss later (see Chapter 7), but it is important to know that there can be limitations when using S mode.

SETTING UP AND SHOOTING IN S MODE

1. Turn your camera on, and then turn the Mode dial to align the S with the indicator line.
2. To select your ISO, press the right side of the Control wheel (next to where it reads ISO), rotate the Control wheel to the desired setting, and press the middle of the wheel to select (the ISO selection will appear in the electronic viewfinder and the rear LCD panel).

3. Point the camera at your subject, and then activate the camera meter by depressing the shutter button halfway.

4. View the exposure information in the electronic viewfinder or on the rear LCD panel.

5. While the meter is activated, use your thumb to roll the Control dial left and right to see the changed exposure values. Roll the dial to the right for faster shutter speeds and to the left for slower speeds.

A: APERTURE PRIORITY MODE

You wouldn't know it from its name, but A mode is one of the most useful and popular of the professional modes. It is one of my favorites, and I believe that it will quickly become one of yours as well. A, more commonly referred to as Aperture Priority mode, is also deemed a semiautomatic mode because it allows you to once again control one factor of exposure while the camera adjusts for the other.

Why, you may ask, is this one of my favorite modes? It's because the aperture of your lens dictates depth of field. Depth of field, along with composition, is a major factor in how you direct attention to what is important in your image. It is the factor that controls how much of your image is in focus. If you want to isolate a subject from the background, such as when shooting a portrait, you can use a large aperture to keep the focus on your subject and make both the foreground and background blurry. If you want to keep the entire scene sharply focused, such as with a landscape, then using a small aperture will render the greatest possible depth of field.

F-STOPS AND APERTURE

As discussed earlier, when referring to the numeric value of your lens aperture, you will find it described as an *f-stop*. The f-stop is one of those old photography terms that, technically, relates to the focal length of the lens (e.g., 200mm) divided by the effective aperture diameter. These measurements are defined as "stops" and work incrementally with your shutter speed to create proper exposure. Older camera lenses used one-stop increments to assist in exposure adjustments, such as 1.4, 2, 2.8, 4, 5.6, 8, 11, 16, and 22. Each stop represents about half the amount of light entering the lens iris as the larger stop before it. Today, most lenses don't have f-stop markings since all adjustments to this setting are performed via the camera's electronics. The stops are also now typically divided into 1/3-stop increments to allow much finer adjustments to exposures, as well as to match the incremental values of your camera's ISO settings, which are also adjusted in 1/3-stop increments.

WHEN TO USE APERTURE PRIORITY (A) MODE

- When shooting portraits or wildlife (**Figure 4.7**)
- When shooting architectural photography, which often benefits from a large depth of field (**Figure 4.8**)
- When shooting macro, or close-up, photography (**Figure 4.9**)
- When shooting landscape photography (**Figure 4.10**)

ISO 100
1/200 sec.
f/5.6
50mm lens

FIGURE 4.7
A fairly large aperture coupled with a longer focal length created a very blurry background, so all the emphasis was left on the subject

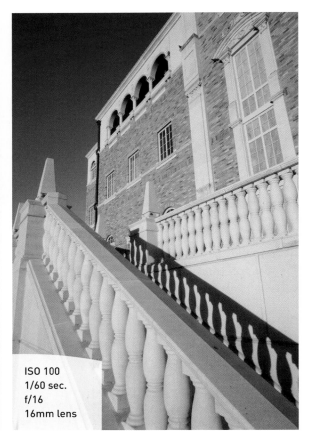

ISO 100
1/60 sec.
f/16
16mm lens

FIGURE 4.8
A wide-angle lens combined with a small aperture makes for a large depth of field

FIGURE 4.9
Small apertures
give more sharpness
in close detail shots.

ISO 100
1/60 sec.
f/8
32mm lens

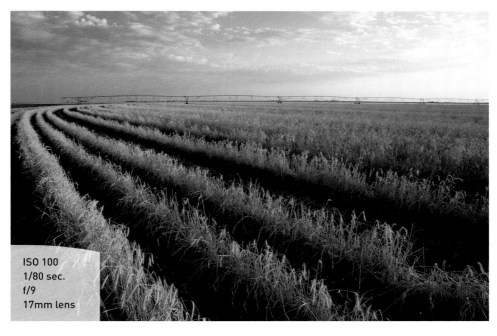

FIGURE 4.10
The smaller aper-
ture setting brings
sharpness to near
and far objects.

ISO 100
1/80 sec.
f/9
17mm lens

We have established that Aperture Priority (A) mode is highly useful in controlling the depth of field in your image. It's also pivotal in determining the limits of available light that you can shoot in. Different lenses have different maximum apertures. The larger the maximum aperture, the less light you need in order to achieve a properly exposed image. You will recall that, when in S mode, there is a limit at which you can handhold your camera without introducing movement or hand shake, which causes blurriness in the final picture. If your lens has a larger aperture, you can let in more light all at once, which means that you can use faster shutter speeds. This is why lenses with large maximum apertures, such as f/1.4, are called "fast" lenses.

On the other hand, bright scenes require the use of a small aperture (such as f/16 or f/22), especially if you want to use a slower shutter speed. That small opening reduces the amount of incoming light, and this reduction of light requires that the shutter stay open longer.

SETTING UP AND SHOOTING IN APERTURE PRIORITY MODE

1. Turn your camera on and then turn the Mode dial to align the A with the indicator line.

2. Select your ISO by pressing the right side of the Control wheel (next to where it reads ISO), rotating the Control wheel to the desired setting, and pressing the middle of the wheel to select (the ISO selection will appear in the electronic viewfinder and the rear LCD panel).

3. Point the camera at your subject, and then activate the camera meter by depressing the shutter button halfway.

4. View the exposure information in the electronic viewfinder or on the rear display.

5. While the meter is activated, use your thumb to roll the Control dial left and right to see the changed exposure values. Roll the dial to the right for a smaller aperture (higher f-stop number) and to the left for a larger aperture (smaller f-stop number).

ZOOM LENSES AND MAXIMUM APERTURES

Some zoom lenses (like the 16–50mm kit lens) have a variable maximum aperture. This means that the largest opening will change depending on the zoom setting. In the example of the 16–50mm zoom, the lens has a maximum aperture of f/3.5 at 16mm and only f/5.6 when the lens is zoomed out to 50mm. Fixed-aperture zoom lenses maintain the same maximum aperture throughout the zoom range. They are typically much more expensive than their variable maximum aperture counterparts.

M: MANUAL MODE

Once upon a time, long before digital cameras and programmed modes, there was manual mode. In those days it wasn't called "manual mode," because there were no other modes. It was just photography. In fact, many photographers, including me, cut their teeth on completely manual cameras. Let's face it—if you want to learn the effects of aperture and shutter speed on your photography, there is no better way to learn than by setting these adjustments yourself. But today, with the advancement of camera technology, many new photographers never give this mode a second thought. That's truly a shame, as not only is it an excellent way to learn your photography basics, it's also an essential tool to have in your photographic bag of tricks.

When you have your camera set to Manual (M) mode, the camera meter will give you a reading of the scene you are photographing. It's your job, though, to set both the f-stop (aperture) and the shutter speed to achieve a correct exposure. If you need a faster shutter speed, you will have to make the reciprocal change to your f-stop. Using any other mode, such as S or A, would mean that you just have to worry about one of these changes, but Manual mode means you have to do it all yourself. This can be a little challenging at first, but after a while you will have a complete understanding of how each change affects your exposure, which will, in turn, improve the way that you use the other modes.

WHEN TO USE MANUAL (M) MODE

- When you need to maintain exposures between different frames for a panorama (**Figure 4.11**)

- When your environment is fooling your light meter and you need to maintain a certain exposure setting (**Figure 4.12**)

- When shooting silhouetted subjects, which requires overriding the camera's meter readings (**Figure 4.13**)

FIGURE 4.11
Setting the camera on Manual for panorama shots helps to keep the exposure consistent across every frame.

ISO 100
1/60 sec.
f/4
50mm lens

FIGURE 4.12
Bright lights, such as this canopy light at a fuel station, can present a challenge to your light meter.

ISO 200
1/100 sec.
f/5.6
16mm lens

ISO 100
1/125 sec.
f/5.6
31mm lens

FIGURE 4.13
I silhouetted these two statues of ancient pachyderms by intentionally underexposing the scene against the vibrant sunrise.

SETTING UP AND SHOOTING IN MANUAL MODE

1. Turn the Mode dial to align the M with the indicator line.

2. Select your ISO by pressing the right side of the Control wheel (next to where it reads ISO), rotating the Control wheel to the desired setting, and pressing the middle of the wheel to select (the ISO selection will appear in the electronic viewfinder and the rear LCD panel).

3. Point the camera at your subject, and then activate the camera meter by depressing the shutter button halfway.

4. View the exposure information in the electronic viewfinder or on the rear display.

5. While the meter is activated, use your thumb to roll the Control wheel left and right to change your shutter speed value until the exposure mark is lined up with the zero mark. The exposure information is displayed by a scale with marks that run from –2 to +2 stops. (You'll note that –3 and +3 are grayed out. They represent the range of exposure compensation available for S and A modes. In M mode, you can forget about –3 and +3.) A "proper" exposure will line up with the arrow mark in the middle. As the indicator moves to the left, it is a sign that you will be underexposing (there is not enough light hitting the sensor to provide adequate exposure). Move the indicator to the right and you will be providing more exposure than the camera meter calls for; this is overexposure.

continues on next page

6. To set your exposure using the aperture, depress the shutter release button until the meter is activated. Then, using your thumb, turn the Control dial right for a smaller aperture (large f-stop number) or left for a larger aperture (small f-stop number).

HOW I SHOOT: A CLOSER LOOK AT THE CAMERA SETTINGS I USE

One of the advantages of using a mirrorless camera system is that it operates just like a DSLR but without the size and noise. I'm attracted to the NEX-6 because I can approach it much like I would any larger rig that I use on a day-to-day basis. Personally, I am drawn to shooting in both the Aperture Priority (A) and Manual (M) modes. I identify myself as an editorial and natural history photographer, which means I'm shooting anything from news to travel, from wildlife to sports, and from environmental portraits to "portraits" of the environment. Working in these areas means that I am almost always going to be concerned with my depth of field—hence, my affinity for Aperture Priority mode. Whether it's isolating my subject with a large aperture or trying to maximize the overall sharpness of a sweeping landscape, I always keep an eye on my aperture setting.

And I always keep an eye on what shutter speed that aperture setting will allow me. If I'm shooting sports or a subject matter that includes a lot of action, I open up my aperture to its maximum to gain as much shutter speed as possible. If I need to shoot faster, only then do I raise my ISO. Raising the ISO is the last part of the exposure formula I want to change, because I want to introduce the least possible amount of digital noise to the image. If I must raise my ISO, I make sure to set the camera's High ISO NR (noise reduction) to Normal (see Chapter 7).

To make quick changes while I shoot, I often use the exposure compensation feature (covered in Chapter 7) so that I can make small over- and underexposure changes. This is different from changing the aperture or shutter; it is more like fooling the camera meter into thinking the scene is brighter or darker than it actually is.

I am also aware of the potential for areas in my frame to be over- or underexposed. I use the Histogram display on the NEX-6 to see whether I am indeed blowing out the highlights (overexposure) or "muddying up" the shadows (underexposure) **(Figure 4.14)**. These exposure alerts come in the form of what are informally known as "blinkies": areas of the image that blink at you on the LCD or EVF. Blinkies are the warning signal that part of my image has been either overexposed or underexposed to the point that there is no longer any detail in the highlights or shadows. Although it is unfortunate that you can only see these alerts using the Histogram display mode, they are very valuable. If you see any area of the thumbnail blinking black, you are probably overexposing that part of the image. If you see any area blinking white, you are risking underexposure.

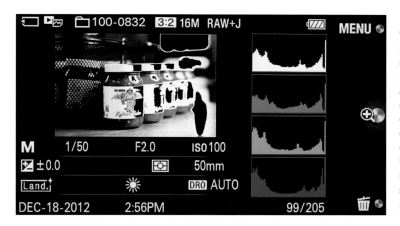

FIGURE 4.14
The NEX-6's highlight alert screen during image playback. One advantage of this display is the histogram, which notes exactly where your exposure values lie. The out-of-place black blobs blink to show you overexposed areas.

For the majority of my shooting, I am in Aperture Priority (A) mode. It is an efficient mode in which to work, and it frees up mental resources for focusing on what you are actually shooting. When I want complete control over the imagery, or when I'm shooting difficult-to-meter subjects, I work in Manual (M). For example, if I am shooting along a row of river rapids and want to create that silky look to the water, I will often switch to Manual since water is rarely a good value to meter for exposure. While the other camera modes have their place, I think you will find that, like me and many other working pros, you will use the A and M modes for 90 percent of your shooting.

As you work your way through the coming chapters, you will see other tips and tricks I use in my daily photography, but the most important tip I can give is that you take the time to understand the features of your camera so you can leverage the technology in a knowledgeable way. This will result in better photographs.

Chapter 4 Assignments

The information covered in this chapter will define how you work with your camera from this point on. Granted, there may be times that you just want to grab some quick pictures and will resort to the automatic modes, but to get serious with your photography, you should learn the professional modes.

Starting off with Program Auto mode

Set your camera on Program Auto mode (P) and start shooting. Become familiar with the adjustments you can make to your exposure by turning the Control dial. While you're shooting, make sure that you keep an eye on your ISO.

Learning to control time with S mode

Find some moving subjects and then set your camera to S mode. Have someone ride a bike back and forth, or even just photograph cars as they go by. Start with a slow shutter speed of around 1/30 of a second and then start shooting with faster and faster shutter speeds. Keep shooting until you can freeze the action. Now find something that isn't moving, like a flower. Start with your shutter speed at something fast like 1/500 of a second and then work your way down to about 1/4 of a second. The point is to see how well you can handhold your camera before you start introducing hand shake into the image.

Controlling depth of field with A mode

The name of the game with A mode is depth of field. Set up three items at different distances from you. I would use chess pieces or something similar. Now focus on the middle item, and set your camera to the largest aperture that your lens allows (remember that large aperture means a small number, like f/3.5). Now, while still focusing on the middle subject, start shooting with ever-smaller apertures until you are at the smallest f-stop for your lens. If you have a zoom lens, try doing this exercise with the lens at the widest and then the most telephoto settings. Now move up to subjects that are farther away, like telephone poles, and shoot them in the same way. The idea is to get a feel for how each aperture setting affects your depth of field.

Giving and taking with Manual mode

Go outside on a sunny day, and with the camera in Manual mode (M), set your ISO to 100, your shutter speed to 1/125 of a second, and your aperture to f/16. Now press your shutter release button to get a meter reading. You should be pretty close to that zero mark. If not, make small adjustments to one of your settings until it hits that mark. Now is where the fun begins. Start moving your shutter speed slower, to 1/60, and then set your aperture to f/22. Now go the other way. Set your aperture to f/8 and your shutter speed to 1/500. Now review your images. If all went well, all the exposures should look the same. This is because you balanced the light with reciprocal changes to the aperture and shutter speed. Now go back to our original setting of 1/125 at f/16 and try just moving the shutter speed without changing the aperture. Just make 1/3-stop changes (1/125 to 1/100 to 1/80 to 1/60), and then review your images to see what 1/3 stop of overexposure looks like. Then do the same thing going in the opposite way. It's hard to know if you want to over- or underexpose a scene until you have actually done it and seen the results.

Share your results with the book's Flickr group!

Join the group here: flickr.com/groups/sonynex6_fromsnapshotstogreatshots

5

ISO 200
1/1600 sec.
f/5.6
24mm lens

Moving Target

THE TRICKS TO SHOOTING SPORTS AND MORE

Now that you have learned about the professional modes, it's time to put your newfound knowledge to good use. Whether you are shooting the action at a professional sporting event or a child on a merry-go-round, you'll learn techniques that will help bring out the best in your photography when your subject is in motion.

The number one thing to know when trying to capture a moving target is that speed is king! I'm not talking about how fast your subject is moving, but rather how fast your shutter is opening and closing. Shutter speed is the key to freezing a moment in time—but also to conveying movement. It's all in how you turn the dial. There are also some other considerations for taking your shot to the next level: composition, lens selection, and a few more items that we will explore in this chapter. So strap on your seatbelt and hit the gas, because here we go!

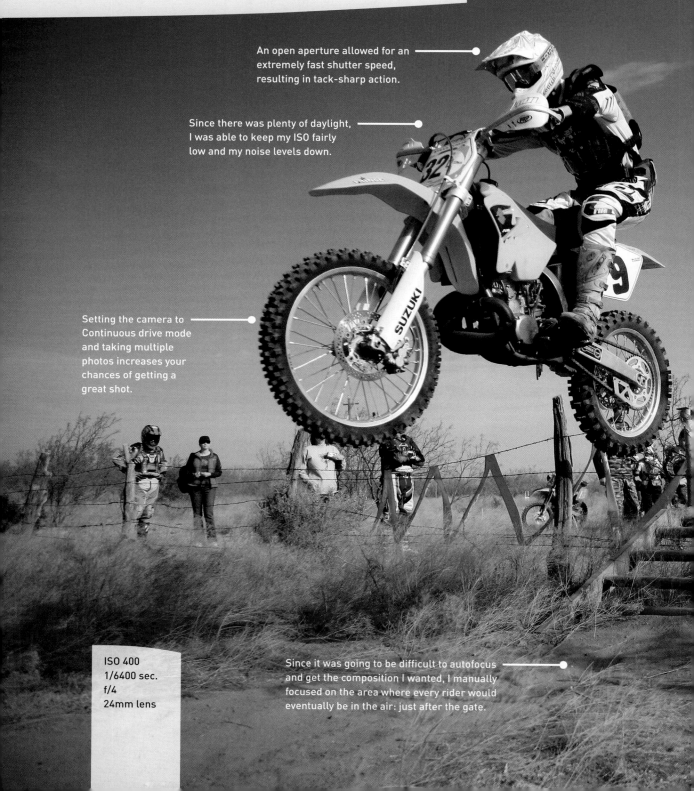

PORING OVER THE PICTURE

An open aperture allowed for an extremely fast shutter speed, resulting in tack-sharp action.

Since there was plenty of daylight, I was able to keep my ISO fairly low and my noise levels down.

Setting the camera to Continuous drive mode and taking multiple photos increases your chances of getting a great shot.

ISO 400
1/6400 sec.
f/4
24mm lens

Since it was going to be difficult to autofocus and get the composition I wanted, I manually focused on the area where every rider would eventually be in the air: just after the gate.

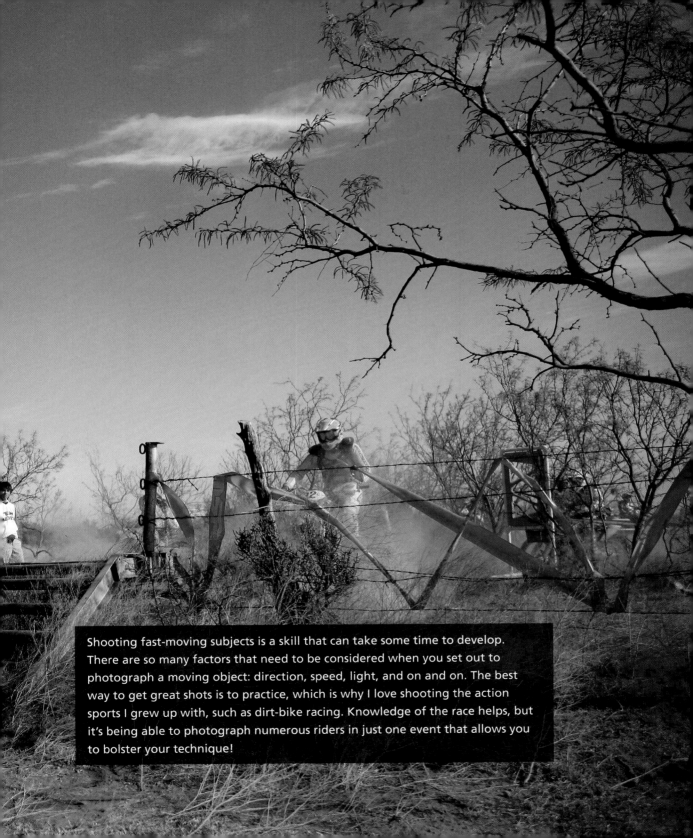

Shooting fast-moving subjects is a skill that can take some time to develop. There are so many factors that need to be considered when you set out to photograph a moving object: direction, speed, light, and on and on. The best way to get great shots is to practice, which is why I love shooting the action sports I grew up with, such as dirt-bike racing. Knowledge of the race helps, but it's being able to photograph numerous riders in just one event that allows you to bolster your technique!

STOP RIGHT THERE!

Shutter speed is the main tool in the photographer's arsenal for capturing great action shots. The ability to freeze a moment in time often makes the difference between a good shot and a great one. To take advantage of this concept, you should have a good grasp of the relationship between shutter speed and movement. When you press the shutter release button, your camera goes into action by opening the shutter curtain and then closing it after a predetermined length of time. The longer you leave your shutter open, the more your subject will move across the frame, so common sense dictates that the first thing to consider is just how fast your subject is moving.

Typically, you will be working in fractions of a second. How many fractions depends on several factors. Subject movement, while simple in concept, is actually based on three factors. The first is the direction of travel. Is the subject moving across your field of view (left to right) or traveling toward or away from you? The second consideration is the actual speed at which the subject is moving. There is a big difference between a moving sports car and a child on a bicycle. Finally, the distance from you to the subject has a direct bearing on how fast the action seems to be taking place. Let's take a brief look at each of these factors to see how they might affect your shooting.

DIRECTION OF TRAVEL

Typically, the first thing that people think about when taking an action shot is how fast the subject is moving, but in reality the first consideration should be the direction of travel. Where you are positioned in relation to the subject's direction of travel is critically important in selecting the proper shutter speed. When you open your shutter, the lens gathers light from your subject and records it on the camera sensor. If the subject is moving across your viewfinder, you need a faster shutter speed to keep that lateral movement from being recorded as a streak across your image. Subjects that are moving perpendicular to your shooting location do not move across your viewfinder and appear to be more stationary. This allows you to use a slightly slower shutter speed (**Figure 5.1**). A subject that is moving in a diagonal direction— both across the frame and toward or away from you—requires a shutter speed in between the two.

ISO 400
1/250 sec.
f/4
24mm lens

FIGURE 5.1
Action coming toward the camera can be captured with slower shutter speeds.

SUBJECT SPEED

Once the angle of motion has been determined, you can then assess the speed at which the subject is traveling. The faster your subject moves, the faster your shutter speed needs to be in order to "freeze" that subject. A person walking across your frame might only require a shutter speed of 1/60 of a second (**Figure 5.2**), whereas a cyclist traveling in the same direction would call for 1/500 of a second. That same cyclist traveling at the same rate of speed toward you, rather than across the frame, might only require a shutter speed of 1/125 of a second. You can start to see how the relationship of speed and direction comes into play in your decision-making process.

FIGURE 5.2
Walking can be captured with a much slower shutter speed than was used for this image of parade-goers in Spain. Nevertheless, it's always appropriate to use as fast a shutter speed as possible if your goal is to freeze the action.

ISO 200
1/1250 sec.
f/2
50mm lens

SUBJECT-TO-CAMERA DISTANCE

So now we know both the direction and the speed of your subject. The final factor to address is the distance between you and the action. Picture yourself looking at a highway full of cars from up in a tall building a quarter of a mile from the road. As you stare down at the traffic moving along at 55 miles per hour, the cars and trucks seem to be slowly moving along the roadway. Now picture yourself standing in the median of that same road as the same traffic flies by at the same rate of speed.

Although the traffic is moving at the same speed, the shorter distance between you and the traffic makes the cars look like they are moving much faster. This is because your field of view is much narrower; therefore, the subjects are not going to present themselves within the frame for the same length of time. The concept of distance applies to the length of your lens as well (**Figure 5.3**). If you are using a wide-angle lens, you can probably get away with a slower shutter speed than if you were using a telephoto, which puts you in the heart of the action. It all has to do with your field of view. That telephoto gets you "closer" to the action—and the closer you are, the faster your subject will be moving across your viewfinder.

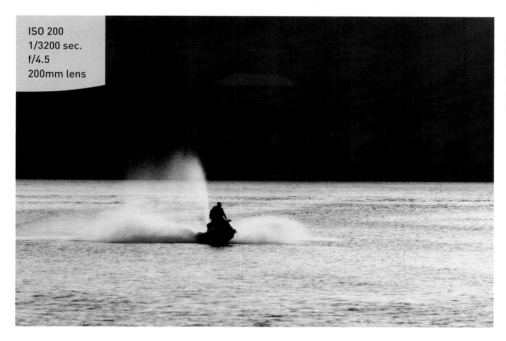

ISO 200
1/3200 sec.
f/4.5
200mm lens

FIGURE 5.3
Due to the action's distance from the camera, a slower shutter speed could be used to capture it.

ZOOM IN TO BE SURE

When reviewing your shots on the LCD, don't be fooled by the display. The smaller your image is, the sharper it will look. To ensure that you are getting sharp, blur-free images, make sure that you zoom in on your LCD display.

To zoom in on your images, press the Playback button located to the upper-right of the LCD display and then press the middle of the Control wheel, as indicated by the icons on the right of the display. Turn the Control wheel clockwise to increase the zoom ratio (**Figure 5.4**).

To zoom out, simply turn the Control wheel counterclockwise. To return to the original playback display, press soft key A on the display.

FIGURE 5.4
Zooming in on your image helps you confirm that the image is really sharp.

USING SHUTTER PRIORITY (S) MODE TO STOP MOTION

In Chapter 4, you were introduced to the professional shooting modes. You'll remember that the mode that gives you ultimate control over shutter speed is S mode, where you are responsible for selecting the shutter speed while handing over the aperture selection to the camera. The ability to concentrate on just one exposure factor helps you quickly make changes on the fly while staying glued to your viewfinder and your subject.

There are a couple of things to consider when using S mode, both of which have to do with the amount of light that is available when shooting. Although you have control over which shutter speed you select in S mode, the range of shutter speeds that is available to you depends largely on how well your subject is lit.

When shooting fast-paced action, you will typically be working with very fast shutter speeds. This means that your lens will probably be set to its largest aperture. If the light is not sufficient for the shutter speed selected, you will need to do one of two things: select a lens that offers a larger working aperture, or raise the ISO of the camera. Working off the assumption that you have only one lens available, let's concentrate on balancing your exposure using the ISO.

Let's say that you are shooting a baseball game at night and want to get some great action shots. You set your camera to S mode and, after testing out some shutter speeds, determine that you need to shoot at 1/500 of a second to freeze the action on the field. When you place the viewfinder to your eye and press the shutter button halfway, you notice that the f-stop readout is blinking at f/4.5. This is your camera's way of telling you that the lens has now reached its maximum aperture and that you will be underexposed if you shoot your pictures at the currently selected shutter speed. You could slow your shutter speed down until the aperture reading stops blinking, but then you would get images with too much motion blur.

The alternative is to raise your ISO to a level that is high enough for a proper exposure. The key here is to always use the lowest ISO that you can get away with. That might mean ISO 200 in bright, sunny conditions, or ISO 1600 (or higher) for an indoor or night situation (**Figure 5.5**). Just remember that the higher the ISO, the greater the amount of noise in your image. This is the reason that you see professional sports photographers using those mammoth lenses perched atop monopods: They could use a smaller lens, but to get those very large apertures they need a huge piece of glass on the front of the lens. The larger the glass on the front of the lens, the more light it gathers, and the larger the aperture for shooting. For the working pro, the large aperture translates into low ISO (and thus low noise), fast shutter speeds, and razor-sharp action.

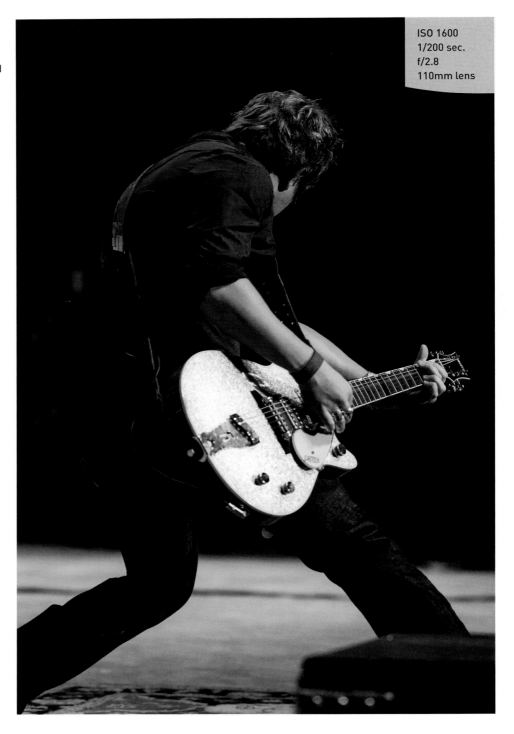

FIGURE 5.5
The only way to stop action under the stage lights and still get a decent shutter speed is to crank up the ISO.

ISO 1600
1/200 sec.
f/2.8
110mm lens

1. Check for the blinking aperture readout in the lower-left portion of your electronic viewfinder.

2. If it is blinking, use your thumb to press the ISO button (the right side of the Control wheel). The ISO options appear in the viewfinder.

3. Turn the Control wheel clockwise to raise the ISO to the next highest level.

4. Lightly press the shutter button and check to see if the aperture is still blinking.

5. If it's not blinking, shoot away. If it is, repeat steps 2–4 until it is set correctly.

USING APERTURE PRIORITY (A) MODE TO ISOLATE YOUR SUBJECT

One of the benefits of working in S mode with fast shutter speeds is that, more often than not, you will be shooting with the largest aperture available on your lens. Shooting with a large aperture allows you to use faster shutter speeds, but it also narrows your depth of field.

To isolate your subject in order to focus your viewer's attention on it, a larger aperture is required. The larger aperture reduces the foreground and background sharpness: The larger the aperture, the more blurred everything except your subject will be.

The reason that I bring this up here is that when you are shooting most sporting events, the idea is to isolate your main subject by having it in focus while the rest of the image has some amount of blur. This sharp focus draws your viewer right to the subject. Studies have shown that the eye is drawn to sharp areas before moving on to the blurry areas. Also, depending on what your subject matter is, there can be a tendency to get distracted by a busy background if everything in the photo is equally sharp. Without a narrow depth of field, it might be difficult for the viewer to identify exactly what the main subject is in your picture.

Let's look at how to use depth of field to bring focus to your subject. In the previous section, I told you that you should use S mode for getting those really fast shutter speeds to stop action. Generally speaking, S mode will be the mode you most often use for shooting sports and other action, but there will be times when you want to ensure that you are getting the narrowest depth of field possible in your image. The way to do this is by using Aperture Priority (A) mode.

So how do you know when you should use A mode as opposed to S mode? It's not a simple answer, but your LCD screen can help you make this determination. The best scenario for using A mode is a brightly lit scene where maximum apertures will still give you plenty of shutter speed to stop the action.

Let's say that you are shooting a soccer game in the midday sun. If you have determined that you need something between 1/500 and 1/1250 of a second for stopping the action, you could just set your camera to a high shutter speed in S mode and start shooting. But you also want to be using an aperture of, say, f/4.5 to get that narrow depth of field. Here's the problem: If you set your camera to S and select 1/1000 of a second as a nice compromise, you might get that desired f/stop—but you might not. As the meter is trained on your moving subject, the light levels could rise or fall, which might actually change that desired f-stop to something higher, like f/5.6 or even f/8. Now the depth of field is extended, and you will no longer get that nice isolation and separation that you wanted.

To rectify this, switch the camera to A mode and select f/4.5 as your aperture. Now, as you begin shooting, the camera holds that aperture and makes exposure adjustments with the shutter speed (**Figure 5.6**). As I said before, this works well when you have lots of light—enough light so that you can have a high-enough shutter speed without introducing motion blur.

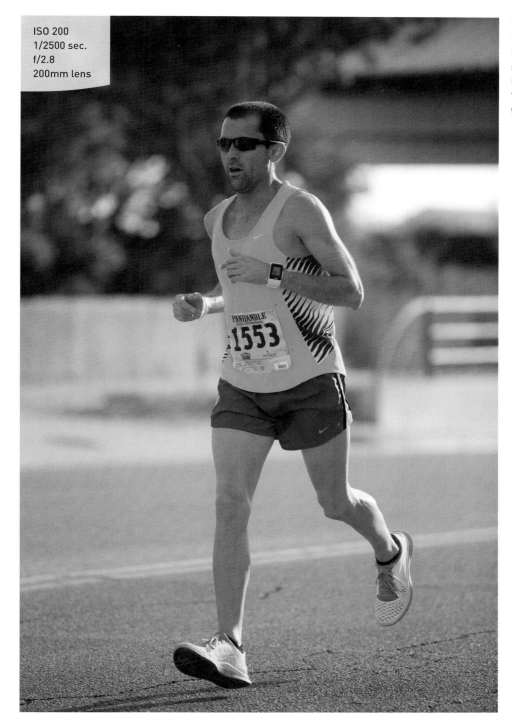

ISO 200
1/2500 sec.
f/2.8
200mm lens

FIGURE 5.6
Because of the large aperture setting, the runner is nicely separated from the background clutter.

KEEP THEM IN FOCUS WITH CONTINUOUS AF AND AUTOFOCUS AREA SELECTION

With the exposure issue handled for the moment, let's move on to a subject of equal importance: focusing. If you have browsed your manual, you know that there are two autofocus modes to choose from in the NEX-6. The first is Single-shot AF, which works best for stationary subjects (such as portraits or macro work). Once focus is achieved, it is locked at that particular distance until the shutter is fully depressed or released and pressed again.

For the most part, Single-shot AF is not a popular mode for photographing movement. For this type of photography, Continuous AF is ideal. Continuous AF uses the focus point (or points) selected in the camera to find a moving subject, and then it locks in the focus when the shutter button is completely depressed. Unlike Single-shot AF mode, Continuous AF mode will help track your subject in the frame, which will give you better focus results.

PHASE-DETECTION AND CONTRAST-DETECTION AF

Typical autofocus technology relies on contrast to detect where focus should be placed when shooting, but contrast-detection AF does not always work well in backlit or low-light situations. Fortunately, the NEX-6 uses both contrast-detection AF and phase-detection AF. Phase-detection AF compares dual images of a scene and ensures focus when both images are sufficiently "lined up," much like a traditional rangefinder focusing system. The NEX-6's hybrid system provides highly reliable autofocus in a variety of light environments.

SELECTING AND SHOOTING IN CONTINUOUS AF MODE

1. Press the Fn button next to the shutter button.

2. Use your right thumb to click to the right on the Control wheel until AF Mode is highlighted. Select this function, and rotate the Control wheel to highlight Continuous AF (AF-C) (**A**). Select it by pressing the middle of the Control wheel.

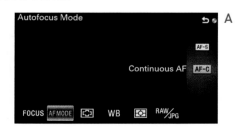

3. Locate your subject in the viewfinder, then press and hold the shutter button halfway to activate the focus mechanism.

4. The camera will maintain focus on your subject as long as it remains within one of the focus points in the viewfinder or until you take a picture.

You should also note that the AF mode is used to select the method with which the camera will focus the lens. This is different from the Autofocus Area, which is the area in the frame used to determine where you want the lens to focus.

When using either Single-shot or Continuous AF mode, you may select from three Autofocus Area options: Multi, Center, and Flexible Spot. Multi puts most of the control in the hands of the camera; the camera determines what to focus on based on the prominent subject matter in the frame. Center allows you to place focus on whatever is in the center of the frame. Lastly, and my personal favorite, Flexible Spot allows you to manually select the point in the frame on which autofocus will engage.

SELECTING AND USING AN AUTOFOCUS AREA

1. Press the Fn button next to the shutter button.

2. Use your right thumb to click to the right on the Control wheel until Autofocus Area is highlighted. Select this function by pressing the center of the Control wheel.

3. Rotate the Control wheel to choose between Multi, Center, and Flexible Spot. Press the center of the Control wheel to choose one. If you choose Multi or Center, you are finished. If you choose Flexible Spot, complete steps 4 and 5.

4. Once you select Flexible Spot (**A**), use the Control wheel to place the small onscreen rectangle where you want to place the focus (**B**). Lock in your choice by pressing the center of the Control wheel.

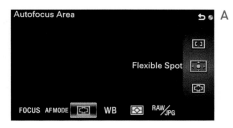

5. You can change your Flexible Spot focus area during shooting by pressing soft key B and then readjusting and selecting with the Control wheel.

Selecting the proper focus mode depends largely on what type of subject you are photographing. Single-shot is typically best for stationary subjects. It allows you to determine exactly where you want your focus to be and then recompose your image while holding the focus in place. If you are taking pictures of an active subject that is moving quickly, trying to set a focus point with Single-shot can be difficult, if not impossible. This is when you will want to rely on the Continuous AF mode to quickly assess the subject distance and set your lens focus.

MANUAL FOCUS FOR ANTICIPATED ACTION

While I utilize the automatic focus modes for the majority of my shooting, there are times when I like to fall back on manual focus. This is usually when I know when and where the action will occur and I want to capture the subject as it crosses a certain plane of focus. This is useful in sports like motocross or auto racing, where the subjects are on a defined track. By pre-focusing the camera, all I have to do is wait for the subject to approach my point of focus and then start firing the camera.

In **Figure 5.7**, I knew I wanted to get low and have the dirt bikes and riders fly past me with quite a bit of energy. However, tracking them with Continuous AF and maintaining this composition would have been difficult. To get my shot, I simply manually focused on the ground in front of the small gate the riders had to jump, recomposed, and waited for them to come into range. As they began their jump over the gate, I started shooting and captured them at the height of the action.

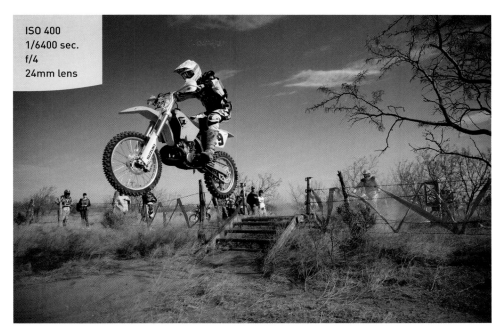

ISO 400
1/6400 sec.
f/4
24mm lens

DRIVE MODES

The drive mode determines how fast your camera will take pictures. Single shooting mode is for taking one photograph at a time; with every full press of the shutter, the camera will take a single image. Continuous shooting allows for a more rapid capture rate. Speed Priority Continuous shooting allows the camera to shoot ten frames a second. Think of it like a machine gun. When you are using one of the Continuous modes, the camera continues to take pictures as long as the shutter release button is held down (or until the memory buffer fills up).

KEEPING UP WITH CONTINUOUS SHOOTING MODE

Getting great focus is one thing, but capturing the best moment on the sensor can be difficult if you are shooting just one frame at a time. In the world of sports, and in life in general, things move pretty fast. If you blink, you might miss it. The same can be said for shooting in Single shooting drive mode. Fortunately, your NEX-6 comes equipped with a Continuous shooting—or "burst"—mode that lets you capture a series of images at up to ten frames a second (**Figure 5.8**).

FIGURE 5.8
Using the
Continuous drive
mode means that
you are sure to
capture the peak
of the action.

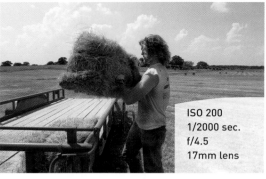

ISO 200
1/2000 sec.
f/4.5
17mm lens

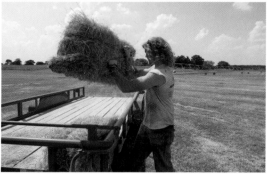

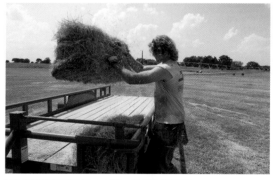

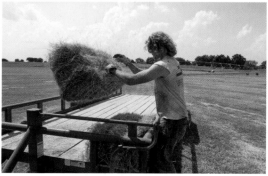

1. Press the left side of the Control wheel.

2. Rotate the Control wheel to select the desired mode. The icon that looks like stacked-up little rectangles is Continuous shooting mode (**A**). The icon that looks the same but with an S in the middle of the stack is the Speed Priority Continuous shooting mode, which allows for even faster bursts. Press the middle of the Control wheel (soft key C) to lock in your change.

3. To shoot, just depress the shutter button and hold until the desired number of frames has been captured.

Your camera has an internal memory, called a "buffer," where images are stored while they are being processed prior to being moved to your memory card. If the buffer fills up (this is more likely when you are shooting in the RAW or RAW+JPEG format), the camera will stop shooting until space is made in the buffer for new images.

A SENSE OF MOTION

Shooting action isn't always about freezing the action. There are times when you want to convey a sense of motion so the viewer can get a feel for the movement and flow of an event. Two techniques you can use to achieve this effect are panning and motion blur.

PANNING

Panning has been used for decades to capture the speed of an object as it moves across the frame. It doesn't work well for subjects that are moving toward or away from you. Panning is achieved by following your subject across your frame, moving your camera along with the subject, and using a slower-than-normal shutter speed so that the background (and sometimes even a bit of the subject) has a sideways blur but the main portion of your subject is sharp and blur-free. The key to a great panning shot is selecting the right shutter speed: Too fast and you won't get the desired blurring of the background; too slow and the subject will have too much blur and will not be recognizable. Practice the technique until you can achieve a smooth

camera motion that follows along with your subject. The other thing to remember when panning is to follow through even after the shutter has closed. This will keep the motion smooth and give you better images.

In **Figure 5.9**, I used the panning technique to follow this classic convertible as it drove past me. I set the camera drive mode to Continuous shooting, and I used S mode to select a shutter speed of 1/40 of a second while the focus mode was on Continuous.

FIGURE 5.9
Following the subject as it moves across the field of view allows for a slower shutter speed and adds a sense of motion to the shot.

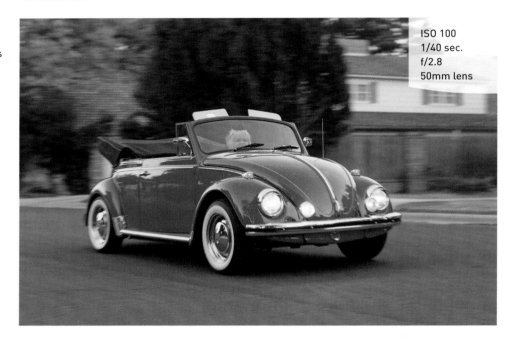

ISO 100
1/40 sec.
f/2.8
50mm lens

MOTION BLUR

Another way to let the viewer in on the feel of the action is to simply include some blur in the image. This isn't accidental blur from choosing the wrong shutter speed. This blur is more exaggerated, and it tells a story. In **Figure 5.10**, I was interested in capturing the movement of the martial arts expert's sword as he ran through various forms. A fast shutter speed would have surely frozen the action, but it would not have told the story of the movement. Instead, I used a slower shutter speed and a flash to help reflect some of the motion of the ancient weapon.

Just as in panning, there is no preordained shutter speed to use for this effect. It is simply a matter of trial and error until you have a look that conveys the action. I usually try to freeze some area of the subject. The key to this technique is the correct shutter speed combined with keeping the camera still during the exposure. You are trying to capture the motion of the subject, not the photographer or the camera, so use a good shooting stance or even a tripod.

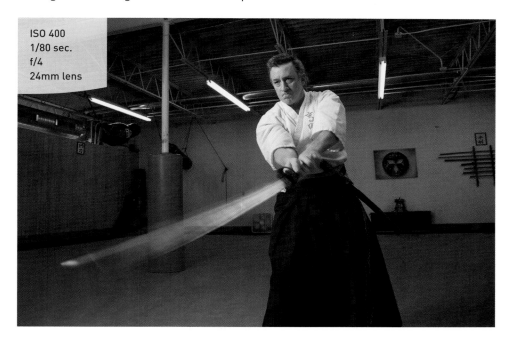

ISO 400
1/80 sec.
f/4
24mm lens

FIGURE 5.10
The movement of the sword was faster than the shutter speed could freeze, helping to convey the action.

TIPS FOR SHOOTING ACTION

GIVE THEM SOMEWHERE TO GO

Whether you are shooting something as simple as your child's soccer match or as complex as the wild motion of a bucking bronco, where you place the subject in the frame is just as important as how well you expose the image. A poorly composed shot can completely ruin a great moment by not holding the viewer's attention.

The one mistake I see many times in action photography is that the photographer doesn't use the frame properly. If you are dealing with a subject that is moving horizontally across your field of view, give the subject somewhere to go by placing them to the side of the frame, with their motion leading toward the middle of the frame (**Figure 5.11**). This offsetting of the subject will introduce a sense of direction and anticipation for the viewer. Unless you are going to completely fill the image with the action, try to avoid placing your subject in the middle of the frame.

FIGURE 5.11
Try to leave space in front of your subject to lead the action in a direction.

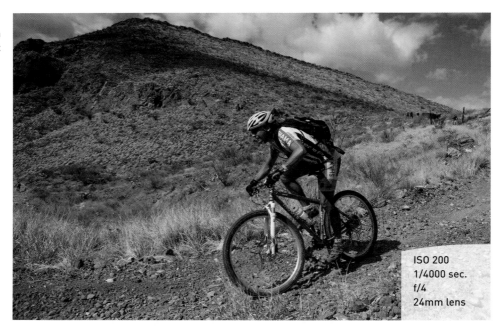

ISO 200
1/4000 sec.
f/4
24mm lens

GET IN FRONT OF THE ACTION

Here's another one. When shooting action, show the action coming toward you (**Figure 5.12**). Don't shoot the action going away from you. People want to see faces.

Faces convey the action, the drive, the sense of urgency, and the emotion of the moment. So if you are shooting action involving people, always position yourself so that the action is coming at you or is at least perpendicular to your position.

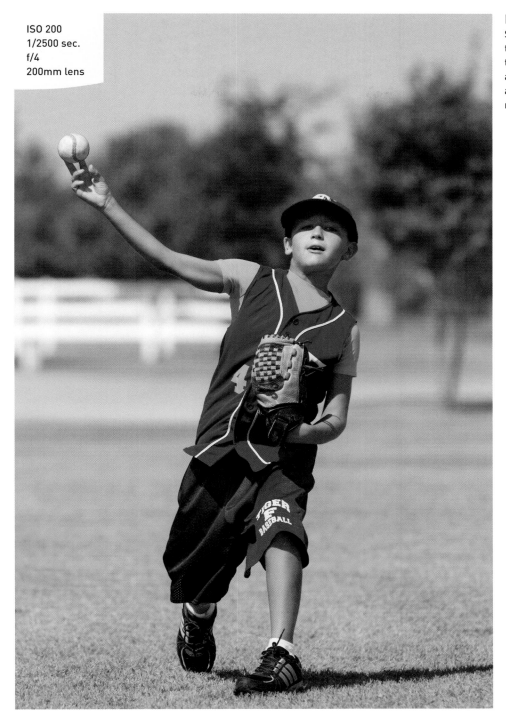

ISO 200
1/2500 sec.
f/4
200mm lens

FIGURE 5.12
Shooting from
the front with a
telephoto lens gives
a feeling that the
action is coming
right at you.

Chapter 5 Assignments

The mechanics of motion

For this first assignment, you need to find some action. Explore the relationship between the speed of an object and its direction of travel. Use the same shutter speed to record your subject moving toward you and across your view. Notice the difference made by the direction of travel.

Wide vs. telephoto

Just as with the first assignment, photograph a subject moving in different directions, but this time, use a wide-angle lens and then a telephoto (or at least a standard zoom lens that zooms from a relatively wide angle to a more telephoto position). Check out how the telephoto setting on the zoom lens requires faster shutter speeds than the lens at its wide-angle setting.

Getting a feel for Continuous AF

We discussed the use of the NEX-6's primary autofocus mode for action: Continuous AF. Find a moving subject and get familiar with the way the mode works. Use the Multi, Center, and Flexible Spot autofocus areas, and note the differences between them.

The point of the exercise is to become familiar enough with the Autofocus Area selection modes to decide which one to use for the situation you are photographing.

Anticipating the spot using manual focus

For this assignment, you will need to find a subject that you know will cross a specific line that you can pre-focus on. A street with moderate traffic works well for this. Focus on a spot on the street that the cars will travel across (don't forget to turn manual focus on). To do this right, you need to set the drive mode on the camera to Continuous or Speed Priority Continuous shooting mode. Now, when a car approaches the spot, start shooting. Try shooting in three- or four-frame bursts.

Following the action

Panning is a great way to show motion. To begin, find a subject that will move across your path at a steady speed, and practice following it in your viewfinder from side to side. Now, with the camera in S mode, set the shutter speed to 1/30 of a second and the focus mode to Continuous AF. Pan along with the subject and shoot as it moves across your view. Experiment with different shutter speeds and focal lengths. Panning takes some time to get a feel for, so try it with different types of subjects moving at different speeds.

Feeling the movement

Instead of panning with the motion, use a stationary camera position and adjust the shutter speed until you get a blurred effect that gives the sense of motion but still allows the subject to be identified. There is a big difference between a slightly blurred photo that looks like you picked the wrong shutter speed and one that looks intentional for the purpose of showing motion. As with panning, it will take some experimentation to find just the right shutter speed to achieve the desired effect.

Share your results with the book's Flickr group!

Join the group here: flickr.com/groups/sonynex6_fromsnapshotstogreatshots

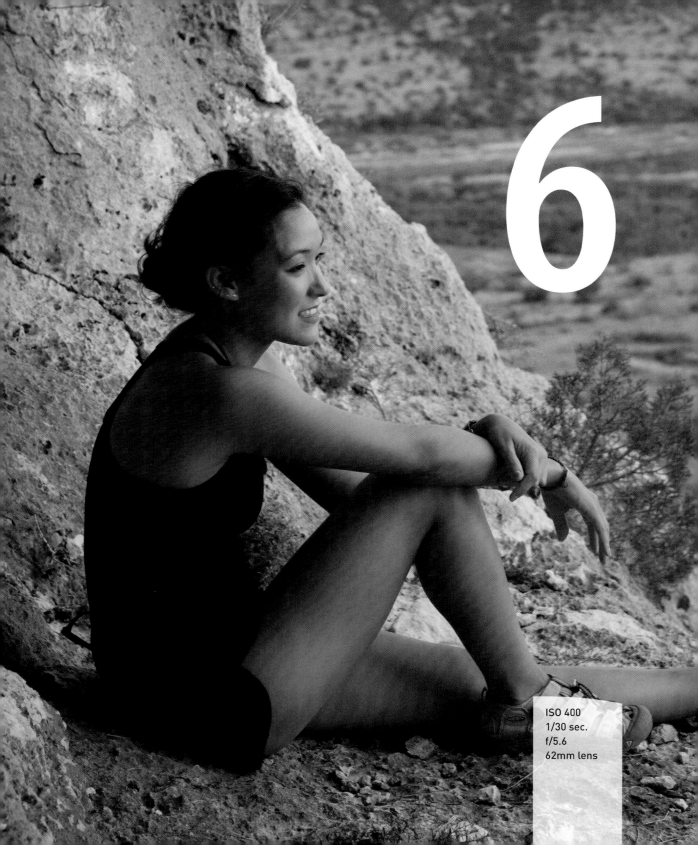

6

ISO 400
1/30 sec.
f/5.6
62mm lens

Say Cheese!

SETTINGS AND FEATURES TO MAKE GREAT PORTRAITS

Taking pictures of people is one of the great joys of photography. You will experience a great sense of accomplishment when you capture the spirit and personality of someone in a photograph. At the same time, you have a great responsibility because the person in front of the camera is depending on you to make them look good. You can't always change how someone looks, but you can control the way you photograph that individual. In this chapter, we will explore some camera features and techniques that can help you create great portraits.

PORING OVER THE PICTURE

I love environmental portraits. The settings are great for learning about your subjects, and they also provide a creative workout, especially when it comes to lighting. I made this portrait of my brother in a rural farm and ranch supply store—a location where you might find him working on a cold winter day. I placed him against a couple of tons of cattle feed and let the light from a large overhead door wash over him and naturally fall to shadow in the darkness of the barn. I love using this type of light for gritty portraits of working-people, and the grime on the dark walls in the background adds that much more to the story.

The wider focal length allows much of the subject's environment to appear, bringing another facet of his story "into the picture."

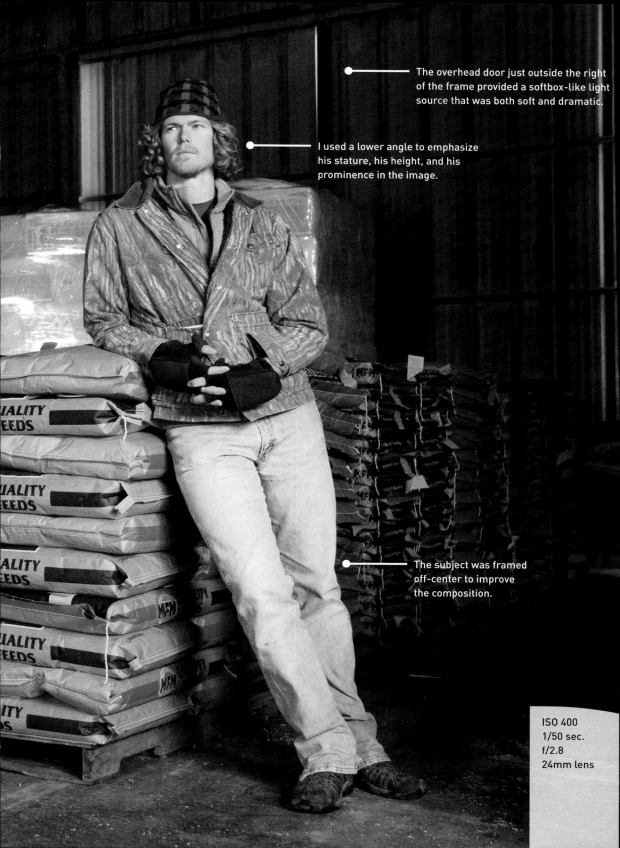

The overhead door just outside the right of the frame provided a softbox-like light source that was both soft and dramatic.

I used a lower angle to emphasize his stature, his height, and his prominence in the image.

The subject was framed off-center to improve the composition.

ISO 400
1/50 sec.
f/2.8
24mm lens

AUTOMATIC PORTRAIT MODE

In Chapter 3, we reviewed the automatic modes. One of the scene selections, Portrait, is dedicated to shooting portraits. While this is not my preferred camera setting, it is a great jumping-off point for those who are just starting out. The key to using this mode is to understand what is going on with the camera so that when you venture further into portrait photography, you can expand on the settings and get the most from your camera and, more importantly, your subject.

Whether you are photographing an individual or a group, the emphasis should always be on the subject. The Portrait scene selection utilizes a larger aperture setting to keep the depth of field very narrow, which means that the background will appear slightly blurred or out of focus. To take full advantage of this effect, use a medium- to telephoto-length lens (**Figure 6.1**). Also, keep a pretty close distance to your subject. If you shoot from too far away, the narrow depth of field will not be as effective.

FIGURE 6.1
Portrait mode works best when combined with a medium or long lens.

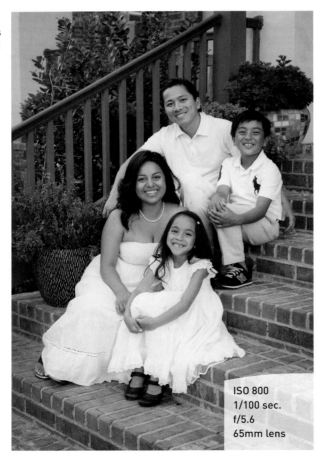

ISO 800
1/100 sec.
f/5.6
65mm lens

USING APERTURE PRIORITY MODE

If you took a poll of portrait photographers to see which shooting mode was most often used for portraits, the answer would certainly be Aperture Priority (A) mode. Selecting the right aperture is important for placing the most critically sharp area of the photo on your subject, while simultaneously blurring all of the distracting background clutter (**Figure 6.2**). Not only will a large aperture give the narrowest depth of field, it will also allow you to shoot in lower light levels at lower ISO settings. Fortunately, the NEX line of cameras has a wide array of E-mount lenses available, and adapters will let you take advantage of the Sony A-mount lenses as well. Between the two types of mounts, there is an entire world of lens choices, many with extremely large maximum apertures.

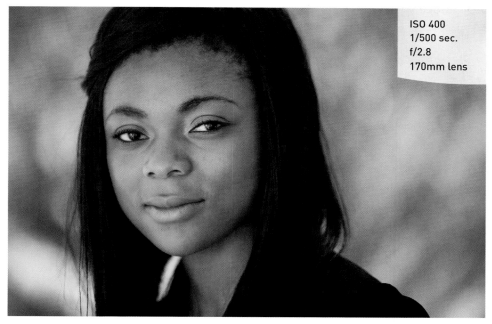

ISO 400
1/500 sec.
f/2.8
170mm lens

FIGURE 6.2
Using a wide aperture, especially with a longer lens, blurs distracting background details.

This isn't to say that you have to use the largest aperture on your lens. A good place to begin is f/5.6. This will give you enough depth of field to keep the entire face in focus, while providing enough blur to eliminate distractions in the background. This isn't a hard-and-fast setting; it's just a good all-around number to start with. Your aperture might change depending on the focal length of the lens you are using and on the amount of blur that you want for your foreground and background elements.

GO WIDE FOR ENVIRONMENTAL PORTRAITS

There will be times when your subject's environment is of great significance to the story you want to tell. This might mean using a smaller aperture to get more detail in the background or foreground. Once again, by using A mode you can set your aperture to a higher f-stop, such as f/8 or f/11, and include the important details of the scene that surrounds your subject.

Using a wider-than-normal lens can also assist in getting more depth of field as well as showing the surrounding area. A wide-angle lens requires less stopping down of the aperture to achieve an acceptable depth of field. This is because wide-angle lenses cover a greater area, so the depth of field appears to cover a greater percentage of the scene.

METERING BASICS

There are multiple metering modes in your camera, but the way they work is very similar. A light meter measures the amount of light being reflected off your subject and then renders a suggested exposure value based on the brightness of the subject and the ISO setting of the sensor. To establish this value, the meter averages all of the brightness values to come up with a middle tone, sometimes referred to as 18 percent gray. The exposure value is then rendered based on this middle gray value. This means that a white wall would be underexposed and a black wall would be overexposed in an effort to make each one appear gray. To assist with special lighting situations, the NEX-6 has three metering modes: Multi (**Figure 6.3**), which evaluates the entire frame in different segments before establishing an exposure; Center (**Figure 6.4**), which looks at the entire frame but places most of the exposure emphasis on the center of the frame; and Spot (**Figure 6.5**), which takes specific readings from a small area outlined in the center of the frame (often used with a gray card).

FIGURE 6.3
The Multi metering mode uses the entire frame.

FIGURE 6.4
The Center metering mode emphasizes the middle of the frame.

FIGURE 6.5
The Spot metering mode uses a very small area in the center of the frame.

A wider lens might also be necessary to relay more information about the subject's environment (**Figure 6.6**). Select a lens length that is wide enough to tell the story but not so wide that you distort the subject. There's nothing quite as unflattering as giving someone a big, distorted nose (unless you are going for that sort of look). When shooting a portrait with a wide-angle lens, keep the subject away from the edge of the frame. This will reduce the distortion, especially in very wide focal lengths. As the lens length increases, distortion will be reduced. I generally don't like to go wider than about 24mm for portraits. For standard portraits, I prefer focal lengths anywhere between 50mm and 135mm.

ISO 100
1/160 sec.
f/8
16mm lens

FIGURE 6.6
A wide-angle lens allows you to capture more of the environment in the scene without having to increase the distance between you and the subject, as in this shot of a water well engineer onsite in the Texas desert.

METERING MODES FOR PORTRAITS

For most portrait situations, the Multi metering mode is ideal. (For more on how metering works, see the "Metering Basics" sidebar.) This mode measures light values from all portions of the viewfinder and then establishes a proper exposure for the scene. The only time you might encounter a problem when using this metering mode is when you have very light or very dark backgrounds in your portrait shots.

In these instances, the meter might be fooled into using the wrong exposure information because it will be trying to lighten or darken the entire scene based on the prominence of dark or light areas (**Figure 6.7**). You can deal with this in one of two ways. You can use the Exposure Compensation feature, which we cover in Chapter 7, to dial in adjustments for over- and underexposure. Or you can change the metering mode from Multi to Center. The Center metering mode assesses the entire frame, but it places more emphasis on the center of the frame. This is the best way to achieve proper exposure for many portraits; metering off of skin tones, averaged with hair and clothing, will often give a more accurate exposure (**Figure 6.8**). This metering mode is also great to use when the subject is strongly backlit.

FIGURE 6.7
The dark background fooled the Multi metering mode into choosing a slightly overexposed setting.

ISO 400
1/50 sec.
f/2.8
24mm lens

FIGURE 6.8
With the Center metering mode, the camera shortens the exposure time based on the brighter values of the subject's skin and clothing.

ISO 400
1/80 sec.
f/2.8
24mm lens

SETTING YOUR METERING MODE TO CENTER METERING

1. Press the Fn button next to the shutter button.

2. Use the Control wheel to highlight and select Metering Mode (**A**).

3. Rotate the Control wheel to select Center (**B**).

4. Press the shutter button or the middle of the Control wheel (soft key C) to return to shooting mode.

USING THE AE LOCK FEATURE

There will often be times when your subject is not in the center of the frame but you still want to use the Center or Spot metering modes. So how can you get an accurate reading if the subject isn't in the center? Try using the AE (Auto Exposure) Lock feature to hold the exposure setting while you recompose.

AE Lock lets you use the exposure setting from any portion of the scene that you think is appropriate, and then lock that setting in regardless of how the scene looks when you recompose. An example of this would be when you're shooting a photograph of someone and a large amount of blue sky appears in the picture. Normally, the meter might be fooled by all that bright sky and try to reduce the exposure. Using AE Lock, you can establish the correct metering by zooming in on the subject (or even pointing the camera toward the ground), taking the meter reading and locking it in with AE Lock, and then recomposing and taking your photo with the locked-in exposure.

SHOOTING WITH THE AE LOCK FEATURE

1. Find the AEL button on the back of the camera and place your thumb on it.

2. While looking through the viewfinder, place the center focus point on your subject.

3. Press and hold the AEL button to get a meter reading. A star will appear in the bottom right of your viewfinder or LCD, letting you know that the exposure has been locked. Continue to hold the AEL button.

4. Recompose your shot, and then take the photo.

5. To take more than one photo without having to take another meter reading, just hold down the AEL button until you are done using the meter setting.

FOCUSING: THE EYES HAVE IT

It has been said that the eyes are the windows to the soul, and nothing could be truer when you are taking a photograph of someone (**Figure 6.9**). You could have the perfect composition and exposure, but if the eyes aren't sharp the entire image suffers. Although there are three different focusing modes to choose from on your NEX-6, as well as two different autofocus modes, for portrait work you can't beat Single-shot AF mode and Flexible Spot. Single-shot automatic focusing will establish a single focus for the lens and then hold it until you take the photograph; the other autofocusing mode, Continuous AF, continues focusing until the photograph is taken. Flexible Spot lets you place the focusing point right on your subject's eye and set that spot as the critical focus point. Using Single-shot AF mode lets you get that focus and recompose all in one motion.

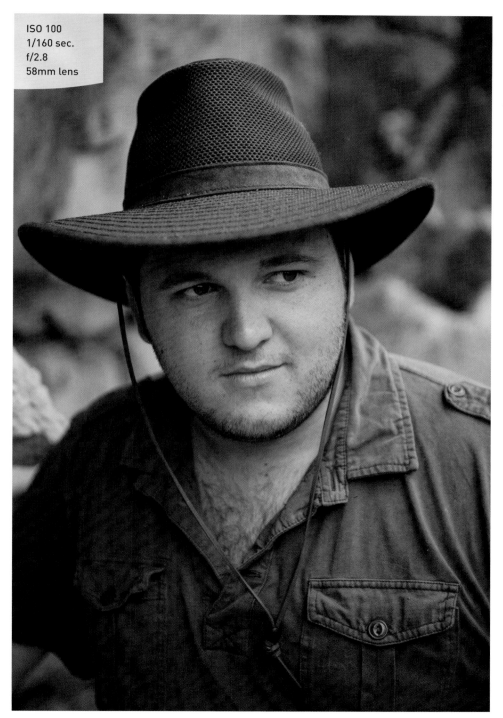

ISO 100
1/160 sec.
f/2.8
58mm lens

FIGURE 6.9
When photograph-
ing people, you
should almost
always place the
emphasis on
the eyes.

SETTING UP FOR SINGLE-SHOT AF FOCUSING MODE

1. To ensure that you are in autofocus, press the Fn button, highlight and select AF/MF Select, and then select Autofocus (AF).

2. Press the Fn button again (or, if you are using the viewfinder's display, simply click the right side of the Control wheel), and use the Control wheel to highlight and select Autofocus Mode.

3. Rotate the Control wheel to highlight and select Single-shot AF (**A**).

SETTING YOUR FOCUS TO FLEXIBLE SPOT

1. Press the Fn button next to the shutter button.

2. Click to the right on the Control wheel until Autofocus Area is highlighted, and select it.

3. Rotate the Control wheel to choose Flexible Spot.

4. A small rectangle will appear onscreen; use the Control wheel to place it where you want to autofocus. After you position the autofocus point, press the center of the Control wheel to make your selection.

5. To change your selection during shooting, press soft key B, readjust, and select your new focus area with the Control wheel.

To shoot using this flexible spot, place it on your subject's eye, and press the shutter button halfway until the focus point turns green and the camera beeps. While still holding the shutter button down halfway, recompose and take your shot.

CLASSIC BLACK AND WHITE PORTRAITS

There is something timeless about a black and white portrait. It eliminates the distraction of color and puts all the emphasis on the subject. To get great black and whites without having to resort to any image-processing software, set your creative style to Black & White (**Figure 6.10**). You should know that the creative styles are automatically applied when shooting with the JPEG file format. If you are shooting in RAW, the picture that shows up on your rear LCD display will look black and white, but it will appear as a color image when you open it in any RAW processing software that isn't proprietary to Sony. For example, if you are using Adobe Photoshop Lightroom

to edit and process your images, the RAW image will appear as an unaltered, color image; you will have to convert it to black and white using the software. However, if you are using Sony's Image Data Converter software, the software will read that you shot the image in the Black & White creative style. You can also change the creative style of a photo in the Sony software. So if you decide black and white isn't the route you want to go, just change the RAW file's creative style in the Sony software.

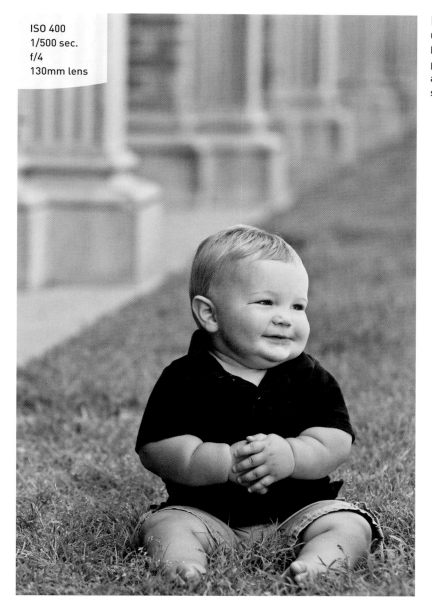

ISO 400
1/500 sec.
f/4
130mm lens

FIGURE 6.10
Getting high-quality black and white portraits is as simple as setting the creative style to Black & White.

The real key to using the Black & White creative style is to customize it for your portrait subject. The style can be changed to alter the contrast and sharpness. For women, children, puppies, and anyone else who should look somewhat soft, set the Sharpness setting to –1 or 0. For old cowboys, longshoremen, and anyone else you want to look really detailed, try a setting of 2 or 3. I like to leave Contrast at a setting of around –1 or 0. This gives me a nice range of tones throughout the image.

SETTING YOUR CREATIVE STYLE TO BLACK & WHITE

1. Start by pressing the Menu button.
2. Use the Control wheel to scroll to and select the Brightness/Color submenu.
3. Rotate the Control wheel to highlight and select Creative Style (**A**).
4. Rotate the Control wheel once more to highlight and select the Black & White (B/W) style (**B**). Lock it in by pressing the middle of the Control wheel (soft key C).

Your camera will continue to shoot with the Black & White creative style until you change it to another setting.

CUSTOMIZING THE CREATIVE STYLE SETTINGS

1. When you're in the Creative Style section of the menu where you have Black & White selected, press the Option button (soft key B) in the bottom right of your LCD.
2. Use the right and left side of the Control wheel to move between Contrast and Sharpness, highlighting the setting you would like to change.
3. Now click up or down on the Control wheel (or rotate it) to select a corresponding value for the highlighted setting (**C**).
4. Perform the same process for the other options, then press the Menu button to return to the regular menu screen. You can now start shooting with your new settings.

THE PORTRAIT CREATIVE STYLE FOR BETTER SKIN TONES

As long as we are talking about creative styles for portraits, there is another style on your NEX-6 that has been tuned specifically for this type of shooting. Oddly enough, it's called Portrait. To set this style on your camera, simply follow the same directions as earlier, except this time select the Portrait style instead of Black & White. There are also individual options for the Portrait style that, like the Black & White style, include sharpness and contrast. You can also change the saturation (how intense the colors will be). I'm cautious about over-saturating my images, particularly skin tones, so if I boost the saturation, I only push it to +1, leaving everything else at the defaults. You won't be able to use the same adjustments for everyone, so do some experimenting to see what works best.

USING FACE DETECTION AND REGISTRATION

Face detection in digital cameras has been around for a few years, and although it might not be the professional portrait photographer's go-to function, it does present a nice technology for those of us who want to bypass some of the more technical approaches to focusing our portraits. Your NEX-6 has two face detection modes: one for general face detection, and another for faces that you register with the camera. Both modes adjust focus and exposure for the detected face, but with Face Registration, you can program eight faces for the camera to prioritize. For the purposes of this book, I'll just explain how to set up standard face detection for your NEX-6. However, I do encourage you to experiment with Face Registration.

When you turn on Face Detection focusing, the camera does an amazing thing: It zeroes in on any face appearing on the LCD and places a box around it (**Figure 6.11**). I'm not sure how it works; it just does. Another great thing about Face Detection is that it doesn't slow down the autofocus function.

FIGURE 6.11
Face Detection
can lock in on your
subject's face for
easy focusing.

ISO 800
1/60 sec.
f/1.8
50mm lens

SETTING UP AND SHOOTING WITH FACE DETECTION FOCUSING

1. Before turning on Face Detection, you must first ensure that your camera's autofocus area is in Multi mode (see how to change your autofocus area in Chapter 5). Since Face Detection also determines exposure based on your subject's face, you must also have Multi metering enabled (see earlier this chapter for how to change metering modes).

2. Press the Menu button and use the Control wheel to highlight and select the Camera submenu.

3. Navigate to the Face Detection function and press soft key C to select (**A**).

4. Once in the Face Detection mode options, rotate the Control wheel until you highlight On (**B**). Select this option with soft key C, and return to shooting.

A

B

5. Point your camera at a person, and watch as a frame appears over the face in the LCD or in the electronic viewfinder.

6. Press and hold the shutter release button halfway to focus on the face, and wait until you hear the confirmation chirp.

7. Press the shutter button fully to take the photograph.

THE SMILE SHUTTER

One of the more fun face detection technologies you can enable with the NEX-6 is the Smile Shutter. It does exactly what it sounds like it does: When the camera detects your subject's smile, it automatically snaps a picture. It's not perfect, but neither is face detection in general. But when the Smile Shutter is turned on, it is relatively responsive to the pearly whites, even in low light. To enable the Smile Shutter, simply go to Menu › Camera › Smile Shutter › On. You even have the option of choosing whether the Smile Shutter will respond to a slight, normal, or big smile. Talk about relaxing behind the lens!

USE FILL FLASH FOR REDUCING SHADOWS

A common problem when taking pictures of people outside, especially during the midday hours, is that the overhead sun can create dark shadows under the eyes and chin. You could have your subject turn his or her face to the sun, but that is usually considered cruel and unusual punishment. So how can you have your subject's back to the sun and still get a decent exposure of the face? Try turning on your flash to fill in the shadows. This also works well when you are photographing someone who's wearing a ball cap or someone who has a bright scene behind them (**Figure 6.12**). The fill flash helps lighten the subject so they don't appear in shadow, while providing a really nice catchlight in the eyes (**Figure 6.13**).

FIGURE 6.12
I was photograph-
ing in a dark
restaurant, and
the bright lights on
the wall behind the
child were forcing
me to underexpose
his face.

ISO 3200
1/40 sec.
f/1.8
24mm lens

FIGURE 6.13
I enabled the
on-camera flash,
reduced its power
by one stop, and
filled in the dark,
detail-less areas of
his face.

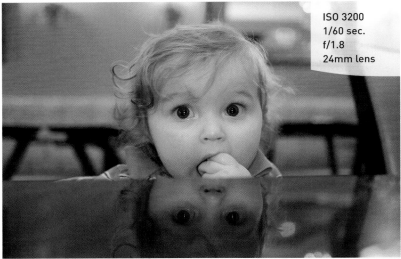

ISO 3200
1/60 sec.
f/1.8
24mm lens

CATCHLIGHT

A catchlight is that little sparkle that adds life to the eyes. When you are photographing a
person with a light source in front of them, you will usually get a reflection of that light
in the eye, be it your flash, the sun, or something else brightly reflecting in the eye. The
light is reflected off the surface of the eyes as bright highlights, which brings attention
to the eyes.

The key to using the flash as a fill is to not use it on full power. If you do, the camera will try to balance the flash with the daylight, and you will get a very flat and featureless face.

SETTING UP AND SHOOTING WITH FILL FLASH

1. Press the pop-up flash button on the back of the camera to raise your pop-up flash into the ready position.

2. Press the top of the Control wheel to change the LCD to the "For viewfinder" display. Using this display, press the Fn button and use the Control wheel to highlight and select Flash Mode (its icon looks like a lightning bolt) (**A**). Ensure that Fill-flash is selected (**B**), and press soft key C to lock it in and return to the LCD display.

3. Press the Fn button once more, and use the Control wheel to select the Flash Compensation function (it is the bottom portion of the meter you see displayed) (**C**).

4. Rotate the Control wheel to select the desired amount of flash compensation (**D**).

5. Press soft key C to confirm the selection and exit the Flash Compensation screen to begin shooting.

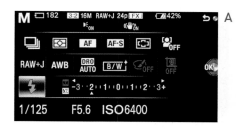

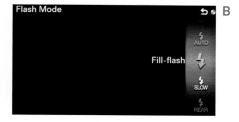

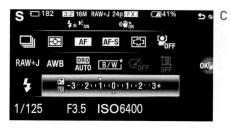

One problem that can quickly surface when using the on-camera flash is red-eye. Not to worry, though—we will talk about that in Chapter 8.

PORTRAITS ON THE MOVE

Not all portraits are shot with the subject sitting in a chair, posed and ready for the picture. Sometimes you might want to get an action shot that says something about the person, similar to an environmental portrait. Children, especially, just like to move. Why fight it? Set up an action portrait instead.

For the photo in **Figure 6.14**, I set my camera to Shutter Priority (S) mode. I wanted to photograph my niece with her new toy, and I knew there would be a good deal of sporadic movement involved. I wanted to make sure that I had a relatively high shutter speed to freeze the action, so I set it to 1/160 of a second. I used a continuous focus mode, set the drive mode to Continuous, and just started firing off shots as she operated the toy. As with most shoots that involve increased drive modes and continuous focusing, there were quite a few throwaway shots, but I was able to capture a few that exhibited her enjoying the ride.

FIGURE 6.14
Although the subject was not moving very fast, the key to this shot was using Shutter Priority mode to ensure that my shutter speed was fast enough for the toy's sporadic movement.

ISO 100
1/160 sec.
f/1.8
50mm lens

TIPS FOR SHOOTING BETTER PORTRAITS

Before we get to the assignments for this chapter, I thought it might be a good idea to leave you with a few extra portrait pointers that don't necessarily have anything specific to do with your camera. There are entire books that cover things like portrait lighting, posing, and so on, but here are a few pointers that will make your people pics look a lot better.

AVOID THE CENTER OF THE FRAME

This falls under the category of composition. Place your subject to the side of the frame (**Figure 6.15**)—it just looks more interesting than plunking them smack dab in the middle (**Figure 6.16**).

ISO 200
1/50 sec.
f/1.8
24mm lens

FIGURE 6.15
Placing the subject (a salsa company owner) off to one side allows the lines of the shelves to lead the viewer's eye to him.

ISO 200
1/50 sec.
f/1.8
24mm lens

FIGURE 6.16
Having the subject in the middle of the frame de-emphasizes the environment's lines and creates a distracting area around him.

CHOOSE THE RIGHT LENS

Choosing the correct lens can make a huge impact on your portraits. A wide-angle lens can distort the features of your subject, which can lead to an unflattering portrait (**Figure 6.17**). Select a longer focal length if you will be close to your subject (**Figure 6.18**).

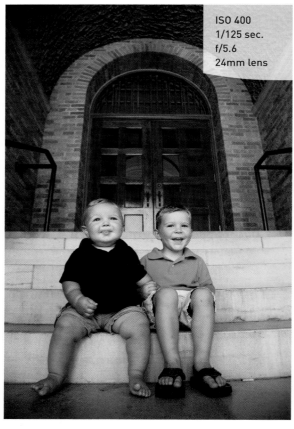

ISO 400
1/125 sec.
f/5.6
24mm lens

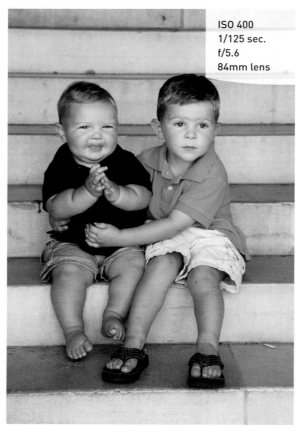

ISO 400
1/125 sec.
f/5.6
84mm lens

FIGURE 6.17
At this close distance and angle, the 24mm lens extends and enlarges the subjects' legs.

FIGURE 6.18
At 84mm, I was able to remove the distortion.

DON'T CUT THEM OFF AT THE KNEES

There is an old rule about photographing people: Never crop the picture at a joint. This means no cropping at the ankles or the knees. If you need to crop at the legs, the proper place to crop is mid-shin or mid-thigh (**Figure 6.19**).

USE THE FRAME

Have you ever noticed that most people are taller than they are wide? Turn your camera vertically for a more pleasing composition (**Figure 6.20**).

ISO 200
1/320 sec.
f/4.5
200mm lens

ISO 100
1/50 sec.
f/4
105mm lens

FIGURE 6.19
A good crop for people is at mid-thigh or mid-shin, even when they are sitting down.

FIGURE 6.20
Get in the habit of turning your camera to a vertical position when shooting portraits. This is also referred to as portrait orientation.

SUNBLOCK FOR PORTRAITS

The midday sun can be harsh and do unflattering things to people's faces (**Figure 6.21**). If you can, find a shady spot out of the direct sunlight, or block the sunlight with a diffuse material such as a white bed sheet. You will get softer shadows, smoother skin tones, and better detail (**Figure 6.22**). This holds true for overcast skies as well. Just be sure to adjust your white balance accordingly.

ISO 100
1/640 sec.
f/2.8
130mm lens

ISO 100
1/800 sec.
f/2.8
135mm lens

FIGURE 6.21
The bright, direct sunlight looks too harsh on the subject's face.

FIGURE 6.22
Using a 48-inch diffusion panel common in many photography reflector kits, I was able to reduce the intensity of the sunlight, as well as soften its resulting shadows.

FRAME THE SCENE

Using elements in the scene to create a frame around your subject is a great way to draw the viewer's eye to what is most important: your subject! You don't have to use a window frame to do this. Just look for elements in the environment's foreground and background that could be used to force the viewer's eye toward your subject (**Figure 6.23**).

GET DOWN ON THEIR LEVEL

If you want better pictures of children, don't shoot from an adult's eye level. Getting the camera down to the child's level will make your images look more personal (**Figure 6.24**).

ISO 800
1/20 sec.
f/5
24mm lens

ISO 100
1/640 sec.
f/1.8
50mm lens

FIGURE 6.23
The wine barrels in the background surround the winemaker, encouraging the viewer's eyes to move directly to him.

FIGURE 6.24
Whenever you are taking photographs of children, get your camera down on their level for a less imposing view.

DON'T BE AFRAID TO GET CLOSE

When you are taking someone's picture, don't be afraid of getting close and filling the frame (**Figure 6.25**). This doesn't mean you have to shoot from a foot away—try zooming in to capture the details.

TRY A LONG LENS FOR CANDID SHOTS

Putting a camera in someone's face can elicit unnatural results. People just feel a need to pose, or they get nervous and stiff. If you really want to capture some nice portraits with a more candid feel, try shooting with a long lens (**Figure 6.26**). The distance will remove you and your camera from the equation, and people will tend to react more normally. If you are looking to be a street photographer, a long lens will be one of your best tools.

ISO 400
1/320 sec.
f/2.8
200mm lens

ISO 200
1/1000 sec.
f/2.8
200mm lens

FIGURE 6.25
Filling the frame with the subject's face can lead to a much more intimate portrait.

FIGURE 6.26
Using a long lens can help you get more candid portraits.

Chapter 6 Assignments

Depth of field in portraits

Let's start with something simple. Grab your favorite person and start experimenting with using different aperture settings. Shoot wide open (the widest your lens goes, such as f/2.8 or f/3.5) and then really stopped down (like f/22). Look at the difference in the depth of field and how it plays an important role in placing the attention on your subject. (Make sure you don't have your subject standing against the background. Give some distance so that there is a good blurring effect of the background at the wide f-stop setting.)

Discovering the qualities of natural light

Pick a nice sunny day and try shooting some portraits in the midday sun. If your subject is willing, have them turn so the sun is in their face. If they are still speaking to you after blinding them, have them turn their back to the sun. Try this with and without the fill flash so you can see the difference. Finally, move them into a completely shaded spot and take a few more.

Picking the right metering method

Find a very dark or very light background and place your subject in front of it. Now take a couple of shots, giving a lot of space around your subject for the background to show. Now switch metering modes and use the AE Lock feature to get a more accurate reading of your subject. Notice the differences in exposure between the metering methods.

Creative styles for portraits

Have some fun playing with the different creative styles. Try the Portrait style as compared to the Standard style. Then try out Black & White and play with the different style options to see how they affect skin tones.

Share your results with the book's Flickr group!

Join the group here: flickr.com/groups/sonynex6_fromsnapshotstogreatshots

7

ISO 200
1/250 sec.
f/2.8
200mm lens

Landscape Photography

TIPS, TOOLS, AND TECHNIQUES TO GET THE MOST OUT OF YOUR LANDSCAPE PHOTOGRAPHY

Landscape photography was my first love as a student of photography. I grew up surrounded by the countryside, and it was natural that I steered toward this type of photography. Landscapes are a great learning ground for photographers, particularly in the areas of light and composition, and for those of us who enjoy spending time outdoors, there are few better ways to do so.

This chapter explores the functions of the NEX-6 that make landscape photography not only a possibility, but also an exciting and enjoyable venture. It also covers techniques that will improve your landscape photography.

PORING OVER THE PICTURE

This is a shot made in the Texas Hill Country along the Llano River near the small town of Mason. You can shoot this stretch of the river from early evening on into twilight. The water is shallow enough that you can navigate nimbly among its rapids, but deep enough in spots to exhibit glassy smoothness when shot with extremely slow shutter speeds.

I used a tripod so that my image would be extremely sharp.

A long shutter speed was used to achieve the silky look to the water, accentuating its flow down the Llano River.

The color in the sky came after the sun set below the horizon, which made for great reflections in the water.

A small aperture and wide-angle lens gives plenty of depth of field.

ISO 200
2 sec.
f/22
17mm lens

SHARP AND IN FOCUS: USING TRIPODS

Most photographers have a love-hate relationship with tripods. Hate in that they're often cumbersome and heavy. Even the ultra-light carbon fiber models can be laborious to handle. But I don't know a photographer out there who doesn't praise that pesky set of sticks when it saves the shot! A tripod is one of the best investments you can make for your photography, particularly if you are interested in landscapes.

The number one reason we use tripods is in order to use relatively slow shutter speeds. Landscape photography is often done at the beginning and end of the day and into the night. At these times, the light values, although extremely attractive, are very low. This forces you to shoot with a slower shutter speed. At the same time, landscape photographers often employ small apertures for greater depth of field, which also necessitates slower shutter speeds for proper exposures. A tripod is the best tool to have at hand in these situations (**Figure 7.1**).

FIGURE 7.1
A sturdy tripod is the key to sharp landscape photos. (Photo: Trace Thomas)

ISO 200
1/125 sec.
f/5.6
63mm lens

MINIMUM SUSTAINING SHUTTER SPEED

The rule of thumb known as minimum sustaining shutter speed gives a photographer an idea of when to place the camera on a tripod. It suggests that when your shutter speed numerically lines up with your focal length, it might be a good time to place the camera on a tripod instead of risking the camera shake that results from hand-holding. For example, if you are zoomed to 50mm on the NEX-6's kit lens and are shooting at or close to 1/50 of a second, place the camera on a tripod to ensure sharp imagery. Of course, the more you shoot and the more comfortable you become with handling the camera, the slower you might be able to shoot at any given focal length.

CHOOSING A TRIPOD

Tripods are seemingly as numerous as camera models, and because a tripod can potentially last you for years, it behooves you to do some shopping before settling on one. One characteristic to consider is the tripod's overall sturdiness. Like it or not, the heavier the sticks, the sturdier they are. Wind and water, two elements one often encounters when shooting landscapes, can be hazardous to the lighter (and sometimes cheaper) tripods. Also, consider a tripod that can extend to and beyond your eye level. This will save you from bending over all the time to compose and view your images, and it will allow you to shoot from a higher level with maximum stability. Finally, consider a tripod with a ball head; ball heads are fluid and quickly manipulated into just the right place. A ball head with a quick-release plate that attaches to the bottom of your NEX-6 may be beneficial. A quick-release plate will let you easily remove the camera from the tripod if you need to quickly grab a handheld shot.

TRIPOD STABILITY

Most tripods have a center column that allows the user to extend the height of the camera above the point where the tripod legs join together. This might seem like a great idea, but the reality is that the farther you raise that column, the less stable your tripod becomes. Think of a tall building that sways near the top. To get the most solid base for your camera, always try to use it with the center column at its lowest point so that your camera is right at the apex of the tripod legs.

OSS LENSES AND TRIPODS DON'T MIX

If you are using Optical SteadyShot (OSS) lenses on your camera, remember to turn this feature off when you use a tripod (**Figure 7.2**). This is because the stabilization technology can, while trying to minimize camera movement, actually create movement when the camera is already stable. To turn off the OSS feature, click Menu › Setup › SteadyShot › Off.

When shooting in Bulb for exposures longer than 30 seconds, the NEX-6 automatically turns off the OSS feature.

FIGURE 7.2
Turn off the OSS feature when using a tripod.

SELECTING THE PROPER ISO

One of the most important things you'll learn about landscape photography is to shoot with the lowest ISO possible. The lower the ISO, the better the quality of the image from a pixel point of view. And the higher the ISO, the more noise there will be in your image (**Figures 7.3** and **7.4**). Noise can detract from both the color quality and the finer details of an image. In landscape photography, you'll want to preserve these details as much as possible. Shooting with lower ISOs forces you to shoot at slower shutter speeds, particularly when you stop your aperture down to f/22 for maximum depth of field, but the finer quality of the images is the payoff (**Figures 7.5** and **7.6**).

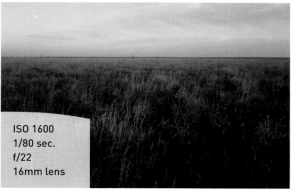

ISO 1600
1/80 sec.
f/22
16mm lens

FIGURE 7.3
A high ISO setting created a lot of digital noise in the shadows and muddied up the midtones, resulting in loss of detail in the golden grasses.

FIGURE 7.4
When the image is enlarged, the noise is even more apparent.

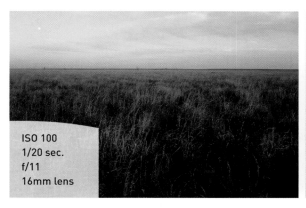

ISO 100
1/20 sec.
f/11
16mm lens

FIGURE 7.5
By lowering the ISO to 100, I was able to avoid the noise and capture a clean image.

FIGURE 7.6
Zooming in shows that the noise levels for this image are almost nonexistent.

Even with continual improvements to in-camera noise reduction, using the lowest ISO possible for landscape photography is ideal. With a good tripod in tow, you'll find little need to shoot above an ISO of 200 or 400. The majority of my landscape work is shot at no more than ISO 100.

USING NOISE REDUCTION

The temptation to use higher ISOs should always be avoided, as the end result will be more image noise and less detail. But low ISOs, although more attractive than high ISOs for landscape photography, are not without their share of noise. When shooting at shutter speeds over 1 second, even low ISOs can accumulate noise simply because of the extended length of time the sensor is activated. This type of noise, sometimes referred to as dark noise, is the result of the camera's sensor heating up during exposure. However, the NEX-6 can compensate for such noise using its noise reduction functionality.

SETTING UP HIGH ISO NOISE REDUCTION

1. Press the Menu button, use the Control wheel to select Setup, and scroll to and select High ISO NR (**A**).

2. The default setting is Normal, but if you desire less noise reduction, choose the Low setting (**B**).

SETTING UP LONG EXPOSURE NOISE REDUCTION

1. To reduce the amount of noise present in images shot with a 1-second or longer shutter speed, Long Exposure noise reduction comes in handy. In order to take advantage of this type of noise reduction, you must first ensure that your drive mode is set to Single shooting (discussed in Chapter 5).

2. After selecting the proper drive mode, press the Menu button to return to the main menu. Use the Control wheel to select Setup, and scroll to and select Long Exposure NR (**C**).

3. The default setting is On. If you know you are going to be making extremely long exposures, ensure that it is set before shooting.

SELECTING A WHITE BALANCE

White balance can be used in two distinct ways: to obtain as close to correct color as possible, or in a more interpretive manner. The NEX-6's preset white balances can be used in corresponding light conditions without any problem. If it's sunny outside, Daylight WB will work well, as will Cloudy WB if it is overcast. At the same time, though, there are no real rules about the use of white balance, and it's worth experimenting with how different iterations affect an image's personality. For instance, **Figure 7.7** was shot right before the sun rose above the horizon, so the light was extremely warm and orange. Daylight WB was used to ensure that those tones remained in the image. However, a simple move to Incandescent WB throws on a blue filter, and the same image now becomes cool in appearance and mood (**Figure 7.8**). This more interpretive approach to white balance can only be used with the knowledge of how different white balance settings affect various light conditions, so try them all out!

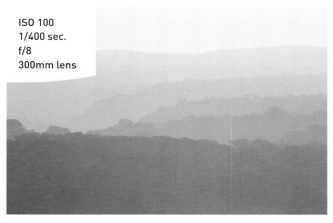

ISO 100
1/400 sec.
f/8
300mm lens

FIGURE 7.7
Using the "proper" white balance yields predictable results.

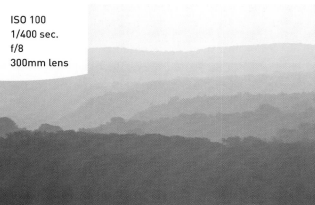

ISO 100
1/400 sec.
f/8
300mm lens

FIGURE 7.8
Changing the white balance to Incandescent gives the impression that the picture was taken at a different time of day than it really was.

You can select the most appropriate white balance for your shooting conditions in a couple of ways. The first is to just take a shot, review it on the LCD, and keep the one you like. Of course, you would need to take one for each white balance setting, which means that you would have to take 12 different shots to see which is most pleasing. The second method doesn't require taking a single shot. Instead, it uses the Live View display to get perfectly selected white balances. As you scroll through the white balance settings, they are displayed for you right on the LCD or the EVF. If you want to be even more precise, you can choose a custom setting that will let you dial in exactly the right look for your image.

USING THE LCD OR EVF TO PREVIEW WHITE BALANCE SETTINGS

1. To ensure that the Live View display is exhibiting the changes you want to see, select Menu > Setup > Live View Display > Setting Effect > ON.

2. Press the Fn button located to the right of the shutter release button.

3. Click either the right or left of the Control wheel to highlight the WB icon.

4. Press either up or down on the Control wheel to select the different white balance presets. You can also rotate the Control wheel to scroll through the settings. The image on the LCD or in the EVF will change to reflect the chosen white balance (keep in mind that the LCD will not project the changes, or the image for that matter, if it is set to the Viewfinder Only display setting).

5. Select the white balance setting that looks most appropriate for your scene, and press the middle button of the Control wheel.

USING THE LANDSCAPE CREATIVE STYLE

When I shoot landscapes on film, I'm continually drawn to using the types of film that accentuate those elements that are indicative of nature, such as color and structure. Films that provide a bit of saturation and contrast help bring out the colors that are enhanced by beautiful early-morning and late-evening light. Fortunately, we're able to achieve this type of effect with the Landscape creative style (**Figures 7.9** and **7.10**). This creative style increases the sharpness of the image, and it provides a saturation increase to the colors relevant to landscape photography, such as greens and blues. Using the Landscape creative style not only gives you that added boost for your images, it also saves you time in postproduction because you don't have to make some of those enhancements on the computer.

ISO 100
1/100 sec.
f/9
16mm lens

FIGURE 7.9
Using the Standard creative style, the colors are OK but don't really pop.

ISO 100
1/100 sec.
f/9
16mm lens

FIGURE 7.10
The Landscape creative style adds sharpness, a little contrast, and more vivid color to skies and vegetation.

1. Press the Menu button, then rotate the Control wheel to Brightness/Color.

2. Rotate to and select Creative Style (**A**).

3. Press up or down on the Control wheel to highlight the Landscape setting (**B**). Press the middle button of the Control wheel to make your selection.

If you are shooting RAW, your images will look like they have the creative style applied when you view them on the back of the camera, but the style will go away once you open the images in postprocessing software. Only JPEGs have the creative style applied as part of the final in-camera image processing.

TAMING BRIGHT AREAS WITH EXPOSURE COMPENSATION

Many landscape photographs are made in conditions that pit high-contrast highlights and darker tones against each other. Often, skies are intensely brighter, and if you are interested in gaining detail in the ground below, you run the risk of overexposing significant areas of the image. Other times, specific areas below the horizon might receive light while others lie in the shadows. For the most part, it is to your advantage to keep from overexposing any of these parts of the frame, especially clouds and running water. If this happens, all detail is lost in those "hot" areas and cannot be resurrected (**Figure 7.11**). The NEX-6's sensor can accommodate only a limited amount of contrast, and burning out skies or waterfalls typically occurs when you want to increase exposure in the land or darker areas of the landscape.

Fortunately, the NEX-6 can tell you when you are overexposing the highlights in an image. Using what's formally known as the Highlight Warning feature (and informally as "blinkies"), the LCD display will indicate which areas of the image are overexposed by blinking at you during image playback (see the "How I Shoot" section of Chapter 4). This blinking tells you that there is no detail in those areas, and you must decide whether those areas are important enough to the image to try to maintain. If you choose to save the detail in those areas, you must compensate for exposure.

The NEX-6's exposure compensation function allows you to dictate to your camera an automatic exposure adjustment of up to three stops under or over what it originally meters. This compensation occurs at 1/3-stop increments for nuanced and gentle image tuning (**Figure 7.12**).

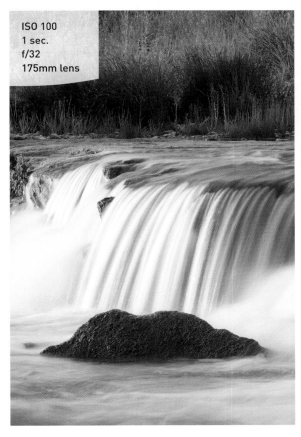

ISO 100
1 sec.
f/32
175mm lens

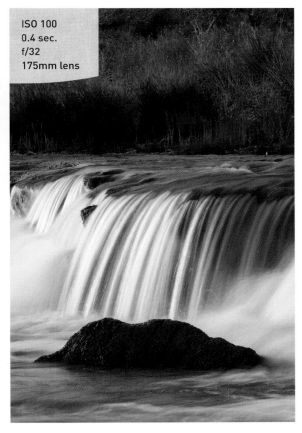

ISO 100
0.4 sec.
f/32
175mm lens

FIGURE 7.11
The camera has done a good job of exposing the foreground water and rock, but the waterfall is too bright and lacks detail.

FIGURE 7.12
A compensation of 1 1/3 stops of underexposure gave me the detail I was after in the waterfall without sacrificing detail in the rock and water below.

1. Activate the camera meter by lightly pressing the shutter release button.

2. Press the bottom portion of the Control wheel (just above the +/- icon) to bring the exposure compensation function onscreen.

3. Rotate the Control wheel to select the amount of over- or underexposure that you desire.

4. Take another photo.

5. If the blinkies are gone, you are good to go. If not, keep subtracting from or adding to your exposure by 1/3 of a stop until you have a good exposure in the highlights.

HIGH-KEY AND LOW-KEY IMAGES

When you hear someone refer to a subject as being high key, it usually means that the entire image is composed of a very bright subject with very few shadow areas—think snow or beach. It makes sense, then, that a low-key subject has very few highlight areas and a predominance of shadow areas. Think of a cityscape at night as an example of a low-key photo.

SHOOTING BEAUTIFUL BLACK AND WHITE LANDSCAPES

There is nothing as timeless as a beautiful black and white landscape photo. For many, it is the purest form of photography. The genre conjures up thoughts of Ansel Adams out in Yosemite Valley, capturing stunning monoliths with his 8x10 view camera. Well, just because you are shooting with a digital camera doesn't mean you can't create your own stunning photos using the power of the Black and White creative style. (See the "Classic Black and White Portraits" section of Chapter 6 for instructions on setting up this feature.)

Options in the Black and White creative style enable you to adjust the sharpness and contrast. I like to have Sharpness set to +1 and Contrast set to +1 for my landscape images. This gives an overall look to the image that is reminiscent of the classic black and white films (**Figure 7.13**). Experiment with the various settings to find the combination that is most pleasing to you.

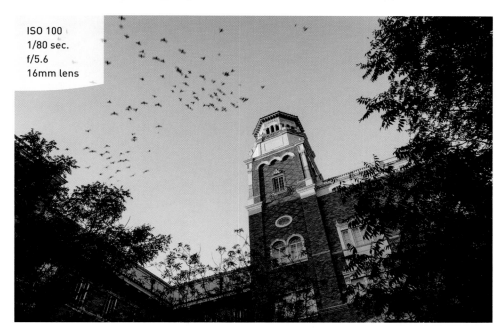

ISO 100
1/80 sec.
f/5.6
16mm lens

FIGURE 7.13
Just as in color photography, strong light, good composition, and compelling subject matter make for a nice image.

THE GOLDEN LIGHT

My favorite times to shoot landscapes are early in the morning and late in the evening, and I daresay that most photographers will tell you the same. The light from sunrise to about an hour afterward, as well as from an hour before sunset until the sun dips below the horizon, is the most used light in landscape photography. At these times, the sun is at an extreme angle to the earth, casting long, texture-creating shadows, and because of all the atmospheric debris it must pass through at these angles, the light is warm and it enhances existing color. At no other time of the day does the light act in such a way. It is compelling, dramatic, and, well, painterly (**Figures 7.14** and **7.15**).

FIGURE 7.14
The right subject can come alive with color during the first few minutes of sunrise. Light that bathes the land at an extreme angle produces texture through shadows and warm light.

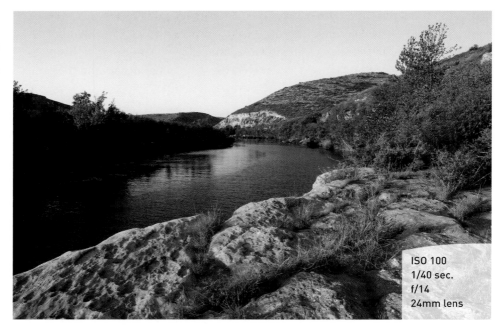

ISO 100
1/40 sec.
f/14
24mm lens

FIGURE 7.15
Late-evening sun is usually warmer and adds drama and warmth to the subject.

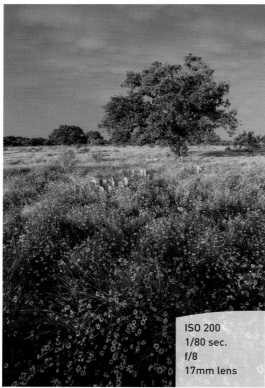

ISO 200
1/80 sec.
f/8
17mm lens

Interesting clouds in the sky also enhance landscapes at these times of day. Clear, or bald, skies are nice when shooting with golden light—point your camera to the north, and the sky becomes even more blue. However, clouds add structure to skies that sometimes have no appeal.

WARM AND COOL COLOR TEMPERATURES

These two terms are used to describe the overall color cast of an image. Reds and yellows are said to be warm, which is usually the look that you get from the late afternoon sun. Blue is usually the predominant color when talking about a cool cast.

SHOOTING COMPELLING SUNRISES AND SUNSETS

Whether you're shooting a golden sunset on top of a flat horizon or the reflections of the sky in a large body of water before the sun comes up over the horizon, there are a few things to keep in mind to make your sunrise and sunset photography even more exciting.

First, consider putting something in front of the sky, silhouetting it against the color. A tree, an iconic rock formation, or a tall cactus might serve the image well, bringing to the viewer one more area of visual interest (**Figure 7.16**). Be careful, though, not to crowd the scene with too many silhouettes—the idea here is simplicity in the foreground and an explosion of color in the background. With this in mind, it is also useful to keep the horizon line low in the frame to avoid including a large area of black space.

Second, look to the sky for structure. When the sun dips below the horizon enough to light the underside of nearby clouds, these wanderers of the sky often light up with color all their own. Clouds can break up the monotony of a bald sky and are frequently featured in exciting sunrise or sunset images (**Figure 7.17**).

Lastly, stay with the sky until the color is absolutely gone. Many an intriguing image is lost because the photographer lacked the patience to see the sky all the way through to nightfall. You never know when a wisp of clouds will suddenly appear in vibrant color against a deep blue sky. Don't get fatigued—stay with the sky and the light, and you might just come away with the next shot you hang up in your living room.

FIGURE 7.16
An ocotillo cactus stretches into the colorful sunset, adding an element of visual and compositional interest to the image.

ISO 200
1/160 sec.
f/4.5
24mm lens

FIGURE 7.17
Once the sun dips below the horizon, vibrant and powerful skies and clouds can make an otherwise mundane Rocky Mountain silhouette more exciting.

ISO 100
1/125 sec.
f/4
24mm lens

WHERE TO FOCUS

As with any type of photography, you can use various depths of field to shoot land-scapes. But if you are interested in those big, encompassing shots (as most landscape shooters are), you more than likely want everything in your shot to be in focus. From the foreground to points way off in the distance, all the details of the grand scene in front of you are tack sharp! But where do you focus in order to achieve this?

First you need to make sure you are set up to shoot the large landscape. To gain maximum depth of field and focus, it is typical to use your smallest aperture. For most wide and standard lenses, this is f/22. Lenses with longer focal lengths usually stop down an additional one or more stops, to around f/32 or f/45. Since a smaller aperture forces you to shoot with a slower shutter speed, you'll need to be set up on a sturdy tripod. The tripod allows you to concentrate on the other part of the formula: where to focus to achieve maximum depth of field. For this, you must utilize something called the "hyper focal distance" of your lens.

Hyper focal distance, also referred to as HFD, is the point of focus that will give you the greatest acceptable sharpness from a point near your camera all the way out to infinity. If you combine good HFD practice with a small aperture, you will get images that are sharp to infinity.

TACK SHARP

Here's one of those terms that photographers like to throw around. Tack sharp refers not only to the focus of an image but also to the overall sharpness of the image. This usually means that there is excellent depth of field in terms of sharp focus for all elements in the image. It also means that there is no sign of camera shake, which can give soft edges to subjects that should look nice and crisp. To get your images tack sharp, use a small depth of field, don't forget your tripod, use the self-timer to activate the shutter if no cable release is handy, and practice achieving good hyper focal distance when picking your point of focus.

After you have composed your shot, focus on an object that is about one-third of the distance into your frame (**Figure 7.18**). That's pretty much it. You'll most easily achieve this by focusing manually, which will allow you to be more exact with where you place the focus.

FIGURE 7.18

To get maximum focus from near to far, the focus was set one-third of the way into the image, on the first sloping ridge behind the boulder in the foreground. I then recomposed before taking the picture. Using this point of focus with an aperture of f/11 gave me an image that is sharply focused from the boulder to the distant plateaus.

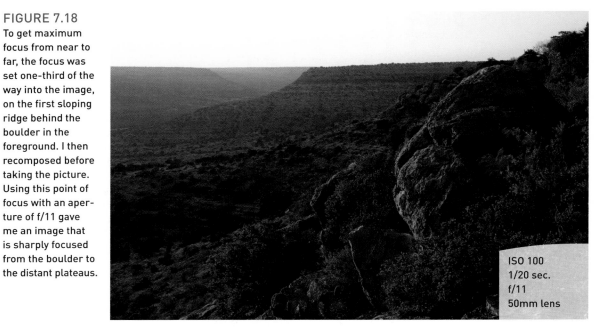

ISO 100
1/20 sec.
f/11
50mm lens

Both the LCD display and the EVF on the NEX-6 allow you to see your depth of field in real time as you adjust your aperture. This is a handy feature when you want to preview the amount of depth of field you will achieve.

Additionally, depth of field is inherently (more like physically) different for different types of lenses. Practically speaking, wider-angle lenses achieve greater depth of field compared to longer lenses. This, among other reasons, is why wide-angle lenses tend to be a part of the landscape photographer's kit. It is also why some photographers choose not to attempt hyper focal distance with telephoto lenses. At stopped-down apertures, longer lenses (even on a tripod) can sometimes render an image soft.

EASIER FOCUSING

There's no denying that the automatic focus features on the NEX-6 are great, but sometimes it just pays to turn them off and go manual. This is especially true when you are shooting on a tripod: Once you have your shot composed in the viewfinder and are ready to focus, chances are that the area you want to focus on is not going to be in the area of one of the focus points. Often this is the case when you have a foreground element that is fairly low in the frame. You could use a single focus point set low in your viewfinder and then pan the camera down until it rests on your

subject. But then you would have to press the shutter button halfway to focus the camera and then try to recompose and lock down the tripod. It's no easy task.

But you can have the best of both worlds by having the camera focus for you, then switching to manual focus to comfortably recompose your shot (**Figure 7.19**).

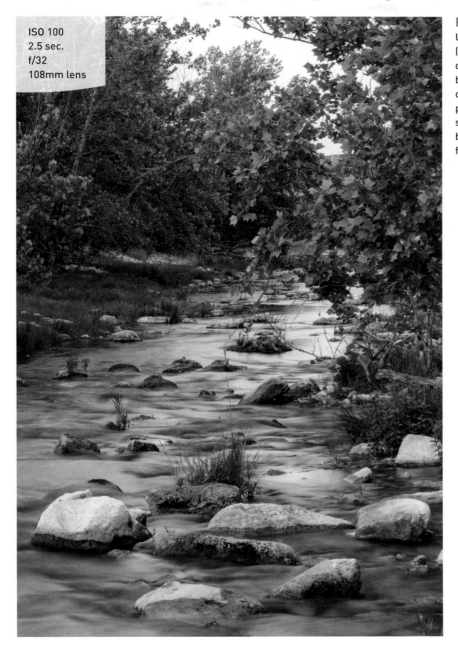

ISO 100
2.5 sec.
f/32
108mm lens

FIGURE 7.19
Using the hyper focal distance (HFD) one-third rule, I focused on the bunch of grass right behind the first grouping of large rocks in the lower portion of the image, then switched to manual focus before recomposing for the final shot.

1. Set up your shot and find the area that you want to focus on.

2. Pan your tripod head so that your active focus point is on that spot.

3. Press the shutter button halfway to focus the camera, and then remove your finger from the button.

4. Switch the camera to manual focus by pressing the Fn button next to the shutter button, navigating to FOCUS, and selecting MF (manual focus).

5. Recompose, and then take the shot.

The camera will fire without trying to refocus the lens. This works especially well for wide focal lengths, which can be difficult to focus in manual mode.

USING MANUAL FOCUS ASSIST

If you choose to manually focus, the Sony NEX-6 has a built-in feature that helps you achieve exact focus. Whether you have your eye to the electronic viewfinder or are using the LCD display to compose your scene, the MF Assist (manual focus assist) function will, once you start to make focus adjustments, digitally "zoom in" to the area on which you are placing focus so you can have greater control over where the plane of critical focus actually lands. Essentially, MF Assist is akin to placing a magnifying glass between the camera and subject so you can specifically adjust for exact focus. To turn on the MF Assist function, simply turn your camera's focus mode to MF, or manual focus. (MF Assist is a default function of the camera, but if you want to ensure that it is turned on, select Menu > Setup > MF Assist > On.)

MAKING WATER FLUID

There's nothing quite as satisfying for the landscape shooter as capturing a silky waterfall shot. Creating the smooth-flowing effect is as simple as adjusting your shutter speed to allow the water to be in motion while the shutter is open. The key is to have your camera on a stable platform (such as a tripod) so that you can use a shutter speed that's long enough to work (**Figure 7.20**). To achieve a great effect, use a shutter speed that is at least 1/15 of a second or longer.

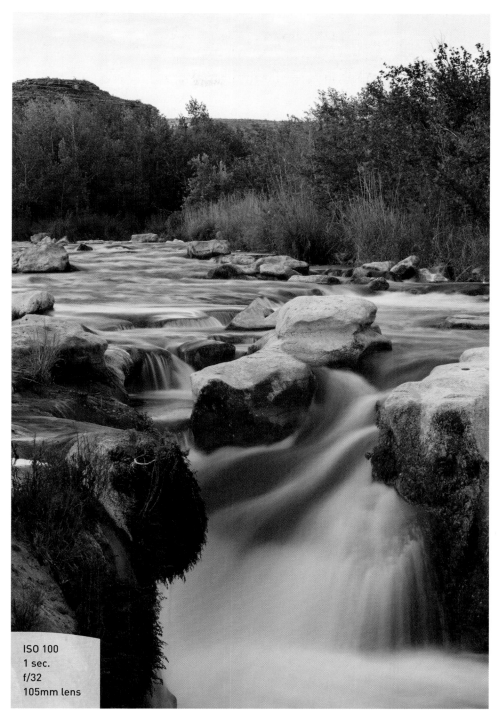

FIGURE 7.20
Using a tripod
combined with a
small aperture,
I was able to get
this 1-second
exposure and
make the water
look silky smooth.

ISO 100
1 sec.
f/32
105mm lens

SETTING UP FOR A WATERFALL OR RIVER SHOT

1. Attach the camera to your tripod, then compose and focus your shot.

2. For the best quality, make sure the ISO is set to 100.

3. Using Aperture Priority (A) mode, set your aperture to the smallest opening (such as f/22 or f/36).

4. Press the shutter button halfway so the camera takes a meter reading.

5. Check to see if the shutter speed is 1/15 of a second or slower.

6. Take a photo and then check the image on the LCD.

If the water is blinking on the LCD during playback, indicating a loss of detail in the highlights, then use exposure compensation (as discussed earlier in this chapter) to bring details back into the waterfall. In order to see the highlight warnings, or "blinkies," you will need to ensure that your playback display is set to Histogram mode (see "How I Shoot" in Chapter 4).

There is a possibility that you will not be able to use a shutter speed that is long enough to capture a smooth, silky effect, especially if you are shooting in bright daylight conditions. To overcome this obstacle, you need a filter for your lens—either a polarizing filter or a neutral density filter. The polarizing filter redirects wavelengths of light to create more vibrant and accurate colors, reduce reflections, and darken blue skies. It is a handy filter for landscape work. The neutral density filter is typically just a dark piece of glass that serves to darken the scene by one, two, three, or even ten stops. This allows you to use slower shutter speeds during bright conditions. Think of it as sunglasses for your camera lens.

DIRECTING THE VIEWER: A WORD ABOUT COMPOSITION

As a photographer, it's your job to lead the viewer through your image. You accomplish this by utilizing the principles of composition, which is the arrangement of elements in the scene that draws the viewer's eye through your image and holds their attention. As the director of this viewing, you need to understand how people see, and then use that information to focus their attention on the most important elements in your image.

There is a general order in which we look at elements in a photograph. The first is brightness. The eye wants to travel to the brightest object within a scene. So if you have a bright sky, it's probably the first place the eye will travel to. The second order of attention is sharpness. Sharp, detailed elements will get more attention than soft, blurry areas. Finally, the eye will move to vivid colors while leaving the dull, flat colors for last. It is important to know these essentials in order to grab—and keep—the viewer's attention and then direct them through the frame.

In **Figure 7.21**, the eye is drawn to the bright yellow Scottish gorse in the left third of the frame. From there, it is pulled toward the water pouring over the small waterfall. The eye then moves back into the canyon from which the water flows and then into the woods in the distance. The elements within the image all help to keep the eye moving but never leave the frame.

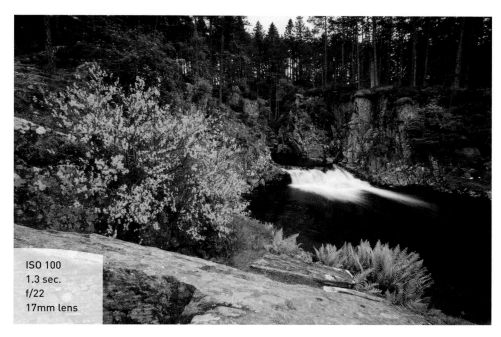

ISO 100
1.3 sec.
f/22
17mm lens

FIGURE 7.21
The composition of the elements pulls the viewer's eyes around the image, leading from one element to the next in a triangular pattern.

RULE OF THIRDS

There are, in fact, quite a few philosophies concerning composition. The easiest one to begin with is known as the "rule of thirds." Using this principle, you simply divide your viewfinder into thirds by imagining two horizontal and two vertical lines that divide the frame equally.

The key to using this method of composition is to have your main subject located at or near one of the intersecting points (**Figure 7.22**).

FIGURE 7.22
With the rule-of-thirds grid atop this image, you can see that I composed the shot so that the grasses peak near the upper-left intersection and that the horizon line is along the bottom third.

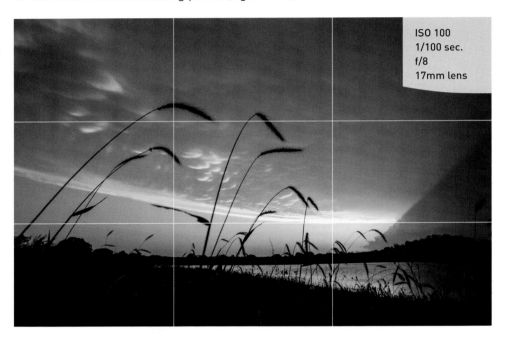

ISO 100
1/100 sec.
f/8
17mm lens

By placing your subject near these intersecting lines, you are giving the viewer space to move within the frame. The one thing you don't want to do is place your subject smack dab in the middle of the frame. This is sometimes referred to as "bull's eye" composition, and it requires the right subject matter for it to work. It's not always wrong, but it will usually be less appealing and may not hold the viewer's focus.

Speaking of the middle of the frame: The other general rule of thirds deals with horizon lines. Generally speaking, you should position the horizon one-third of the way up or down in the frame. Splitting the frame in half by placing your horizon in the middle of the picture is akin to placing the subject in the middle of the frame—it doesn't lend a sense of importance to either the sky or the ground, creating two equally competing areas of the image.

In **Figure 7.23**, I incorporated the rule of thirds by aligning my horizon in the top third of the frame, with the varying landscape textures occupying the bottom two-thirds. In doing so, I have created a sense of depth in the image. By selecting the right lens focal length (24mm, in this instance) and the right vantage point, I was able to place my horizon line so that it gives the greatest emphasis to the subject.

ISO 100
1/50 sec.
f/16
24mm lens

FIGURE 7.23
Placing the horizon of this image in the top third of the frame puts emphasis on the landscape below.

USING THE RULE-OF-THIRDS GRID

If you want additional help with composing along the rule of thirds, the NEX-6 has a built-in grid overlay function that divides the image into equal vertical and horizontal thirds. You can use it guide the placement of subject matter and horizons or simply to check your already composed image.

SETTING UP THE RULE-OF-THIRDS GRID

1. Press the Menu button, and use the Control wheel to rotate to and select Setup.
2. Under Shooting Settings, rotate the Control wheel to Grid Line. Select it by pressing the middle button of the Control wheel.
3. Select the Rule of 3rds Grid option.
4. Feel free to experiment using the other grid guides for more compositional exploration.

CREATING DEPTH

Because a photograph is a flat, two-dimensional space, you need to create a sense of depth by using the elements in the scene to create a three-dimensional feel. This is accomplished by including different and distinct spaces for the eye to travel: foreground, middle ground, and background. By using these three spaces, you draw the viewer in and render depth to your image.

The garden scene in northern Scotland shown in **Figure 7.24** illustrates this well. The large plants in the lower third of the shot strongly define the foreground area, the stone wall helps separate the large leafy plants from the middle ground (the walking garden), and the large trees in the upper third of the frame provide a great background that also contrasts in tone with the middle ground.

FIGURE 7.24
The leafy plants
and stone wall in
the foreground, the
walking garden in
the middle ground,
and the trees in the
background all add
to the feeling of
depth in the image.

ISO 200
1/60 sec.
f/8
105mm lens

SHOOTING PANORAMAS

If you have ever visited the Grand Canyon, you know just how large and wide open it truly is—so much so that it would be difficult to capture its splendor in just one frame. The same can be said for a mountain range or a cityscape or any extremely wide vista. There are two methods that you can use to capture the feeling of this type of scene.

THE "FAKE" PANORAMA

The first method is to shoot as wide as you can and then crop out the top and bottom portion of the frame. Panoramic images are generally two or three times wider than a normal image.

CREATING A FAKE PANORAMA

1. To create the look of a panorama, find your widest lens focal length. If you're using the kit lens that came with the NEX-6, it would be the 16mm setting on the 16–50mm lens.

2. Using the guidelines discussed earlier in the chapter, compose and focus your scene, and select the smallest aperture possible.

3. Shoot your image. That's all there is to it from a photography standpoint.

4. Then, open the image in your favorite image-processing software and crop the extraneous foreground and sky from the image, leaving you with a wide panorama of the scene. It is often useful to compose your shot with this final step in mind, knowing that you will crop out portions of the scene.

Figure 7.25 shows an example using a photo taken in "The Big Empty" portion of Texas's ranchland.

As you can see, the image was shot with a lot of headroom that is void of much structure. It looked like a good crop at the time, but after opening it in my postprocessing software I had second thoughts. I opened the Crop tool, took off the top two-thirds of the frame, and came up with a panorama that is much more dynamic and visually interesting (**Figure 7.26**).

ISO 100
1/250 sec.
f/5.6
108mm lens

FIGURE 7.25
This is a nice silhouette with some lingering detail in the foreground, but the sky is a bit empty.

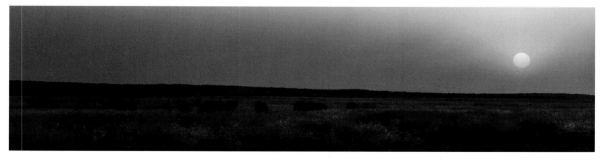

FIGURE 7.26
Cropping adds more immediate impact for both the sky and the grazing horses in the foreground, making for a more appealing image.

THE MULTIPLE-IMAGE PANORAMA

The reason the previous method is sometimes referred to as a "fake" panorama is because it is made with a standard-size frame and then cropped down to a narrow perspective. To shoot a true panorama, you need to use either a special panorama camera that shoots a very wide frame, or the following method, which requires the combining of multiple frames.

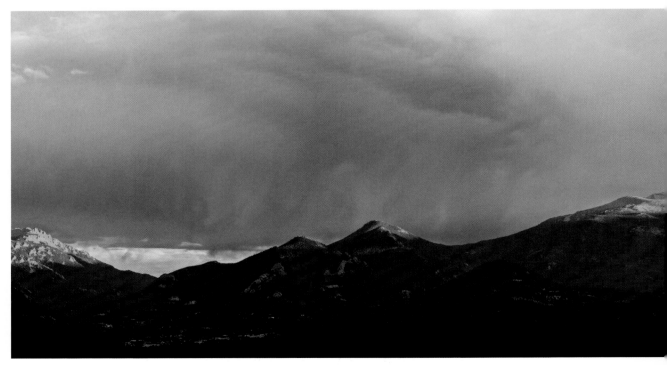

The multiple-image pano has gained in popularity in the past few years; this is principally because of advances in image-processing software. Many software options are available now that will take multiple images, align them, and then "stitch" them into a single panoramic image. The real key to shooting a multiple-image pano is to overlap your shots by about 30 percent from one frame to the next (**Figures 7.27** and **7.28**).

It is possible to handhold the camera while capturing your images, but the best method for capturing great panoramic images is to use a tripod.

ISO 100
1/60 sec.
f/5.6
105mm lens

FIGURE 7.27
Here you see the makings of a panorama, with ten shots overlapping by about 30 percent from frame to frame.

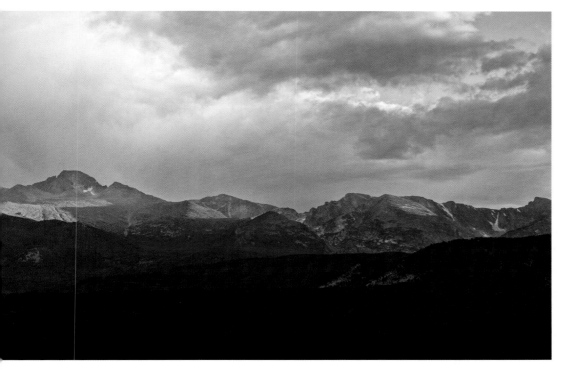

FIGURE 7.28
I used Adobe Photoshop to combine all of the exposures into one large panorama of a late evening rainstorm over Rocky Mountain National Park.

1. Mount your camera on your tripod and make sure it is level.

2. Choose a focal length for your lens that is, ideally, somewhere between 35mm and 50mm. (I used 105mm in Figure 7.27, which worked well, but a focal length similar to the perspective of the human eye is appropriate in most cases.)

3. In Aperture Priority (A) mode, use a very small aperture for the greatest depth of field. Take a meter reading of a bright part of the scene, and make note of it.

4. Now change your camera to Manual (M) mode, and dial in the aperture and shutter speed that you obtained in the previous step.

5. Set your lens to manual focus, and then focus your lens for the area of interest using the HFD method of finding a point one-third of the way into the scene. (If you use the autofocus, you risk getting different points of focus from image to image, which will make the image stitching more difficult for the software.)

6. While carefully panning your camera, shoot your images to cover the entire area of the scene from one end to the other, leaving a 30 percent overlap from one frame to the next.

Now that you have your series of overlapping images, you can import them into your image-processing software to stitch them together and create a single panoramic image.

SORTING YOUR SHOTS FOR THE MULTI-IMAGE PANORAMA

If you shoot more than one series of shots for your panoramas, it can sometimes be difficult to know when one series of images ends and the other begins. Here is a quick tip for separating your images.

Set up your camera using the steps listed here. Now, before you take your first good exposure in the series, hold up one finger in front of the camera and take a shot. Now move your hand away and begin taking your overlapping images. When you have taken your last shot, hold two fingers in front of the camera and take another shot.

Now, when you go to review your images, use the series of shots that falls between the frames with one and two fingers in them. Then just repeat the process for your next panorama series.

THE SWEEP PANORAMA

The Sony NEX-6 also includes its own panorama feature, and even through it takes a bit of control away from you during shooting, it serves as a great way to preview what your multiple-image panorama might look like. Depending on how well the

camera stitches the shots together, the resulting panorama might just be the one you like most. In a context with enough light, the sweep panorama also allows you to forgo the tripod because it provides you a visual guide on the LCD to follow while you are shooting. Simply turn the Mode dial to Sweep Panorama (the icon that looks like a concave rectangle), turn the Control dial to indicate which direction you want to pan, and while holding the shutter button down, pan the camera using the guide. The camera will then stitch all of the individual images together into one final image. Personally, this is not the method I prefer to shoot panoramas, but it is useful for previewing panoramas and for those in need of a quick shot.

Chapter 7 Assignments

We've covered a lot of ground in this chapter, so it's definitely time to put this knowledge to work in order to get familiar with these new camera settings and techniques.

Comparing depth of field: Wide-angle vs. telephoto

Practice using the hyper focal distance of your lens to maximize the depth of field. You can do this by picking a focal length to work with on your lens. If you have a zoom lens, try using the longest length. Compose your image and find an object to focus on. Set your aperture to f/22 and take a photo. Now do the same thing with the zoom lens at its widest focal length. Use the same aperture and focus point.

Review the images and compare the depth of field when using a wide-angle focal length as opposed to a telephoto focal length. Try this again with a large aperture as well.

Applying hyper focal distance to your landscapes

Pick a scene that has objects that are near the camera position as well as something that is clearly defined in the background. Try using a wide to medium-wide focal length for this (18–35mm). Use a small aperture and focus on the object in the foreground; then recompose and take a shot. Without moving the camera position, use the object in the background as your point of focus and take another shot. Finally, find a point that is one-third of the way into the frame from near to far and use that as the focus point. Compare all of the images to see which method delivered the greatest range of depth of field.

Using the rule-of-thirds grid guide

Using the rule-of-thirds grid, practice shooting while placing your main subject in one of the intersecting line locations. Then take some comparison shots with the same subject in the middle of the frame.

Share your results with the book's Flickr group!

Join the group here: flickr.com/groups/sonynex6_fromsnapshotstogreatshots

8

ISO 400
10 min 14 sec.
f/4
45mm lens

Mood Lighting

SHOOTING WHEN THE LIGHTS GET LOW

There is no reason to put your camera away when the sun goes down. Your NEX-6 has some great features that let you work with available light as well as with the built-in flash. In this chapter, we will explore ways to push your camera's technology to the limit in order to capture great photos in difficult lighting situations. We will also explore the use of flash and how best to utilize your built-in flash features to improve your photography. But let's first look at working with low-level available light.

A parking garage was recently constructed next to my city's crosstown highway, and it was open enough to position a camera on a tripod pointing west. Thirty minutes after sunset, I started shooting long exposures, which allowed me to balance the exposure of the headlights and streetlights with the saturated colors of the sky. From that point, I just kept extending my shutter speed times to achieve the exposure I wanted while extending the length of the light trails in the foreground.

To help minimize camera shake, I used a 2-second self-timer to activate the shutter.

ISO 100
4 sec.
f/6.3
16mm lens

I set the white balance to Daylight to maintain the warmth of the reds but also emphasize the blues in the sky.

The camera was secured to a tripod to keep it from moving during the long exposure.

I composed the shot so that the light trails would sweep the viewer past the Raider Park sign and through the image to the horizon.

RAIDER PARK

17 FT 4 IN

RAISING THE ISO: THE SIMPLE SOLUTION

Let's begin with the obvious way to keep shooting when the lights get low: raising the ISO (**Figure 8.1**). By now you know how to change the ISO: Just press the right side of the Control wheel and rotate it to adjust. In typical shooting situations, you should keep the ISO in the 100–800 range. This will keep your pictures nice and clean by keeping the digital noise to a minimum. As the available light gets low, however, you might find yourself working in the higher ranges of the ISO scale, which could lead to more noise in your image.

FIGURE 8.1
The light inside this mosque-turned-cathedral in Cordoba, Spain, was low enough that I had to raise my ISO considerably to get the shot without using a flash.

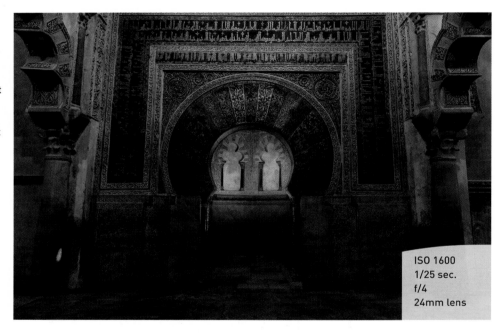

ISO 1600
1/25 sec.
f/4
24mm lens

You could use the flash, but that has a limited range (15–20 feet at higher ISOs, much shorter at lower ISOs) that might not work for you. Also, you could be in a situation where flash is prohibited or at least frowned upon, like at a wedding or in a museum.

And what about a tripod in combination with a long shutter speed? That is also an option, and we'll cover it a little further into the chapter. The problem with using a tripod and a slow shutter speed in low-light photography, though, is that it performs best when subjects aren't moving. Besides, try to set up a tripod in a cathedral and see how quickly you grab the attention of the security guards.

So if the only choice to get the shot is to raise the ISO to 800 or higher, make sure that you turn on the High ISO Noise Reduction feature. This menu function has two levels:

Low and Normal. As you start using higher ISO values, it is in your favor to leave it at the default, Normal. (See Chapter 7 for setting the noise reduction features.)

To see the effect of High ISO NR, you need to zoom in and take a closer look (**Figures 8.2** and **8.3**).

ISO 3200
1/80 sec.
f/1.8
24mm lens

ISO 3200
1/80 sec.
f/1.8
24mm lens

FIGURE 8.2
(left) Here is an enlargement of a shot of hot and sour soup without any noise reduction.

FIGURE 8.3
(right) Here is the same soup with noise reduction set to Normal. The noise has been reduced in the shadows and in the soup itself.

Using High ISO NR slightly increases the processing time for your images, so if you are shooting in the Continuous drive mode, you might see a small reduction in the speed of your frames per second.

NOISE REDUCTION SAVES SPACE

When shooting at very high ISO settings, running High ISO NR at the Low or Normal setting can save you space on your memory card. If you are saving your photos as JPEGs, the camera will compress the information in the image to take up less space. When you have excessive noise, you can literally add megabytes to the file size. This is because the camera has to deal with more information: It views the noise in the image as photo information and, therefore, tries not to lose that information during the compression process. That means more noise equals bigger files. So not only will turning on the High ISO NR feature improve the look of your image, it will also save you some space so you can take a few more shots.

USING VERY HIGH ISOS

The NEX-6 is capable of reaching ISO 25600, in one-stop increments from ISO 100. Photographers often joke that ISOs above 6400 help you see in the dark. This isn't too far from the truth!

A word of warning about using extremely high ISOs: Although it is great to have high ISO settings available during low-light shooting, they should always be your last resort. Even with the High ISO NR turned on, the amount of visible noise will be extremely high. I can't think of a situation where I ever needed to use ISO 25600, but you might find yourself in an environment—such as a nighttime sporting event or a dark restaurant—that would require an ISO of 3200 or 6400 to improve your shutter speeds and capture the action (**Figure 8.4**).

FIGURE 8.4
Ninetieth birthdays are certainly worth documenting, but sometimes doing so requires you to boost your ISO because of a low-light environment. I used a very wide aperture *and* ISO 3200 in this dark restaurant.

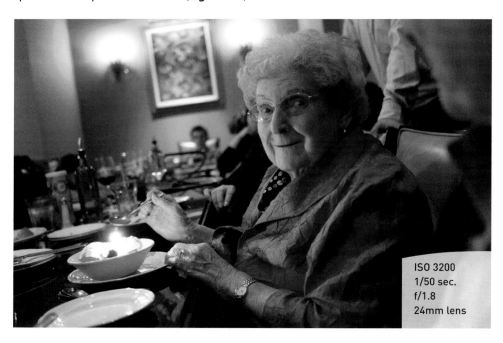

ISO 3200
1/50 sec.
f/1.8
24mm lens

STABILIZING THE SITUATION

If you purchased your camera with a lens that uses Optical SteadyShot (OSS) technology, you already own a great tool to squeeze two to four stops (I would err on the lower side) of exposure out of your camera when shooting without a tripod (**Figure 8.5**). Typically, the average person can handhold their camera down to about 1/60 of a second before blurriness results due to hand shake. As the length of the lens is increased (or zoomed), the ability to handhold at slow shutter speeds (1/60 and slower) and still get sharp images is further reduced.

FIGURE 8.5
Set the SteadyShot feature to On when using longer shutter speeds and hand-holding your camera.

The SteadyShot technology corrects for camera shake and stabilizes the image. It is so good that it is possible to improve your handheld photography by two, three, or four stops, meaning that if you are pretty solid at a shutter speed of 1/60, SteadyShot lets you shoot at 1/15 and possibly even 1/8 or 1/4 of a second (**Figures 8.6** and **8.7**). But know that shooting any lens, even extremely wide-angle lenses, at slower than 1/15 of a second can be hazardous to the image's focus.

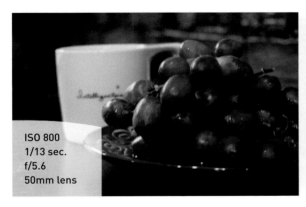

ISO 800
1/13 sec.
f/5.6
50mm lens

FIGURE 8.6
This image was shot handheld with SteadyShot turned off.

FIGURE 8.7
Here is the same subject shot with the same settings, but this time with SteadyShot turned on.

Even though image-stabilizing technology like OSS is extremely helpful for shooting in low-light situations, it is still important to continually apply proper shooting technique to bolster your own stability (see Chapter 1 for a more specific look at camera-stabilizing posture).

FOCUSING IN LOW LIGHT

The NEX-6 has a great focusing system, but occasionally the light levels might be too low for the camera to achieve an accurate focus. There are a few things that you can do to overcome this obstacle.

First, you should know that the camera utilizes contrast to establish a point of focus. This is why your camera will not be able to focus when you point it at a white wall or a cloudless sky; it simply can't find any contrast in the scene to work with. These conditions even limit the phase-detection AF capabilities discussed in Chapter 5. Knowing this, you might be able to use a Flexible Spot focus point in Single-shot AF mode to find an area of contrast that is at the same distance as your subject. You can then hold that focus by holding down the shutter button halfway and recomposing your image.

Then there are those times when there just isn't anything there for you to focus on. A perfect example of this would be a fireworks display. If you point your lens to the night sky in any automatic focus (AF) mode, it will just keep searching for—and not finding—a focus point. On these occasions, you can turn off the autofocus feature and manually focus the lens (**Figure 8.8**). Simply push the Fn button, highlight the AF/MF Select option, and rotate the Control wheel to Manual Focus mode.

Don't forget to put it back in AF mode at the end of your shoot.

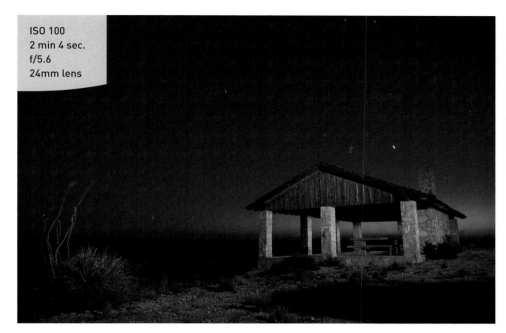

ISO 100
2 min 4 sec.
f/5.6
24mm lens

FIGURE 8.8
Focusing on the night sky, and in extremely dark environments in general, is best done in manual focus mode. Be sure to get on location early to pre-focus.

AUTOFOCUS ILLUMINATOR

Another way to ensure good focus is to enable the NEX-6's AF Illuminator. The AF Illuminator uses a small reddish-orange LED light near the shutter button to shine some light on the scene, which assists the autofocus system in locating more detail. The AF Illuminator should be enabled by default, but you can check the menu just to make sure.

ACTIVATING THE AF ILLUMINATOR

1. Press the Menu button, rotate the Control wheel to Setup, and select it.

2. Rotate the Control wheel until you highlight AF Illuminator, and select it.

3. Select Auto if it is not already enabled. Depress the shutter button halfway to exit the menu once you've made your selection. Now whenever the lighting is too low for the camera to grab focus, it will use the AF illuminator.

SHOOTING LONG EXPOSURES

We have covered some of the techniques for shooting in low light, so let's go through the process of capturing a night or low-light scene for maximum image quality (**Figure 8.9**). The first thing to consider is that in order to shoot in low light with a low ISO, you will need to use shutter speeds that are longer than you could possibly handhold (longer than 1/15 of a second). This will require the use of a tripod or stable surface for you to place your camera on. For maximum quality, the ISO should be low—somewhere at or below 400. The Long Exposure noise reduction should be turned on to minimize the effects of exposing for longer durations. (To set this up, see Chapter 7.)

Once you have the noise reduction turned on, set your camera to Aperture Priority (A) mode. That way, you can concentrate on the aperture that you believe is most appropriate and let the camera determine the best shutter speed. If it is too dark for the autofocus to function properly, try manually focusing. Finally, consider using a remote commander (see the bonus chapter "Pimp My Ride") to activate the shutter. If you don't have one, use the self-timer function described in Chapter 3 to trip the shutter while not incurring any camera shake. Once you shoot the image, you may notice some lag time before it is displayed on the rear LCD. This is due to the noise reduction process, which can take anywhere from a fraction of a second up to 30 seconds, depending on the length of the exposure.

FIGURE 8.9
A long exposure and a tripod were necessary to capture this twilight photo of a cotton gin that operates 24 hours a day in Idalou, Texas.

ISO 100
2 sec.
f/5
30mm lens

The basic idea behind the term *flash synchronization* (*flash sync* for short) is that when you take a photograph using the flash, the camera needs to ensure that the shutter is fully open at the time that the flash goes off. This is not an issue if you are using a long shutter speed such as 1/15 of a second but does become more critical for fast shutter speeds. To ensure that the flash and shutter are synchronized so that the flash is going off while the shutter is open, the NEX-6 implements a top sync speed of 1/160 of a second. This means that when you are using the flash, you will not be able to have your shutter speed set any faster than 1/160. If you did use a faster shutter speed, the shutter would actually start closing before the flash fired, which would cause a black, underexposed area to appear in the frame where the light from the flash was blocked.

USING THE BUILT-IN FLASH

There are going to be times when you have to turn to your camera's built-in flash to get the shot. The pop-up flash on the NEX-6 is not extremely powerful, but with the camera's advanced metering system it does a pretty good job of lighting up the night…or just filling in the shadows.

If you are working in any of the professional modes, you will have to turn the flash on for yourself. To do this, just press the pop-up flash button located on the back of the camera (**Figure 8.10**). Once the flash is up, it is ready to go (**Figure 8.11**). It's that simple.

FIGURE 8.10
A quick press of the pop-up flash button will release the built-in flash to its ready position.

FIGURE 8.11
The pop-up flash in its ready position

BOUNCE THE BUILT-IN FLASH

Like many built-in flash units, the NEX-6's is spring-loaded and pops up quickly, making the camera look a bit like a Transformer. But you can do something with this flash that you can't do with many built-in flashes without breaking them: bounce it. Bouncing the flash takes some of the bite out of the harsh light that small flashes like this cast on your subjects. Essentially, bouncing the flash against a ceiling or wall increases the size of the light source, softening the light somewhat. You cannot rotate or swivel the built-in flash, but since the spring-loaded mechanism forces you to push it backwards to seat it after you are finished with it, it makes sense that with a little repositioning of your fingers, you can tilt the flash back when you are shooting. I rarely like to fire a flash straight onto my subject, especially a person. This not-so-intentional feature offers an alternative to doing so (see the second Poring Over image at the beginning of this chapter).

SHUTTER SPEEDS

The standard flash synchronization speed for your camera is between 1/60 and 1/160 of a second. When you are working with the built-in flash in the Auto modes, the camera will choose an appropriate shutter speed for each scene mode in which you are shooting. For example, the camera will set the shutter speed at the maximum sync speed of 1/160 of a second for Portrait and Sports Action, but it will use 1/80 of a second for Landscape. For the Night Scene and Night Portrait modes, the camera slows the shutter speed to 1/60 of a second to bring in a bit more ambient light to balance with the flash.

The real key to using the flash to get great pictures is to control the shutter speed. The goal is to balance the light from the flash with the existing light so that everything in the picture has an even illumination. Let's take a look at the shutter speeds for the professional modes.

Program Auto (P): The shutter speed stays at 1/60 of a second. With the flash up, you are not able to use the Control dial to manipulate your shutter speed or aperture.

Shutter Priority (S): You can adjust the shutter speed from as fast as 1/160 of a second all the way down to 30 seconds. The lens aperture will adjust accordingly, but at long exposures the lens will typically be set to its smallest aperture.

Aperture Priority (A): Like Program Auto, Aperture Priority leaves the shutter at 1/60 of a second, despite any change you make to the aperture. However, when the flash mode is changed to either Slow Sync or Rear Sync, the shutter speed is slowed down considerably and will change according to any change you make to the aperture.

Manual (M): Manual mode works with shutter speeds from 1/160 of a second down to 30 seconds. Bulb is accessible as well. The difference, of course, is that you must manually set the f-stop.

FLASH RANGE

Because the pop-up flash is fairly small, it does not have enough power to illuminate a large space (**Figure 8.12**). The effective distance varies depending on the ISO setting. At ISO 100, the range is about 7 feet at f/2.8. This range can be extended to as far as 39 feet when the camera is set to an ISO of 3200 at f/2.8, and will extend farther at higher ISOs. The more stopped down the aperture, though, the shorter the distance. For the best image quality, your ISO setting should not go above 800. Anything higher will begin to introduce excessive noise into your photos.

ISO 1600
1/8 sec.
f/4
28mm lens

FIGURE 8.12
The built-in flash filled in the shadows on the bride and her friends, while the long exposure time allowed the ambient light to illuminate the rest of the scene and bring back some of the color that would have been lost to underexposure.

COMPENSATING FOR THE FLASH EXPOSURE

The flash metering system will usually do an excellent job of balancing the flash and ambient light for your exposure, but it does have the limitation of not knowing what effect you want in your image. You may want more or less flash in a particular shot. You can achieve this by using the flash compensation feature.

Just as with exposure compensation, flash compensation allows you to dial in a change in the flash output in increments of 1/3 of a stop. You will probably use this most often to tone down the effects of your flash, especially when you are using the flash as a subtle fill light (**Figures 8.13** and **8.14**).

ISO 800
1/60 sec.
f/2
24mm lens

ISO 800
1/60 sec.
f/2
24mm lens

FIGURE 8.13
This shot was taken with the pop-up flash set to normal power. As you can see, it was trying too hard to illuminate my subjects, overexposing skin tones.

FIGURE 8.14
This image was made with the same camera settings. The difference is that the flash compensation was set to –2/3 of a stop.

USING THE FLASH COMPENSATION FEATURE TO CHANGE THE FLASH OUTPUT

1. Press Menu, rotate the Control wheel to Brightness/Color, and select it. Then use the Control wheel to select Flash Comp.

2. As you rotate the Control wheel, you are increasing or decreasing the power output of the flash in 1/3-stop increments (**A**). Push the middle of the Control wheel (soft key C) to make your selection.

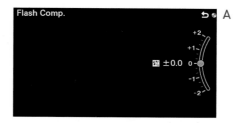

3. Press the shutter button halfway to return to shooting mode, and then take the picture.

4. Review your image to see if more or less flash compensation is required, and repeat these steps as necessary.

Another way to adjust the flash compensation that might seem more accessible is to change your LCD display setting to "For viewfinder." This setting does not display an image, but only information relevant to your shooting. Many traditional SLR shooters will enjoy this setting since it is made for those who are used to looking through a viewfinder only to shoot. To adjust your flash compensation with this setting, you simply need to press the Fn button next to the shutter button and rotate the Control wheel until you highlight the Flash Compensation icon (a lightning bolt with a +/- next to it). It is the bottom portion of the exposure meter, just above the ISO readout. Select this function, and change your flash compensation as outlined above. Simple and quick.

Keep in mind that the flash compensation feature does not reset itself when the camera is turned off, so whatever compensation you have set will remain in effect until you change it.

REDUCING RED-EYE

We've all seen the result of using on-camera flashes when shooting people: the dreaded red-eye! This demonic effect is the result of the light from the flash entering the pupil and then reflecting back as an eerie red glow. The closer the flash is to the lens, the greater the chance that you will get red-eye. This is especially true when it is dark and the subject's pupils are dilated. There are two ways to combat this problem. The first is to get the flash away from the lens. That's not really an option, though,

if you are using the built-in flash. Therefore, you will need to turn to the Red Eye Reduction feature.

This is a simple feature that emits a pre-flash burst from the camera toward the subject, causing his or her pupils to shrink, thus eliminating or reducing the effects of red-eye (**Figure 8.15**).

The feature is set to Off by default and needs to be turned on in the Setup menu.

FIGURE 8.15
The picture on the left did not utilize Red Eye Reduction, thus the glowing red eyes. Notice that the pupils in the image on the right, without red-eye, are smaller as a result of using the red-eye reduction pre-flash burst (but good luck getting that one-year-old to sit still long enough for the flash to emit the burst).

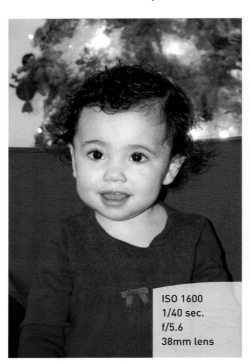

ISO 1600
1/40 sec.
f/5.6
38mm lens

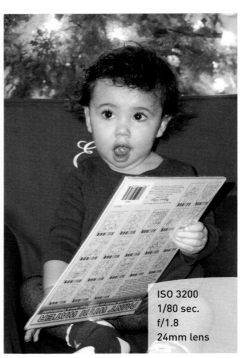

ISO 3200
1/80 sec.
f/1.8
24mm lens

TURN ON THE LIGHTS!

When shooting indoors, another way to reduce red-eye is to turn on a lot of lights. The brighter the ambient light levels, the smaller the subject's pupils will be. Although this might not completely rid you of the need for red-eye reduction, it will provide your image with ambience and a sense of place.

1. Press the Menu button, and then use the Control wheel to select Setup.
2. Use the Control wheel to highlight and select Red Eye Reduction. Select On.
3. Press the Menu button or the shutter release button twice to return to shooting.

Truth be told, I rarely shoot with Red Eye Reduction turned on because of the time it takes before being able to take a picture. If I am after candid shots and have to use the flash, I will take my chances on red-eye and try to fix the problem in my image-processing software.

REAR SYNC FLASH

There are two flash synchronization modes in the NEX-6: Slow Sync and Rear Sync. You may be asking, "What in the world does synchronization do?" Good question.

When a traditional digital SLR camera fires, there are two curtains that open and close to make up the shutter. The first curtain moves out of the way, exposing the camera sensor to the light. At the end of the exposure, the second curtain moves in front of the sensor, ending that picture cycle. Since the NEX-6 is a mirrorless camera, the first "curtain" is fully electronic, meaning the sensor simply turns on to start the exposure. The second, or rear, curtain is a physical shutter that ends the exposure. In flash photography, timing is extremely important because the flash fires in milliseconds and the shutter is usually opening in tenths or hundredths of a second. To make sure these two functions happen in order, the camera usually fires the flash just as the first "curtain" is enabled (see the sidebar "Flash Sync" earlier in this chapter).

In Rear Sync mode, the flash will not fire until just before the second shutter curtain ends the exposure. So, why have this mode at all? Well, there might be times when you want to have a longer exposure to balance out the light from the background to go with the subject needing the flash. Imagine taking a photograph of a friend standing in Times Square at night with all the traffic moving about and the bright lights of the buildings and signs overhead. If the flash fires at the beginning of the exposure and then the objects around the subject move, those objects will often blur the subject a bit. If the camera is set to Rear Sync, though, all of the movement of the existing light is recorded first, and then the subject is "frozen" by the flash at the end by the exposure.

There is no right or wrong to it. It's just a decision on what type of effect you would like to create. Many times, Rear Sync is used for artistic purposes or to record movement in the scene without it overlapping the flash-exposed subject (**Figure 8.16**). To make sure that the main subject is always getting the final pop of the flash, I leave my camera set to Rear Sync.

Using Slow Sync mode will give a similar effect, but the flash will fire at the beginning of the sequence (**Figure 8.17**). If you do intend to use a long exposure with Slow Sync, you need to have your subject remain fairly still so that any movement that occurs after the flash goes off will be minimized in the image.

ISO 200
1/15 sec.
f/2
24mm lens

ISO 400
1/15 sec.
f/2.8
24mm lens

FIGURE 8.16
The effect of using Rear Sync is most evident during long flash exposures.

FIGURE 8.17
Slow Sync flash is revealed by how the arm is lit before it finishes moving backwards after bowling the ball. This flash mode is useful if you want to achieve this effect with slow shutter speeds.

SETTING YOUR FLASH SYNC MODE

1. Press the Menu button, navigate to the Camera submenu, and select Flash Mode by pressing soft key C (**A**).

2. Rotate the Control wheel to highlight either Slow Sync or Rear Sync (**B**).

3. Lock in your selection by pressing soft key C.

USING AN EXTERNAL FLASH

An exciting and useful feature of the NEX-6 is its ability to control an off-camera flash using a control flash unit mounted to the camera. The biggest benefit to doing this is that you can move the flash to the side of the camera, which gives you more natural-looking light and shadows. You can also do things like fire the external flash through umbrellas, softboxes, or simple diffusion panels to make the quality of light much softer and more complimentary to your subject (**Figure 8.18**).

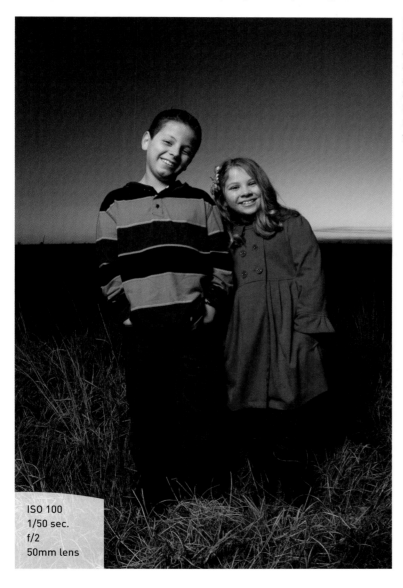

ISO 100
1/50 sec.
f/2
50mm lens

FIGURE 8.18
By moving the flash away from the camera and firing it through an umbrella, you can achieve a quality of light that is much more flattering to your subjects.

USING OFF-CAMERA FLASH

In order to use an off-camera flash, you'll need to purchase two external flashes. Unfortunately, the NEX-6's on-camera flash is not capable of wirelessly triggering an external flash, so one of the flash units you purchase will be a hot-shoed control unit for the other off-camera remote unit. There is (as of this writing) one Sony external flash model that is compatible with the NEX-6 and that will allow you to use the wireless feature: the HVL-F60M (**Figure 8.19**). It has the added benefit of having a built-in LED light that can be used as both a focus assist lamp and a video recording light. It also has a pivoting head that allows the light to be bounced off the ceiling to create softer, more flattering light. This model is one of my favorite flash units I have worked with over the years.

FIGURE 8.19
The HVL-F60M is a great external flash to use with your NEX-6.

SETTING UP YOUR CAMERA FOR WIRELESS OPERATION

1. Attach one of the flash units to the camera's onboard hot shoe slipper and lock it into place. Turn it on (you will not be able to access the wireless feature on the camera without a compatible flash attached).

2. Press the Menu button on the camera, and use the Control wheel to highlight and select the Camera submenu.

3. Navigate to Flash Mode, and select it using soft key C (**A**).

4. Rotate the Control wheel to Wireless (WL), and select it using soft key C (**B**).

5. From here, you can use the flash unit on your camera to manipulate the light level coming from your off-camera flash.

SETTING UP THE HOT-SHOED AND OFF-CAMERA FLASH UNITS FOR WIRELESS CONTROL

1. On the unit connected to the camera, press the MODE button, and then use the control wheel on the flash to highlight and select wireless control (WL CTRL).

2. Turn on the off-camera flash unit, press the MODE button, and place it in the wireless remote mode (WL RMT).

3. From this point, you are set to use the control unit (the flash attached to the camera) to trigger the off-camera unit when you snap a photograph. The flashes talk to each other via TTL and can determine how much power is needed to light your subject. If you want more nuanced control of this function, press the Fn button on the hot-shoed unit and you can access the power ratios of both units and the flash compensation controls.

A NOTE ABOUT WIRELESS FLASH

Wireless (off-camera) flash allows you to take your photography, especially your portraits, to another level. I use it all the time, from assignment work to family functions. However, this chapter only scratches the surface of how to get the most out of your camera's ability to interface with off-camera flash units. One piece of advice I want to give, though, is to learn how to control your off-camera flash's power level manually. The HVL-F60M defaults to TTL exposure settings, but to switch your remote flash unit to Manual, press the Fn button, highlight and select TTL Remote on the unit's display, and select Manual Remote from the options it provides you. On the home display, you can now press the unit's Fn button and use the Control wheel to adjust the flash's power output by 1/3-stop increments in the Level section.

FLASH AND GLASS

If you find yourself in a situation where you want to use your flash to shoot through a window or display case, try placing your lens right against the glass so that the reflection of the flash won't be visible in your image (**Figures 8.20** and **8.21**). This is extremely useful in museums and aquariums.

FIGURE 8.20
(left) The bright spot at the top left of the frame is a result of the flash reflecting off the shop window.

FIGURE 8.21
(right) To eliminate the reflection, place the lens against the glass or as close to it as possible. You might also have to zoom out a bit and reduce the flash's power through flash exposure compensation.

ISO 800
1/15 sec.
f/11
16mm lens

ISO 800
1/15 sec.
f/11
16mm lens

Chapter 8 Assignments

Now that we have looked at the possibilities of shooting after dark, it's time to put it all to the test. These assignments cover the full range of shooting possibilities, both with flash and without. Let's get started.

How steady are your hands?

It's important to know just what your limits are in terms of handholding your camera and still getting sharp pictures. This will change depending on the focal length of the lens you are working with. Wider-angle lenses are more forgiving than telephoto lenses, so check this out for your longest and shortest lenses. Using a 16–50mm zoom as an example, set your lens to 50mm and then, with the camera set to ISO 100 and the mode set to S, start taking pictures with lower and lower shutter speeds. Review each image on the LCD at a zoomed-in magnification to take note of when you start seeing visible camera shake in your images. It will probably be around 1/30 of a second for a 50mm lens.

Now do the same for the wide-angle setting on the lens. My limit is about 1/15 of a second. These shutter speeds are with the SteadyShot feature turned off. Try it with and without SteadyShot enabled to see just how slow you can set your shutter while getting sharp results.

Pushing your ISO to the extreme

Find a place to shoot where the ambient light level is low. This could be at night or indoors in a darkened room. Using the mode of your choice, start increasing the ISO from 100 until you get to 25600. Make sure you evaluate the level of noise in your image, especially in the shadow areas. Only you can decide how much noise is acceptable in your pictures.

Getting rid of the noise

Set the High ISO Noise Reduction to Normal and repeat the previous assignment. Find your acceptable limits with the noise reduction turned on. Also pay attention to how much detail is lost in your shadows with this function enabled.

Long exposures in the dark

If you don't have a tripod, find a stable place to set your camera outside and try some long exposures. Set your camera to A mode and then use the self-timer to activate the camera (this will keep you from shaking the camera while pressing the shutter button).

Shoot in an area that has some level of ambient light, be it a streetlight, traffic lights, or even a full moon. The idea is to get some late-night, low-light exposures.

Reducing the noise in your long exposures

Now repeat the last assignment with the Long Exposure Noise Reduction set to On. Look at the difference in the images that were taken before and after the noise reduction was enabled. For best results, perform this assignment and the previous assignment in the same shooting session using the same subject.

Testing the limits of the pop-up flash

Wait for the lights to get low and then press that pop-up flash button to start using the built-in flash. Try using the different shooting modes to see how they affect your exposures. Use the flash compensation feature to take a series of pictures while adjusting from –2 stops all the way to +2 stops so that you become familiar with how much latitude you will get from this feature.

Getting the red out

Find a friend with some patience and a tolerance for bright lights. Have them sit in a darkened room or outside at night and then take their picture with the flash. Now turn on Red Eye Reduction to see if you get better results.

Getting creative with Rear Sync

Now it's time for a little creative fun. Set your camera up for Rear Sync and start shooting. Moving targets are best. Experiment with S and A modes to lower the shutter speeds and exaggerate the effect. Try using a low ISO so the camera is forced to use longer shutter speeds. Be creative and have some fun!

Share your results with the book's Flickr group!

Join the group here: flickr.com/groups/sonynex6_fromsnapshotstogreatshots

9

ISO 100
1/125 sec.
f/5.6
50mm lens

Creative Compositions

IMPROVE YOUR PICTURES WITH SOUND COMPOSITIONAL ELEMENTS

Creating a great photograph takes more than just using the right settings on your camera. To take your photography to the next level, you need to gain an understanding of how the elements within the frame come together to create a compositionally pleasing image. Composition is the culmination of light, shape, and, to borrow a word from iconic photographer Jay Maisel, gesture. Composition is a way for you to pull your viewing audience into your image and guide them through the scene. Let's examine some common compositional elements you can use to add interest to your photos.

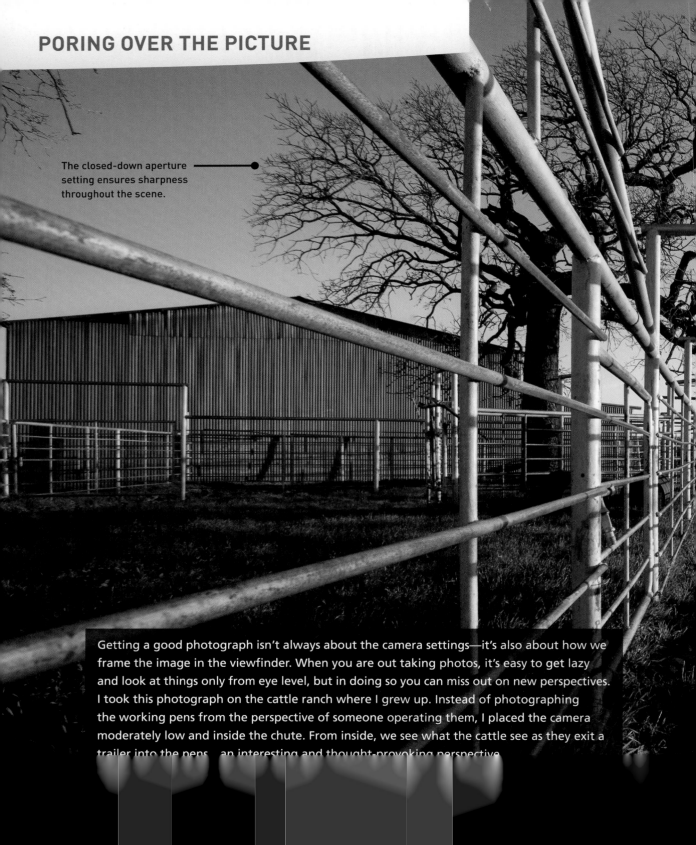

The closed-down aperture setting ensures sharpness throughout the scene.

Getting a good photograph isn't always about the camera settings—it's also about how we frame the image in the viewfinder. When you are out taking photos, it's easy to get lazy and look at things only from eye level, but in doing so you can miss out on new perspectives. I took this photograph on the cattle ranch where I grew up. Instead of photographing the working pens from the perspective of someone operating them, I placed the camera moderately low and inside the chute. From inside, we see what the cattle see as they exit a trailer into the pens—an interesting and thought-provoking perspective.

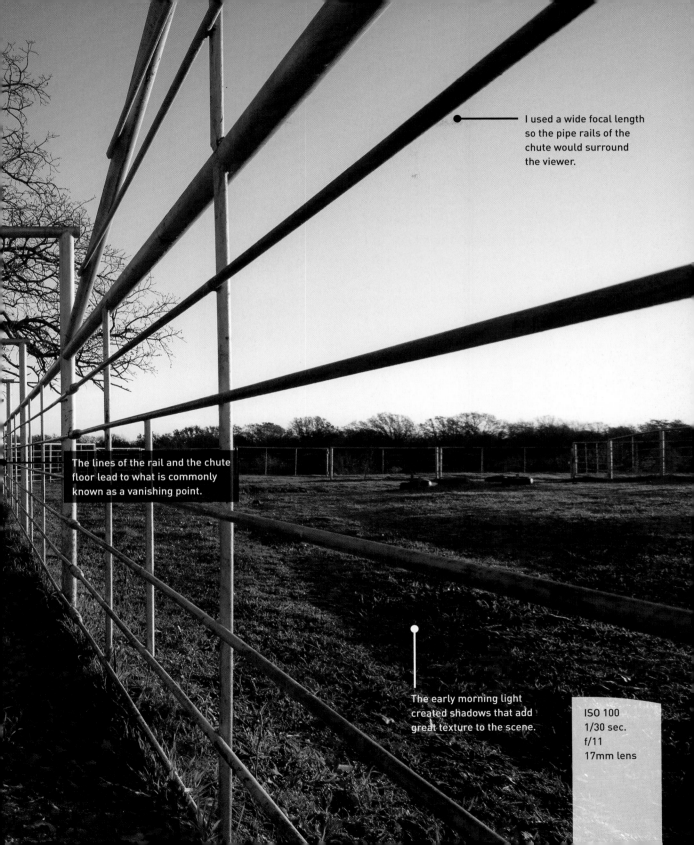

I used a wide focal length so the pipe rails of the chute would surround the viewer.

The lines of the rail and the chute floor lead to what is commonly known as a vanishing point.

The early morning light created shadows that add great texture to the scene.

ISO 100
1/30 sec.
f/11
17mm lens

DEPTH OF FIELD

Long focal lengths and large apertures allow you to isolate your subject from the chaos that surrounds it. I utilize Aperture Priority (A) mode for the majority of my shooting. I also like to use a longer focal length lens to shrink the depth of field to a very narrow area (**Figure 9.1**).

The blurred background and foreground force the viewer's eye toward the sharper, in-focus areas, which gives greater emphasis to the subject.

Occasionally, a greater depth of field is required to maintain sharp focus across a greater distance. This might be due to the sheer depth of your subject, where you have objects that are near the camera but sharpness is desired at a greater distance as well (**Figure 9.2**).

FIGURE 9.1
A large aperture setting can create a shallow depth of field to isolate the subject.

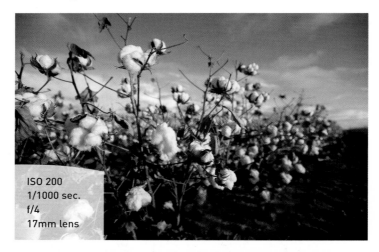

ISO 200
1/1000 sec.
f/4
17mm lens

FIGURE 9.2
Using a smaller aperture setting brings more of the subject matter into focus as it trails off into the distance. Wide-angle lenses are also useful in achieving greater depth of field.

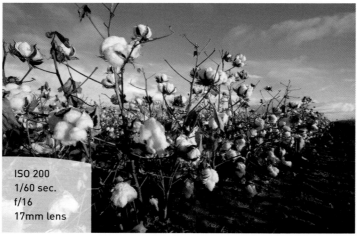

ISO 200
1/60 sec.
f/16
17mm lens

Or perhaps you are photographing a reflection in a puddle or another smooth, calm water surface. With a narrow depth of field, you would only be able to get either the reflected object or the surface in focus. By making the aperture smaller, you will be able to maintain acceptable sharpness in both areas (**Figure 9.3**).

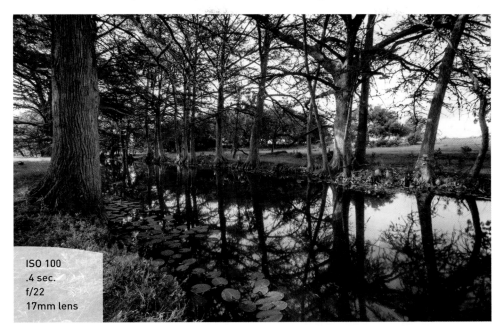

ISO 100
.4 sec.
f/22
17mm lens

FIGURE 9.3
Getting a distant subject in focus in a reflection, along with the reflective surface itself, requires a small aperture.

PHOTOGRAPHING REFLECTIONS

A mirror is a two-dimensional surface, so why do you have to focus at a different distance for the image in the mirror? The answer is pretty simple, and it has to do with light. When you focus your lens, you are focusing the light being reflected off a surface onto your camera sensor. So if you wanted to focus on the mirror itself, it would be at one distance, but if you wanted to focus on the subject being reflected, you would have to take into account the distance that the object is from the mirror and then to you. Remember that the light from the subject has to travel all the way to the mirror and then to your lens. This is why a smaller aperture can be required when shooting reflected subjects. Sit in your car and take a few shots of objects in the sideview mirrors to see what I mean.

ANGLES

Having strong angular lines in your image can add to the composition, especially when they are juxtaposed to each other (**Figure 9.4**). This can create a tension that is different from the standard horizontal and vertical lines that we are so accustomed to seeing in photos.

FIGURE 9.4
The strong diagonal lines of the pergola-like structure create a dynamic composition.

ISO 100
1/1600 sec.
f/5.6
50mm lens

POINT OF VIEW

Sometimes the easiest way to influence your photographs is to simply change your perspective. Instead of always shooting from a standing position, try moving your camera to a place where you normally would not see your subject. Try getting down on your knees or even lying on the ground. This low angle can completely change how you view your subject and can create a new interest in common subjects (**Figure 9.5**). I like to think of this as trying to achieve a cat's-eye view, since cats can put themselves in any position, high or low.

ISO 100
1/30 sec.
f/11
17mm lens

FIGURE 9.5
Put your camera into a position that presents an unfamiliar view of your subject.

PATTERNS

Rhythm and balance can be added to your images by finding the patterns in everyday life and concentrating on the elements that rely on geometric influences. Try to find the balance and patterns that often go unnoticed (**Figure 9.6**).

FIGURE 9.6
I was attracted by not only the repetition of the straight lines and the color, but also the arches at the top and the circles of the reddish-orange bricks.

ISO 100
1/80 sec.
f/8
22mm lens

COLOR

Color works well as a tool for composition when you have very saturated colors to work with. Some of the best colors are those within the primary palette. Reds, greens, and blues, along with their complementary colors (cyan, magenta, and yellow), can all be used to create visual tension (**Figure 9.7**). This tension between bright colors will add visual excitement, drama, and complexity to your images when combined with other compositional elements.

You can also use color as a theme for your photography. Many of my sunset shots are extremely vibrant and filled with energy due to the amount of color in the sky. I live in an area of Texas that celebrates its sky, and a unique display of color above the horizon is something that I'm continually seeking (**Figure 9.8**).

ISO 100
1/640 sec.
f/6.3
200mm lens

FIGURE 9.7
I love how the heavy blue sky grounds the rich yellow of the tall weeds in the pasture. Combined, they make for a great abstract shot of the cattle moving along one after the other.

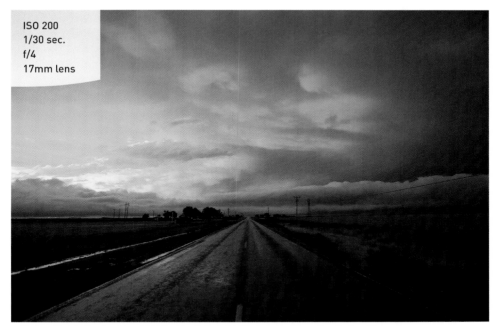

ISO 200
1/30 sec.
f/4
17mm lens

FIGURE 9.8
The thunderstorm is made even more intimidating by the abundance of loud oranges and yellows.

CONTRAST

We just saw that you can use color as a strong compositional tool. One of the most effective uses of color is to combine two contrasting colors that make the eye move back and forth across the image (**Figure 9.9**). There is no exact combination that will work best, but consider using dark and light colors, like red and yellow or blue and yellow, to provide the strongest contrasts.

FIGURE 9.9
The blue background contrasts nicely with the red of the paintbrush flowers. Red is a contrasty color because it visually advances away from other colors.

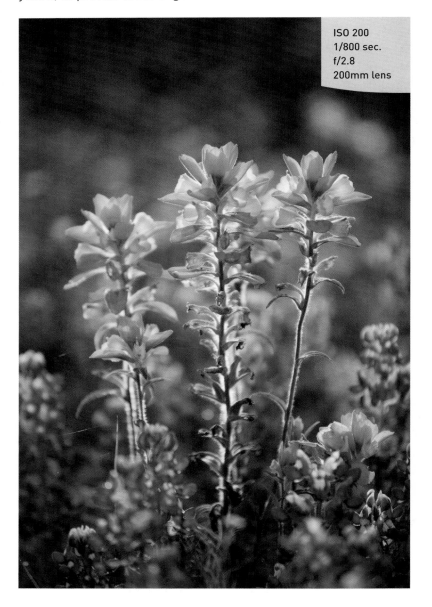

ISO 200
1/800 sec.
f/2.8
200mm lens

You can also introduce contrast through different geometric shapes that battle (in a good way) for the attention of the viewer. You can combine circles and triangles, ovals and rectangles, curvy and straight, hard and soft, dark and light, and so many more (**Figure 9.10**). You aren't limited to just one contrasting element either. Combining more than one element of contrast will add even more interest. Look for these contrasting combinations whenever you are out shooting, and then use them to shake up your compositions.

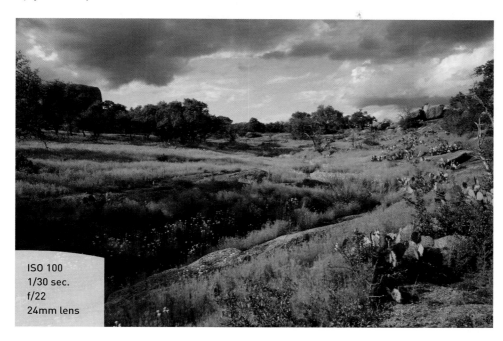

ISO 100
1/30 sec.
f/22
24mm lens

FIGURE 9.10
The shadows contrast greatly with where the light hits the landscape, providing direction for the eye to move through the scene.

LEADING LINES

One way to pull a viewer into your image is to incorporate leading lines. These are elements that come from the edge of the frame and then lead into the image toward the main subject. At other times, the lines themselves may be the primary subjects (**Figure 9.11**). This can be the result of vanishing perspective lines (which converge at what is commonly known as a vanishing point), an element such as a river, or some other feature that is used to move the eye from the outer edge in to the heart of the image.

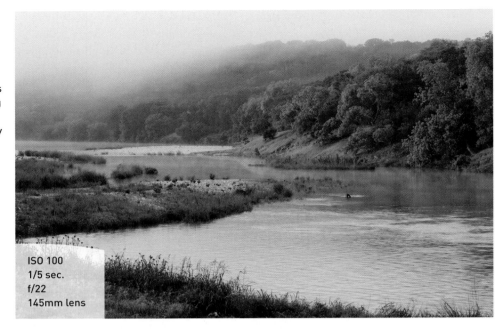

FIGURE 9.11
The river winds through the scene, creating a line to follow. It is often good to shoot rivers and roads as strong diagonal lines, showing where they are coming from and where they are going.

ISO 100
1/5 sec.
f/22
145mm lens

SPLITTING THE FRAME

Generally speaking, splitting the frame right down the middle is not necessarily your best option. While it may seem more balanced, it can actually be pretty boring. You should utilize the rule of thirds when deciding how to divide your frame.

With horizons, a low horizon will give a sense of stability to the image. When the emphasis is to be placed on the landscape, the horizon line should be moved upward in the frame, leaving the bottom two-thirds to the subject.

FRAMES WITHIN FRAMES

Along with looking for leading lines, unique angles, and patterns, search for mechanisms in the composition that can visually frame your primary subject matter. Frames are useful when you want to drive attention toward a specific person, thing, or area in the photograph (**Figure 9.12**).

ISO 400
1/40 sec.
f/4
23mm lens

FIGURE 9.12
Surrounded by a frame of dark shadow, each archway in this walkway serves as a frame for the next.

FOCAL LENGTH AND COMPOSITION

Different focal lengths, as obvious as it sounds, provide various ways of seeing composition in a single environment. Take for example the difference between wide and telephoto focal lengths. Wide angles usually convey a sense of great distance, especially when the lens is pushed up close to a foreground subject (**Figure 9.13**). Telephoto focal lengths achieve the exact opposite, compressing foreground and background together. This can be useful for creating patterns out of the landscape or for depicting density in a crowd (**Figure 9.14**).

FIGURE 9.13
The wide focal length makes the sunflowers in the foreground look farther away from those in the background than if they had been shot with a longer focal length.

ISO 200
1/250 sec.
f/13
24mm lens

FIGURE 9.14
Along with creating shallower depth of field with a smaller aperture, using longer focal lengths compresses the distance between subjects, emphasizing a layering effect in your images.

ISO 200
1/1600 sec.
f/4
105mm lens

Chapter 9 Assignments

If you apply the shooting techniques and tools that you have learned in the previous chapters to these assignments, you'll improve your ability to incorporate good composition into your photos. Make sure you experiment with all the different elements of composition and see how you can combine them to add interest to your images.

Learning to see lines and patterns

Take your camera for a walk around your neighborhood and look for patterns and angles. Don't worry as much about getting great shots as about developing an eye for details.

The ABCs of composition

Here's a great exercise that Vincent Versace suggests for those looking to advance their compositional vision: shoot the alphabet. This will be a little more difficult, but with practice you will start to see beyond the obvious. Don't just find letters in street signs and the like—instead, find objects that aren't really letters but that have the shape of letters.

Finding the square peg and the round hole

Circles, squares, and triangles. Spend a few sessions concentrating on shooting simple geometric shapes.

Using the aperture to focus attention

Depth of field plays an important role in defining your images and establishing depth and dimension. Practice shooting wide open, using your largest aperture for the narrowest depth of field. Then find a scene that would benefit from extended depth of field, using very small apertures to give sharpness throughout the scene.

Leading them into a frame

Look for scenes where you can use elements as leading lines, and then look for framing elements that you can use to isolate your subject and add both depth and dimension to your images.

Share your results with the book's Flickr group!

Join the group here: flickr.com/groups/sonynex6_fromsnapshotstogreatshots

10

ISO 200
1/125 sec.
f/9
95mm lens

Advanced Techniques

IMPRESS YOUR FAMILY AND FRIENDS

We covered a lot of ground in the previous chapters, especially on the general photographic concepts that apply to most, if not all, shooting situations. There are, however, some specific tools and techniques that will give you an added advantage in obtaining a great shot.

Where I live, the land is extremely flat and you can see thunderstorms coming for miles. The sky is big, and if you are far enough away from the storm, you have a clear view of the area above those high clouds. Shooting thunderstorms is a fun photographic activity (when you're being safe), and it offers you the opportunity to experiment with long exposures, Bulb mode, and high ISOs. In this image, the high ISO brought out the stars above the violent-looking lightning attack on the ground.

The exposure was long enough to capture several lightning bolts in one frame.

High ISOs amplify the camera's sensitivity to light. Using a relatively high ISO and an open aperture for this shot helped pick up the stars above the thunderstorm.

I lowered the white balance from 4850K to 3800K to cool down the oranges and reds and bring a nighttime feel to the image.

A tripod was used to secure the camera in high winds and to ensure a sharp image during the long exposure.

ISO 800
30 sec.
f/4
24mm lens

SPOT METER FOR MORE EXPOSURE CONTROL

Generally speaking, Multi metering mode provides accurate metering information for the majority of your photography. It does an excellent job of evaluating the scene and then relaying the proper exposure information to you. The only problem with this mode is that, like any metering mode on the camera, it doesn't know what it is looking at. There will be circumstances where you want to get an accurate reading from just a portion of a scene and discount the remaining area. To give you greater control of the metering operation, you can switch the camera to Spot metering mode. This allows you to take a meter reading from a very small circle in the center of the viewfinder, while ignoring the rest of the viewfinder area.

So, when would you need to use this? Think of a person standing in front of a very dark wall. In Multi metering mode, the camera would see the entire scene and try to adjust the exposure information so that the dark background is exposed to render a lighter wall in your image. This means that the scene would actually be overexposed and your subject would then appear too light. To correct this, you can place the camera in Spot metering mode and take a meter reading right off of—and only off of—your subject, ignoring the dark wall altogether.

Other situations that would benefit from Spot metering include:

- Snow or beach environments where the overall brightness level of the scene could fool the meter

- Concerts, particularly those that are performed on heavily lit stages and in dark environments (**Figures 10.1** and **10.2**)

- Strongly backlit subjects that are leaving the subject underexposed

- Cases where the overall feel of a photo is too light or too dark

SETTING UP AND SHOOTING IN SPOT METERING MODE

1. Press the Fn button, and press the right side of the Control wheel until you highlight the metering mode icon (it looks like a rectangle containing cross hairs and a circle). Select this option by pressing the middle of the Control wheel.

2. Rotate the Control wheel until the Spot metering icon appears (**A**), and then press the shutter release button halfway to return to shooting mode.

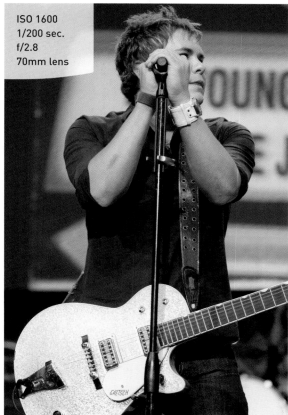

ISO 1600
1/200 sec.
f/2.8
70mm lens

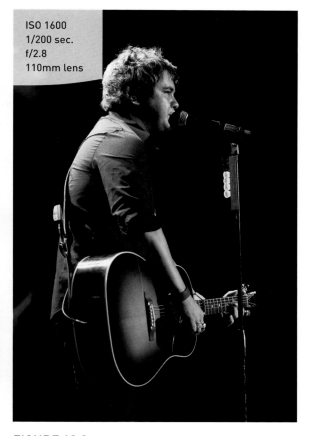

ISO 1600
1/200 sec.
f/2.8
110mm lens

FIGURE 10.1

The darker tones in the shot, particularly the performer's shirt and the background, were fooling my meter and causing me to overexpose and lose contrast.

FIGURE 10.2

By switching to Spot metering and measuring the light hitting the performer's face, I was able to get a more accurate—and dramatic—exposure.

3. In the viewfinder, you'll see a black circle. Point this circle at the spot you wish to use for the meter reading.

4. If you are in A, S, or P mode, press the AEL button with your right thumb to enable AE Lock, which will hold the exposure value while you recompose and then take the photo.

When using Spot metering mode, remember that the meter believes it is looking at a medium gray value, so you might need to incorporate some exposure compensation of your own to the reading that you are getting from your subject. This will come from experience as you use the meter.

METERING FOR SUNRISE OR SUNSET

In Chapter 7, we talked about shooting interesting sunrises and sunsets, but we didn't discuss metering for more effectiveness. Remember, capturing a beautiful sunrise or sunset is all about the sky. If there is too much foreground in the viewfinder, the camera's meter will deliver an exposure setting that is accurate for the darker areas but leaves the sky looking overexposed, undersaturated, and generally just not very interesting (**Figure 10.3**). To gain more emphasis on the colorful sky, point your camera at the brightest part of it and take your meter reading there. Use the AEL button and then recompose. The result will be an exposure setting that underexposes the foreground but provides a darker, more dramatic sky (**Figure 10.4**).

FIGURE 10.3
By metering for details in the deep shadows, you get bright, washed-out colors in the sunrise and and more detail in the top clouds.

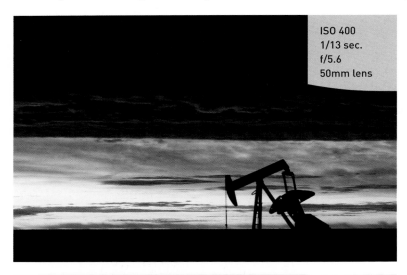

ISO 400
1/13 sec.
f/5.6
50mm lens

FIGURE 10.4
By taking the meter reading from the brightest part of the sky, you will get darker, more colorful sunsets.

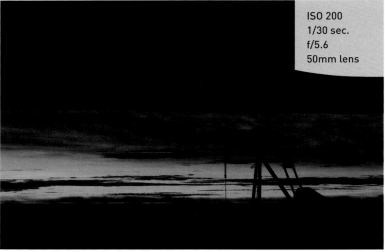

ISO 200
1/30 sec.
f/5.6
50mm lens

MANUAL MODE

Probably one of the most advanced and yet most basic skills to master is shooting in Manual mode. With the power and utility of most of the automatic modes, Manual mode almost never sees the light of day. I have to admit that I don't select it for use as often as I used to, but there are times when no other mode will do. One situation that works well with Manual is studio work with external flashes. I know that when I work with studio lights, my exposure will not change, so I use Manual to eliminate any automatic changes that might happen from shooting in P, S, or A mode.

Since you probably aren't too concerned with studio strobes at this point, I will concentrate on one of the ways in which you will want to use Manual mode for your photography: long nighttime exposures.

BULB PHOTOGRAPHY

If you want to work with long shutter speeds that don't quite fit into one of the selectable shutter speeds, you can select Bulb. This setting is available only in Manual mode, and its sole purpose is to open the shutter at your command and then close it again when you decide. I can think of three scenarios where this would come in handy: shooting fireworks, lightning, and star trails.

If you are photographing fireworks, you could certainly use one of the longer shutter speeds available in S mode, since they are available for exposure times up to 30 seconds. That is fine, but sometimes you don't need 30 seconds' worth of exposure and sometimes you need more.

BULB

If you are new to the world of photography, you might be wondering where in the world the *Bulb* shutter function got its name. After all, wouldn't it make more sense to call it the Manual Shutter setting? It probably would, but this is one of those terms that harkens back to the origins of photography. Way back when, the shutter was actually opened through the use of a bulb-shaped device that forced air through a tube, which, in turn, pushed a plunger down, activating the camera shutter. When the bulb was released, it pulled the plunger back, letting the shutter close and ending the exposure.

If you open the shutter and then see a great burst of fireworks, you might decide that that is all you want for that particular frame, so you click the button to end the exposure (**Figure 10.5**). Set the camera to 30 seconds and you might get too many bursts, but if you shorten it to 10 seconds you might not get the one you want.

FIGURE 10.5
A great use for the Bulb setting is capturing fireworks.

ISO 100
3 sec.
f/8
26mm lens

The same can be said for photographing a lightning storm. I have a friend who loves the large electrical storms that creep up along the plains every so often, and he has some amazing shots that he captured using the Bulb setting. Lightning can be very tricky to capture, and using the Bulb setting to open and then close the shutter at will allows for more creativity, as well as more opportunity to get the shot.

Lastly, a steady tripod, lots of time, and a dark, moonless sky are all you need to pull off a star trail. I shoot star trails for anywhere from five minutes to several hours. Folks that live near the earth's poles can shoot all night long. Don't hesitate to experiment with the time of night at which you shoot star trails, as well as with the lengths of the exposures. Each one will result in something different (**Figure 10.6**).

To select the Bulb setting, simply place your camera in Manual mode and then rotate the Control wheel until the shutter speed displays Bulb.

If you want to make a change to the aperture, turn the Control dial with your right thumb.

ISO 100
30 min.
f/4
17mm lens

FIGURE 10.6
The Bulb setting and a remote commander come in handy when you want to achieve extra-long exposure times, such as those needed for star trails.

When you're using the Bulb setting, the shutter will stay open only for the duration that you are holding down the shutter button. It is a good idea to use a stopwatch, clock, or phone to determine the length of each exposure. You should also be using a sturdy tripod or shooting surface to eliminate any self-induced vibration.

I want to point out that using your finger on the shutter button for a bulb exposure will definitely increase the chances of getting camera shake in your images. To get the most benefit from the Bulb setting, I suggest using a remote commander, such as the Sony RMT-DSLR1 or RMT-DSLR2. You'll also want to turn on Long Exposure noise reduction, as covered in Chapter 7.

SHOOTING LIGHTNING

If you are going to photograph lightning strikes in a thunderstorm, please exercise extreme caution. Standing in the open with a tripod is like standing over a lightning rod. Work from indoors or at a safe distance from the storm if at all possible.

AVOIDING LENS FLARE

Lens flare is one of the problems you will encounter when shooting in the bright sun. Lens flare will show itself as bright circles or odd appearances of color on the image (**Figure 10.7**). Often you will see multiple circles in a line leading from a very bright light source such as the sun. The flare is a result of the sun bouncing off the multiple pieces of optical glass in the lens and then being reflected back onto the sensor. Lens flare is especially frequent when using wide-angle lenses, because of their greater angle of coverage. You can avoid the problem using one of these methods:

- Try to shoot with the sun coming from over your shoulder, not in front of you or in your scene.

- Use a lens hood to block the unwanted light from striking the lens. You don't have to have the sun in your viewfinder for lens flare to be an issue. All it has to do is strike the front glass of the lens to make it happen.

- If you don't have a lens hood, just try using your hand or some other element to block the light (stay aware of the sides of the frame—sometimes your hand can show up in your images if you're not being careful).

ISO 100
1/15 sec.
f/32
200mm lens

FIGURE 10.7
The bright sun in the upper portion of the frame has created flare spots that are visible as colored circles radiating down into the canyon walls, making for a distracting element in the scene.

USING THE SUN CREATIVELY

Have you ever seen photographs where the sun is peeking through a small hole and it creates a very cool starburst effect (**Figure 10.8**)? There is actually a little trick to pulling it off, and it's fairly easy once you know how. The real key is to shoot with a small aperture, such as f/22, f/16, or f/11. Then you need to have just a small bit of the sunlight in your frame, either peeking over an edge or through a small hole. The other thing you need to do is make sure that you are properly exposing for the rest of your scene, not the bright bit of sunlight that you are allowing in. With a little practice, you can make some very cool shots.

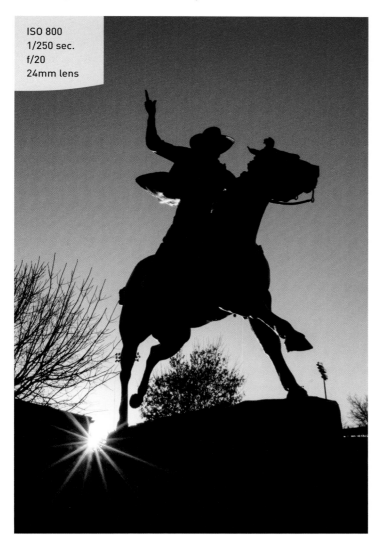

ISO 800
1/250 sec.
f/20
24mm lens

FIGURE 10.8
By letting the sun peek into my shot and using f/20, I was able to capture this cool starburst.

MACRO PHOTOGRAPHY

Macro photography is close-up photography. The NEX-6 is compatible with a variety of lenses, some of which have macro capabilities. But even if you don't have a macro lens, there's a good chance that you own a lens that can be used for this type of photography. Check the spec sheet that came with your lens to see what the minimum focusing distance is.

If you have a zoom lens, one option you have for macro photography is to shoot at its longest focal length. It is also a good idea to use a sturdy tripod since maintaining focus while handholding at such long focal lengths can be difficult.

I recommend shooting in Manual mode for macro photography. Often, you will be shooting a very small area of an environment that reflects many values of light. Manual mode allows you to easily compensate for the changing light. One way to avoid large amounts of contrast between light values is to shoot on an overcast day, in the shade, or with a diffusion panel (this could even be a white sheet); all of these reduce shadows, allowing you more detail throughout the image.

Aperture Priority mode is another popular exposure mode for macro photography, since it more easily allows you to control the aperture and depth of field. Since you are working at distances and focal lengths that provide very shallow depth of field, you will more than likely want to work with smaller apertures.

EXTENSION TUBES

If you do not have a dedicated macro lens, one of the most affordable ways to achieve this type of functionality without any sacrifice to the quality of the image is through the use of extension tubes. Extension tubes are hollow cylinders that attach between the lens and the camera body, physically allowing the lens to focus closer than its manufactured minimum focusing distance. I always carry a set of extension tubes with me. Unlike *extenders*, which increase the effective focal length of a lens, extension tubes do not contain any glass, and they are a perfect alternative to purchasing a macro lens. Although Sony does not make extension tubes, third-party manufacturers, such as Kenko, offer compatible products (just ensure that you are purchasing them for E-mount lenses).

HIGH DYNAMIC RANGE PHOTOGRAPHY

One of the more recent trends in digital photography is the use of high dynamic range (HDR) to capture the full range of tonal values in your final image. When you photograph a scene that has a wide range of tones from shadows to highlights, you typically have to make a decision regarding which tonal values you are going to emphasize, and then adjust your exposure accordingly. This is because your camera has a limited dynamic range, at least as compared to the human eye. HDR photography allows you to capture multiple exposures for the highlights, shadows, and midtones and then combine them into a single image using software (**Figures 10.9** through **10.12**).

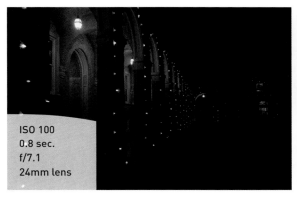

ISO 100
0.8 sec.
f/7.1
24mm lens

FIGURE 10.9
Underexposing by two stops renders more detail in the arches.

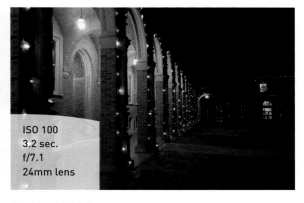

ISO 100
3.2 sec.
f/7.1
24mm lens

FIGURE 10.10
This is the normal exposure as dictated by the camera meter.

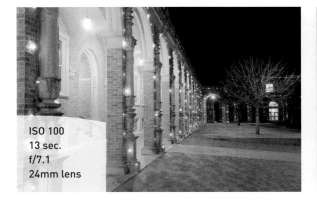

ISO 100
13 sec.
f/7.1
24mm lens

FIGURE 10.11
Overexposing by two stops ensures that the darker areas are exposed to get detail in the shadows.

FIGURE 10.12
This is the final HDR image that was rendered from the three other exposures you see here.

A number of software applications allow you to combine the images and then perform a process called "tonemapping," whereby the complete range of exposures is represented in a single image. I will not be covering the software applications, but I will explore the process of shooting a scene to help you render properly captured images for the HDR process. Note that using a tripod is absolutely necessary for this technique, since you need to have perfect alignment of each image when they are combined.

SETTING UP FOR SHOOTING AN HDR IMAGE

1. Set your ISO to 100, if possible, to ensure clean, noise-free images.

2. Set your program mode to A. During the shooting process, you will be taking three shots of the same scene—creating an overexposed image, an underexposed image, and a normal exposure. Since the camera is going to be adjusting the exposure, you want it to make changes to the shutter speed, not the aperture, so that your depth of field is consistent.

3. Set your camera file format to RAW. This is extremely important because the RAW format contains a much larger range of exposure values than a JPEG file, and the HDR software will need this information.

4. Change your drive mode to Bracket: Continuous: 2.0 EV. To do so, select Menu > Camera > Drive Mode. From here, rotate the Control wheel to the icon that shows the letters BRK in an orange box (**A**). Don't select it just yet. The default bracket exposure value is 0.3 EV (1/3 stop). Press soft key B, and you will see several EV options for the bracket. Rotate the Control wheel until the option for 2.0 EV is highlighted (**B**). Press the center of the Control wheel to make your selection. Bracketing continuously will allow you to capture your exposures quickly, minimizing any subject movement between frames. Even though you will be using a tripod, there is always a chance that something within your scene will be moving (like clouds or leaves).

5. Focus the camera manually, compose your shot, secure the tripod, and hold down the shutter button until the camera has fired three consecutive times.

A software program—such as Adobe Photoshop, Photomatix Pro, or Nik's HDR Efex Pro—can now process your exposure-bracketed images into a single HDR file. The NEX-6 also has an auto HDR function that is surprisingly good. But although auto HDR technology keeps improving, many professionals will tell you that maintaining as much control as possible over the final product is key. The more drawn-out process of bracketing your exposures and combining them later using tonemapping software allows you that control.

BRACKETING YOUR EXPOSURES

In HDR, *bracketing* is the process of capturing a series of exposures at different stop intervals. You can bracket your exposures even if you aren't going to be using HDR. Sometimes this is helpful when you have a tricky lighting situation and want to ensure that you have just the right exposure to capture the look you're after. You can bracket in increments as small as a third of a stop. This means that you can capture several images with very subtle exposure variances and then decide later which one is best.

WIRELESS AND THE NEX-6

A new trend working its way into the camera world is the ability to connect your camera to the Internet or to other devices for image capture, processing, and sharing. The NEX-6, like its little brother the NEX-5R, allows you to connect it to a wireless network or to your smartphone for such purposes. Although it's not in the scope of this book to delve too far into this feature, it is worth noting that this technology can only advance and is worth keeping an eye on.

One function you might find useful is the ability to control your camera via your smartphone. Although the Smart Remote Control application is limited (as of this writing) to snapping the photograph, setting a 2-second timer, and compensating for exposure when in A or S mode, your phone can essentially serve as a spare remote (or as a primary remote, if you don't already have a remote commander). The application allows you to stream a live feed from your camera to your mobile device, allowing you to remain remote from the camera.

In order to take advantage of the Smart Remote Control application, as well as all of the other wireless and connectivity features that are available with the NEX-6, you'll first need to set up an account at the Sony Entertainment Network website (www.sony.net/pmca), download the PlayMemories Mobile app, and install it on your smartphone. You can then download the Smart Remote Control application directly to your camera by selecting Menu > Application > PlayMemories Camera Apps (the camera will prompt you to log on to your wireless network).

Manual callout

For more specific information on connecting your NEX-6 to a wireless network, setting up a wireless connection with your smartphone, and downloading and installing applications, read pages 69–74 in your owner's manual.

CONCLUSION

As you'll see, the online bonus chapter "Pimp My Ride" covers a lot of gadgets, filters, and accessories that will make your photography better. It can become an obsession to always have the latest thing out there. But you already have almost everything you need to take great pictures: an awesome camera and the knowledge necessary to use it. Everything else is just icing on the cake. So although I introduce a few items in "Pimp My Ride" that I do think will make your photographic life easier and even improve your images, don't get caught up in the technology and gadgetry.

Use your knowledge of basic photography to explore everything your camera has to offer. Explore the limits of your camera. Don't be afraid to take bad pictures. Don't be too quick to delete them off your memory card, either. Take some time to really look at them and see where things went wrong. Look at your camera settings and see if perhaps there was a change you could have made to make things better. Be your toughest critic and learn from your mistakes. With practice and reflection, you will soon find your photography getting better and better. Not only that, but your instincts will improve to the point that you will come upon a scene and know exactly how you want to shoot it before you even take your camera out of the bag.

Chapter 10 Assignments

Many of the techniques covered in this chapter are specific to certain shooting situations that may not come about very often. This is even more reason to practice them so that when the situation does present itself you will be ready.

Adding some drama to the end of the day

Most sunset photos don't reflect what the photographer saw because they weren't metered correctly. The next time you see a colorful sunset, pull out your camera and take a meter reading from the sky and then one without and see what a difference it makes.

Making your exposure spot on

Using the Spot metering mode can give accurate results, but only when the camera is pointed at something that has a middle tone. Try adding something gray to the scene and taking a reading off it. Now switch back to your regular metering mode and see if the exposure isn't slightly different.

Using the Bulb setting to capture the moment

This is definitely one of those settings that you won't use often, but it's pretty handy when you need it. If you have the opportunity to shoot a fireworks display or a distant storm, try setting the camera to Bulb and then playing with some long exposures to capture just the moments that you want.

Bracketing your way to better exposures

Why settle for just one variation of an image when you can bracket to get the best exposure choice? Set your camera up for a 1/3-stop bracket series, and then expand it to a one-stop series. Review the results to see if the normal setting was the best or if perhaps one of the bracketed exposures was even better.

Share your results with the book's Flickr group!

Join the group here: flickr.com/groups/sonynex6_fromsnapshotstogreatshots

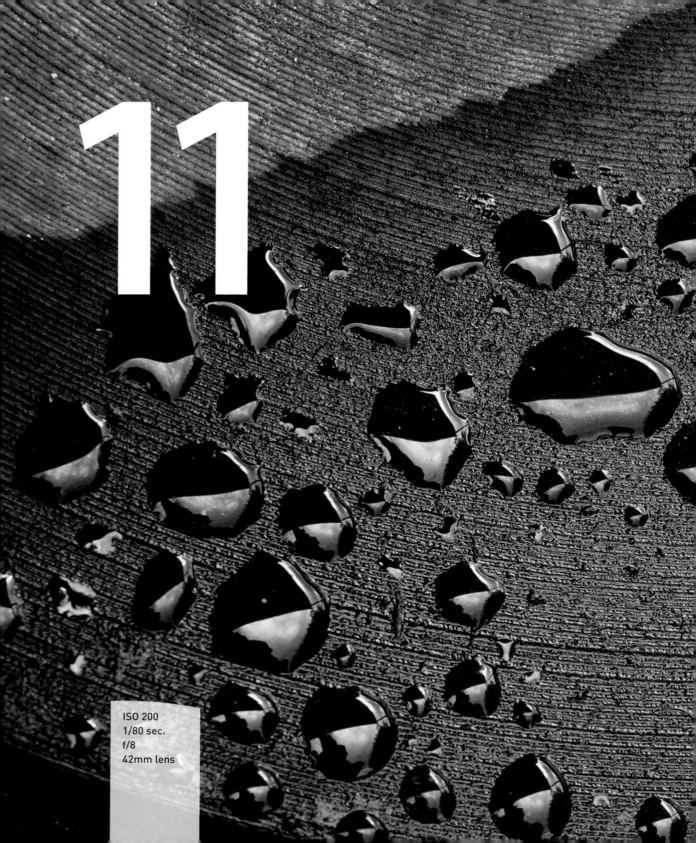

11

ISO 200
1/80 sec.
f/8
42mm lens

NEX-6 Video: Beyond the Basics

GETTING PROFESSIONAL-LOOKING VIDEO FROM YOUR NEX-6

One of the reasons you purchased the NEX-6 might have been its ability to capture video. Not just regular video, but high-definition video. In fact, much has been said about the quality of video this camera is able to capture. As I discussed in the book's introduction, I have kept the focus of this book on the photography aspects of the camera, but that doesn't mean I am going to simply ignore the video functions. First, let's cover some of the basic facts about the moviemaking features.

Video recording is a feature you can access at any time by simply pressing the Movie button on the right side of the camera below the Control dial (**Figure 11.1**). No matter what LCD display mode you are using, you can press the Movie button once to start recording and then press it again to stop. Once Movie mode is active, the camera will focus on the dominant subject matter in your frame if it is set to autofocus.

When the camera begins recording, you will notice that any focus boxes disappear. You do still have the ability to change LCD display modes. In the bottom center of the display, there will be a red REC icon and the duration of the video clip in minutes and seconds to let you know that the camera is in active record mode.

FIGURE 11.1
The Movie button on the NEX-6 is easily accessible with your right thumb.

VIDEO QUALITY

The highest-quality video setting on your NEX-6 will render high-definition video with a resolution of 1920 x 1080. This is also referred to as 1080p. The *1080* represents the height of the video image in pixels, and the *p* stands for progressive, which is how the camera actually records/draws the video on the screen. Sony has also included several other resolutions and recording formats for video, including several interlaced scanning modes and 1440 x 1080 resolution (which actually is the same size as 1920 x 1080, but created with rectangular pixels). You can also select a 640 x 480 VGA resolution based on your needs. For high-definition TV and computer/media station viewing, you will be best served using the 1080 recording resolutions. If you plan on recording for standard-definition TV, you might want to consider using the 640 x 480 resolution. The benefit of 640 x 480, as well as the 1440 x 1080 resolution, is that it requires less physical storage since it contains a smaller pixel count. This means that you will fit more video on your storage card, and it will take less time to upload the video to the Internet or to a more permanent recording medium, such as a DVD.

The other thing to consider when selecting a quality setting is the capture frame rate. At the 1920 x 1080 size, you have two frame rates to choose from: 24 frames per second or 60 frames per second (fps). The 24 fps setting is more of a film/Hollywood standard. The faster frame rate (60 fps) setting will render smooth video sequences, but they might also look a little like slow motion. One reason for using this frame rate is that it helps with fast movement of the camera or subject.

PROGRESSIVE SCAN

When it comes to video, there are usually two terms associated with the quality of the video and how it is captured and displayed on a monitor/screen: *progressive* and *interlaced*. The two terms describe how the video is drawn per line for each frame. Video frames are not displayed all at once like a photograph. In progressive video, the lines are drawn in sequence from top to bottom. Interlaced video draws all of the odd-numbered lines and then all of the even-numbered lines. This odd-even drawing can present itself as screen flicker, which is why the progressive video standard is preferred, especially when viewing high-definition video. Even though you have the option of shooting interlaced video at 60 fps, I encourage you to stay with progressive video.

SETTING THE MOVIE FORMAT AND QUALITY

1. To change the quality of your video recording, press Menu and navigate to the Image Size submenu.

2. Rotate the Control wheel to highlight and select File Format under the Movie section. Select AVCHD. (The NEX-6 lets you select from two video compression formats: AVCHD and MP4. I encourage AVCHD because it offers higher recording quality and less compression.)

3. Highlight and select Record Setting under the Movie section of the Image Size submenu (**A**).

4. Under Record Setting, you are given a list of quality settings from which you can choose, three progressive scan options (denoted by a *p* after the frame rate) and two interlaced options (denoted by *i*). Select the desired quality setting by pressing soft key C (**B**).

5. Press the shutter button halfway to return to shooting.

SOUND

The NEX-6 can record stereo audio to go along with your video, but there are a couple of things to keep in mind when using it. The first is to make sure you don't block the microphone ports on the front of the camera. If you look closely at the top of the camera body, you will notice two small holes on either side of the lens mount (**Figure 11.2**).

FIGURE 11.2
The NEX-6's built-in microphones

The next thing you need to know about the sound is that because the microphone is part of the camera, any noise that the camera makes, such as when you zoom the lens, will be audible in your movies. If you find that the zooming or lens focus noise is distracting, or you plan to add your own soundtrack to the video at a later time, you can turn the audio recording off.

TURNING OFF THE SOUND

1. Press the Menu button, and rotate the Control wheel to highlight and select the Setup submenu. Then, rotate the Control wheel to Movie Audio Rec (**A**).

2. Press soft key C to select Movie Audio Rec, and then select Off (**B**). Press the shutter button halfway to return to shooting.

BETTER SOUND FOR YOUR MOVIES

If you want to eliminate the camera noise that comes with recording sound with your camera, you should consider using an external microphone. You can have much more control over the quality of the audio because you are using a device whose sole purpose is to record audio. There is a growing market of microphones for mirrorless and DSLR cameras, including mics with hot shoe adapters that allow you to mount the mic to the camera so you can record without having to worry about holding the external mic. Unfortunately, as of this writing, there is no microphone available that you can pair with the NEX-6's new multi-interface shoe. Since there is no other external audio input, I suggest doing what the pros do: Record sound separately and sync it later using software. This does take a bit more time, but it also provides you the best sound. Several manufacturers sell separate audio recorders that produce high-quality sound at an affordable price, such as the Zoom H1, which retails for about $100. I prefer the H1's bigger brother, the H4n ($270) because it includes two XLR inputs, which allow the use of a variety of specialized high-quality microphones, such as a more sensitive dynamic or condenser mic, or a shotgun mic that can reach out and grab audio from far away.

FOCUSING THE CAMERA

With the NEX-6, you can focus the camera using the shutter button while you are recording video. However, if you are already in autofocus, the camera will already be employing Continuous AF during video recording. This will allow you to follow your subject or achieve focus on the dominant subject matter in your scene as you move or recompose. The continuous autofocusing is barely audible, if at all, and that is a good thing. Even if you switch to manual focus, you would still pick up the same amount of sound since the focusing mechanism is electronically controlled (meaning that when you turn the focus ring on a lens like the kit 16–50mm, you're simply telling a very quiet motor to move the focus—you don't physically move the lens elements with your turning). However, if you would prefer not to run the risk of picking up any noise, the primary option is to turn the sound recording off on the camera and use an external microphone or sound recorder.

IT'S ALL ABOUT THE LENSES

Video cameras have been around for a long time, so why is it such a big deal that you can now use a mirrorless camera like the NEX-6 to record video? The answer is simple: It's all about the lenses. If you have any experience using a video camcorder, you know that it always seems like everything is in focus. While this isn't always a bad

thing, it can also be pretty boring. The NEX-6 has a physically larger sensor than most video cameras. Combine that with lenses that sport large apertures, and you can achieve a much shallower depth of field than you can with the aforementioned video camera. This shallow depth of field can add a sense of dimension and depth that is otherwise lacking. The truth is that many videographers are turning their attention from video cameras costing many thousands of dollars to the much more affordable DSLR and mirrorless cameras to produce similar high-definition results.

Using the NEX-6 will allow you to capture video with a more shallow depth of field, and you will also have the flexibility of using different lenses for different effects. While you may own only one lens right now, you have the ability to buy specialty lenses to enhance your video as well as your still capture. Any lens that you can use for still photography on your NEX-6 can also be used for video, including ultra-wide lenses such as the E-mount 10–18mm f/4 wide-angle zoom lens, or even the E-mount 30mm f/3.5 macro lens for getting extreme close-up videos.

USING FILTERS

CLOSE-UP

You can use the same extension tubes and close-up filters that you use for stills to get great close-up video of tiny little subjects such as insects or flowers. See the bonus chapter "Pimp My Ride" for more.

POLARIZING

The polarizing filter offers the same benefits for your videos as it does for your photographs. By utilizing this filter you can eliminate the bluish color cast that can happen on those blue-sky days, bring accurate color and contrast to vegetation, reduce annoying reflections from water and glass, and darken your blue skies, giving them more depth and character.

NEUTRAL DENSITY

Shooting in bright daylight conditions can sometimes overwhelm any attempts at using a larger aperture and, thus, a shallow depth of field (see the section "Getting a Shallow Depth of Field," later in this chapter). To help combat this problem, you might want to employ a neutral density filter to darken the scene. The filters come in varying densities, or darkness values, so you will need to determine how much light

you need to cut down to get the effect you desire. A great filter for this is the Singh-Ray Vari-ND filter, which lets you vary the amount of density by up to eight stops. The problem with this filter is that it only comes in 77mm and 82mm sizes, and it is pretty darned expensive. You can create your own variable ND filter by purchasing a linear polarizing filter and a circular polarizer, which cost much less. Place the linear polarizer on your lens and then the circular on top of that. Then just rotate the circular polarizer and watch the scene get darker and darker. Just dial in the amount of density you want and start recording.

TRIPODS

The use of a tripod for video is not quite the same as for still image applications. When you are shooting video, you want to present a nice, smooth video scene that is fairly free of camera shake. One particular case for this is the pan shot. When you are following a subject from side to side, you will want the viewer's attention to be focused on the subject, not the shaky look of the video. To help in this cause, your tool of choice should be a tripod with a fluid head. A fluid head looks a little different than a standard tripod head, in that it usually has one long handle for controlled panning. To really make things smooth, the head uses a system of small fluid cartridges within the panning mechanisms so that your panning movements are nice and smooth. For around $67, you can get a nice fluid pan head like the Manfrotto 700RC2, which will mount on your existing tripod legs (if your existing tripod has a removable head).

For more information on the Manfrotto tripod head, go to www.manfrotto.us.

CAMERA STABILIZER

Aside from using a boom arm, there's really only one way to get jitter-free video on your camera while moving around, and that is to use a steady device. You have probably heard of Steadicam rigs, but they can be cumbersome, expensive, and frankly a little bit of overkill for the normal video experience. There are, however, smaller handheld rigs that provide the same benefit without the cost and bulk, like the ModoSteady from Manfrotto. One of the big advantages of this rig is that it has three different setups to choose from. The steady mode hangs a counterbalance under the camera to allow you to capture fluid-looking video movement. You can also move the balance arm to a different position and then use it as a shoulder rig, much like the stock of a rifle. And finally, you can open the handle and turn it into a small tabletop tripod. That's a lot of functionality for under $100.

EASIER VISION

Unlike DSLRs, which don't allow you to use the optical viewfinder when shooting video, the NEX-6's high-resolution electronic viewfinder is very capable of displaying your video while you are shooting. Instead of being forced to use the rear LCD screen, you are able to view your scene as if you were using a larger monitor by putting your eye to the EVF. In manual focus, you are even provided focus peaking to ensure accurate focus placement while shooting. Although it is not ideal to have your face pressed near the camera while you are shooting video, planned shots make it feasible to use the EVF during moviemaking.

GETTING A SHALLOW DEPTH OF FIELD

As I said earlier, getting the look of a production cinema camera means working with shallow depths of field. Achieving this look is fairly simple with the NEX-6 since in any exposure mode, you can shoot video with the press of a button. With what you know now, you can flick the Mode dial to Aperture Priority (A) and rotate the Control dial to open the aperture as far as the exposure will allow. Use the LCD or EVF to assess the amount of depth of field in the scene, and begin shooting your video. **Figures 11.3** and **11.4** are frames from video clips used to illustrate the amount of depth of field you can achieve with video on the NEX-6.

You can also use Manual (M) mode for shooting video, as long as you don't mind manipulating both shutter speed and aperture. Many videographers, like still photographers, manually operate their cameras to achieve maximum control over their shots.

FIGURE 11.3
This frame was made with the aperture set to f/5.6. You can see that the background is completely out of focus.

FIGURE 11.4
This frame uses an aperture of f/22. As the aperture is closed down, the other rails come into focus.

When shooting video, especially in the professional modes (P, A, S, M), you also have control over your ISO level as part of the exposure formula. If you would rather not worry about manipulating one more control while managing other technical aspects of shooting video, you can use Auto ISO. Doing so lets the camera determine the lowest ISO level needed, leaving you free to compose your shot.

GIVING A DIFFERENT LOOK TO YOUR VIDEOS

USING CREATIVE STYLES

Something a lot of people don't realize is that you can use the creative styles to give your video a completely different look. Sure, you can use the Standard style for everyday video, but why not add some punch by using a different creative style setting? Maybe you want to shoot a landscape scene—go ahead and set the creative style to the Landscape setting to improve the look of skies and vegetation. If you really want to get creative, try using the Black & White setting. The great thing about using the creative styles is that you will see the effect right on your LCD screen as you record, so you will know exactly what your video is going to look like. Want to take things up a notch? Try customizing the creative style's contrast, sharpness, and color, and do things like shoot sepia-colored video. Check out the "Classic Black and White Portraits" section of Chapter 6 to see how to customize the look of the Black & White creative style.

WHITE BALANCE

You can select a white balance that matches your scene for accurate color rendition, but a great way to change the look of your video is to choose one that doesn't match, to give a different feel to your video. You can completely change the mood of the video by selecting a white balance setting that is different from the actual light source that you are working in. Don't be afraid to be creative and try out different looks for your video.

TIPS FOR BETTER VIDEO

SHOOT SHORT CLIPS

Even though your camera can record fairly long video sequences, you should probably limit your shooting time to short clips and then edit them together. Here's the deal: Most professional video shot today is actually made up of very short video sequences that are edited together. If you don't believe me, watch any TV show and see how long you actually see a continuous sequence. I am guessing that you won't see any clip that is longer than about 10 seconds. You can thank music videos for shortening our attention span, but the reality is that your video will look much more professional if you shoot in shorter clips and then edit them together.

STAGE YOUR SHOTS

If you are trying to produce a good-looking video, take some time before you begin shooting to determine what you want to shoot and from where you want to shoot it. You can mark the floor with tape to give your "actors" a mark to hit. You can also use staging to figure out where your lens needs to be set for correct focus on these different scenes.

FOCUS MANUALLY

This will be difficult to do at first, but the fact is that if you want to change the point of focus in your video while you are recording, then you should learn to manually focus the lens. Much has been said about the nearly silent autofocusing on the NEX-6. The autofocus tracks focus based on your autofocus area, and it is very useful when you are using the Flexible Spot option. But I advise you to be comfortable manually focusing as well. If you are recording audio using the on-board microphone, there is still a chance the sound of the autofocusing will be picked up. The autofocus can also be jumpy or slow, making it difficult to find focus and track your subject.

To change your focus, set the focus mode to manual and then use the focus ring on the front of the lens. This will be difficult at first, especially if you have never had to manually focus, but with a little practice you can become adept at it.

AVOID THE QUICK PAN

While recording video, your camera uses something called a rolling shutter, which, as the name implies, rolls from the top to the bottom of the frame. If you are panning quickly from one side to another, you will see your video start to jiggle like it is being shot through Jell-O. This is something that can't be overcome except by using a slower panning motion. If you are going to be shooting a fast subject, consider using a faster frame rate (such as the 60 frames per second options) to get a faster frame rate and smoother motion. The more frames you record, the smoother the video will look when played back.

USE A FAST MEMORY CARD

Your video will be recording at up to 60 frames per second, and as it is recording, it's placing the video into a buffer, or temporary holding spot, while the camera writes the frames to your memory card. If you are using a slower memory card, it might not be able to keep up with the flow of video—with the result being dropped frames. The camera will actually not record some frames because the buffer will fill up before the images have time to be written. This will be seen as small skips in the video when you watch it later. You can prevent this from happening by using an SD card that has a speed rating of Class 6 or higher (**Figure 11.5**). These cards have faster writing speeds and will keep the video moving smoothly from the camera to the card.

FIGURE 11.5
A fast card, such as this Sandisk SDHC Class 10, will help capture more of your video frames.

Although the manufacturer suggests Class 4 or faster media, my recommendation is that you use only Class 10 cards for video applications. I have found that some Class 4 and 6 cards just can't meet the demands of video and have caused my camera to pause or stop in the middle of a video shoot.

TURN OFF THE SOUND

Earlier, I told you how to turn off the audio option while recording video. If you don't have an external mic hooked up to your camera, your only audio option is to use the built-in microphone on the camera. The truth is that the microphone does not produce audio that is up to the quality of the video. To make your videos stand out, try turning it off and then adding a music soundtrack. You will be amazed at how the right music can enhance a video. Of course, you will need to do this on your computer, which will require special video editing software, which leads us to our next section.

WATCHING AND EDITING YOUR VIDEO

WATCHING VIDEO

There are a few ways to watch your videos. Actually, there are three:

- In your camera
- On your TV
- On your computer

To watch video clips on your camera, simply press the Playback button and then use soft key C and the Control wheel to activate the play commands that appear onscreen. You may have to press the top of the Control wheel (DISP) to see these commands if they do not appear right away. Pretty simple.

To watch on your TV, you will need to purchase an HDMI cable to make a connection between camera and TV. This will allow you to view your video in HD, as long as your TV can display at least 720 HD resolution. Make sure that you purchase a Mini-HDMI-to-HDMI cable since the camera does not use a standard-sized HDMI jack for outputting video (**Figure 11.6**). You can find them at most electronics stores that sell HD cameras and TVs. (Here's a little hint for purchasing a Mini-HDMI cable: Search the Internet for the best prices. Most

FIGURE 11.6
The mini-HDMI port on the NEX-6

electronics stores have huge mark-ups on cables, and you can usually find a suitable one online for about a third of the price of those in your local store.) Once you have the cable hooked up to your TV, tune it to the channel used for HDMI input, and use the same camera controls that you used for watching the video on the LCD screen to view it on the larger screen.

If you would like to watch your video on your computer, you will first need to download the files or access them using an SD card reader. For Mac owners, you can use Apple's QuickTime Player to watch the MP4 videos that you record. If it is too large for your screen, try pressing Command- – (minus) to decrease the size of the video frame, or Command-3 to fit the frame to your screen. If you want to view AVCHD clips, there are two options. One, you can import the videos into an editing program that is capable of reading AVCHD, such as iMovie ('08 version or later). If using iMovie, it is best to import the files from the camera, since the software uses the entire file and folder structure of the AVCHD format to import the video. Copying just the .mts files to your computer and trying to import will unfortunately not work. Second, you can convert the AVCHD files to MP4 or another Mac-compatible format by using software, such as iSkysoft Video Converter for Mac.

For Microsoft Windows users, it is possible to view the MP4-formatted video, but you will need to download the Media Player Codec Pack. Instead, try downloading QuickTime for Windows from Apple (www.apple.com/quicktime). The basic player is free and will allow you to view your movie files. The latest versions of Windows Movie Maker and Windows Media Player 12 are capable of playing your AVCHD files.

EDITING VIDEO

If you are a Mac owner, you can edit both high-definition MP4 and AVCHD video using the current version of iMovie. The most recent version of Windows Movie Maker is also capable of working with both file formats. Windows Movie Maker allows you to edit your video, and it also provides you a way to upload your finished videos to places like YouTube and Facebook. If you don't already have Movie Maker on your system, try this link for more information on how to download and install the free program: http://windows.microsoft.com/en-US/windows-live/movie-maker-get-started. There are many other Mac and Windows video-editing applications, such as Adobe Premiere Elements 11. You can find more information and download a trial version at www.adobe.com/products/premiere-elements.

EXPANDING YOUR KNOWLEDGE

I have given you a few quick tips and suggestions in this chapter to get you started with your moviemaking, but if you really want to get serious, there is a lot more you need to know. Videography can be a complex endeavor, and there is much to learn and know if you want to move beyond the simple video capture of the kids in the backyard or the trip to the amusement park. If you really want to explore all that your camera has to offer in the way of video moviemaking, then I suggest you read *Creating DSLR Video: From Snapshots to Great Shots* (Peachpit Press, 2012). Even though the NEX-6 is not considered a traditional DSLR, the same principles of moviemaking apply (and there's not much difference in operating the two camera platforms). The author, Rich Harrington, is a true master at shooting and editing digital video, and he is a top-notch instructor and author. This book is packed solid with everything you need to know about taking your videomaking to the next level and beyond.

Chapter 11 Assignments

Your NEX-6 has the ability to capture high-quality video as well as great-looking stills. The next time you are out shooting, take some time to shoot video and become more familiar with it.

Play with the depth of field

Since switching to video is as easy as pushing a button on the side of the camera, you still retain the functionality of each shooting mode. This means that manipulating the depth of field—one of the reasons that pros like shooting with cameras like the NEX-6—is just as simple as it is when shooting stills. Start in Aperture Priority mode and set your aperture to f/5.6. Press the Movie button and make a video clip. Set the next clip up with the same subject matter, but this time change your aperture to f/11. Then shoot a clip at f/22. Notice that more of your frame comes into focus the more you close down your aperture. If you want your entire frame in focus (what is called "deep focus"), your aperture should be closed down to around f/16 or f/22. To place focus only on your video subject (such as a person), shoot with a wide-open aperture such as f/5.6 or f/3.5. To throw the background even more out of focus, pull your subject away from anything he or she might be able to lean against. The farther you pull your subject away from the background, the more the background drops out of focus.

Practice manually focusing

Autofocus can sometimes leave you frustrated during a shoot, especially if you are shooting video. This is where tracking your subject while manually focusing comes in handy. Switch your camera to Manual focus mode, and use the electronic viewfinder to keep your subject in focus as you rotate the focus ring on the front of your lens. Keep in mind that focus can more easily be achieved when you have a deep depth of field, such as when your aperture is at f/8 and higher. The slower your subject, the easier it is to focus on, so start out with someone walking, and hone your skills until you can tackle faster subjects.

Find unique angles for your video

You've probably noticed that your NEX-6 is not very large—this has its advantages. You can find unique angles and interesting vantage points from which to shoot since the camera can easily be placed where larger cameras cannot. When you're shooting video, make sure you find an alternative angle for each clip and defy the urge to simply shoot from a standing position.

Share your results with the book's Flickr group!

Join the group here: flickr.com/groups/sonynex6_fromsnapshotstogreatshots

INDEX

WATCH READ CREATE

Unlimited online access to all Peachpit, Adobe Press, Apple Training and New Riders videos and books, as well as content from other leading publishers including: O'Reilly Media, Focal Press, Sams, Que, Total Training, John Wiley & Sons, Course Technology PTR, Class on Demand, VTC and more.

No time commitment or contract required! Sign up for one month or a year.
All for $19.99 a month

SIGN UP TODAY
peachpit.com/creativeedge

creative edge